KU-516-499

WITHDRAWN

86 0056473 5

WIGAN AND LEIGH COLLEGE

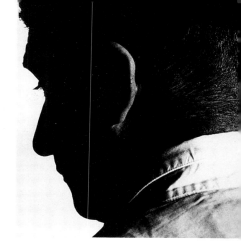

MEL GOODING

BRUCE McLEAN

PHAIDON · *OXFORD*

PHAIDON UNIVERSE · *NEW YORK*

1. HALF-TITLE: Bruce McLean. 1982.
Photographer: Dirk Buwalda.

2. OVERLEAF: *Untitled (Red)* (detail).
1982. Acrylic and crayon on canvas.
Two parts, each 78″×59″ (200×150 cm).
T̶...

...ted from *Dream Work.*
Knife Edge Press. 1985

WIGAN & LEIGH COLLEGE LIBRARY
LOCATION: CL
COLLECTION:
CLASS MARK 709.2 MAC
BARCODE No. 8600564735
DATE: 30/4/96 JS
24900

Phaidon Press Limited
Musterlin House, Jordan Hill Road
Oxford, OX2 8DP

Phaidon Universe
381 Park Avenue South
New York, N.Y. 10016

First published 1990

© Phaidon Press Limited 1990

Text © Mel Gooding 1990

Designed by Ray Carpenter

A CIP catalogue record for this book
is available from the British Library

ISBN 0 7148 2613 8

All rights reserved. No part of this publication
may be reproduced, stored in a retrieval system
or transmitted, in any form or by any means,
electronic, mechanical, photocopying, recording
or otherwise, without the prior permission of
Phaidon Press.

Typeset by Wyvern Typesetting Ltd, Bristol

Printed in Great Britain by
The Roundwood Press Limited
Kineton, Warwickshire

Photographic Acknowledgement

All colour reproductions in Chapters 5, 6, 7 and 8, unless
otherwise stated, are courtesy of the Anthony d'Offay
Gallery, London.

Acknowledgements

Acknowledgements and special thanks are due to
Rosy McLean, Rhiannon Gooding, Lynne Skelton,
Robin Vousden and Robin Harris of the Anthony d'Offay
Gallery, William Furlong, John Hilliard, Paul Richards,
Nena Dimitrijevic, and Dirk Buwalda. Above all I owe
a special debt to Bruce McLean himself, who has
collaborated at every stage of the book's preparation
with unfailing patience and generosity.

Contents

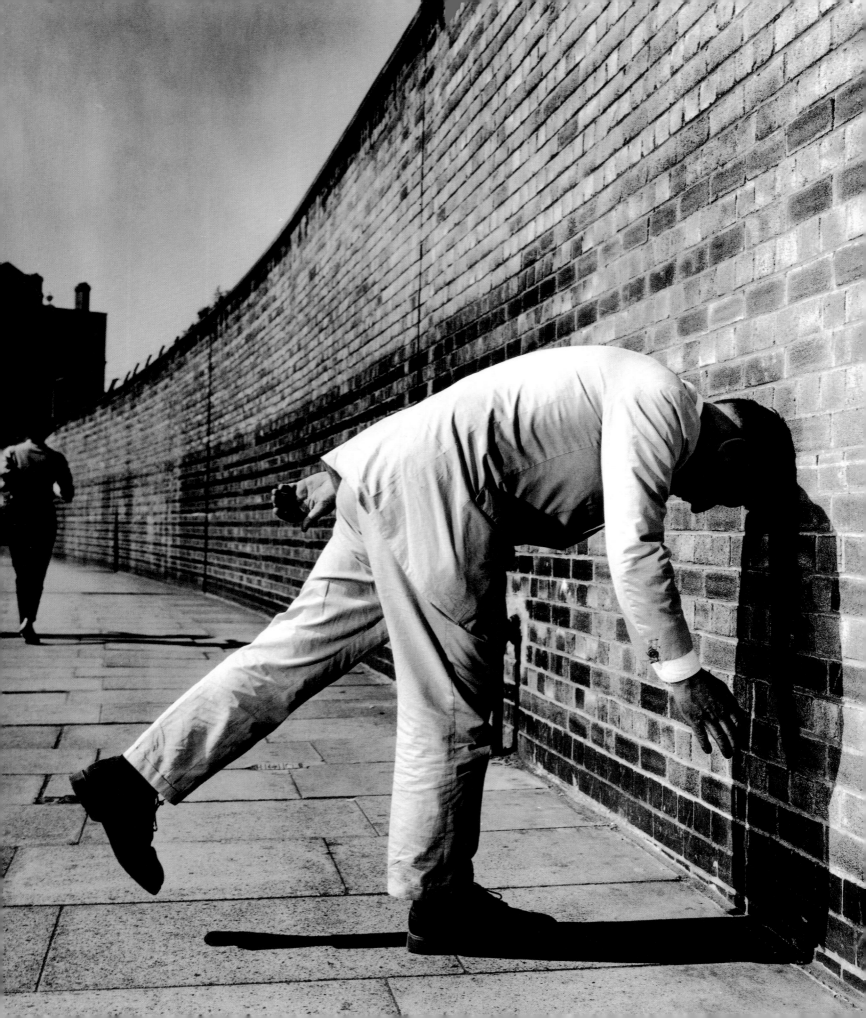

CHAPTER I

Opening Moves:

Glasgow to St Martin's

Nothing is lost

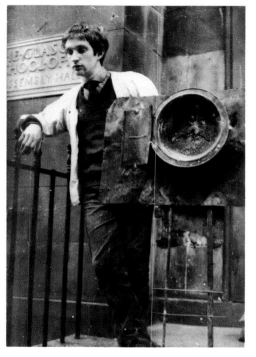

5. The artist at Glasgow School of Art. 1961

E ARLY one morning in the spring of 1963 Bruce McLean caught a train from Glasgow to London. The journey, made on impulse, was the result of a remark made in conversation the night before by a casual acquaintance, a painting student at the Academy Schools whom McLean never met again: *If he wanted to be a sculptor then the only place to be was St Martin's School of Art, and he should go there as soon as possible.*

The speed and energy with which the seventeen-year-old McLean acted upon this suggestion was characteristic: before lunch, unannounced and unexpected, he presented himself in the office of Frank Martin, Head of Sculpture at St Martin's since 1952. Martin was a remarkable administrator, generously open-minded and imaginative, with a genius for letting things creative happen around him and for recognizing who was likely to make them do so. His response to McLean was immediate and direct: when would he like to start? In the following September McLean left Glasgow for good, to complete his formal training at St Martin's before spending a final year on the famous 'vocational' advanced course in sculpture.

The impulsive vigour of his response to a well-directed remark reveals much about McLean. The quick wits and speed of action; the unconcern about conventional or official procedures when something important must be done, which goes with a perfect sureness that what is desired or required can be achieved (*there's nothing you can't do if you want to*); the boldness of spirit fired by a largeness of ambition; the risk-taking *chutzpah*: all these are recognizable components of a unique artistic personality, shaped and defined above all by an absolute vocational certainty. McLean cannot remember when he was not going to be an artist; the teenager on the train had already known for many years that making art was what he wanted to do and what he did best; the only question was where best to learn more? *Given a clue, he acted upon it,* which in a nutshell sums up McLean's creative and critical procedures. That he successfully circumvented bureaucratic formality in pursuit of what he needed will surprise no one who has met him or seen him perform.

Awareness of himself as destined for a life in art developed soon after McLean's mother encouraged him to join children's classes on Saturday mornings at the Glasgow School of Art when he was six years old. McLean remembers being left there by his father each week half an hour before classes began, and exploring Rennie Mackintosh's building with a sense of wonder at the strange aptness of its

4. OPPOSITE: Bruce McLean. 1987
Photographer: Alastair Thain

corridors and studios, recesses, stairwells and landings, and with intense pleasure at its variety of material, the sharp niceness and clarity of its craftwork. Peter McLean, Bruce's father, was himself an architect and passionately devoted to Mackintosh's work; he never passed the building without drawing his son's attention to some aspect of its design, to some detail or prospect.

So in a sense McLean grew up in Mackintosh's School, attending classes there with hardly a break until at sixteen he enrolled as a full-time student, and he has never lost his love and admiration for it. The building's uncompromising grandeur and simplicity, honouring and demanding respect for the activity it houses; its brilliantly imaginative solutions to the problems of the site, turning every difficulty to positive advantage; its functional diversity of structure and space; the uncompromising modernity of its perfect fitness for purpose; in every way the building came to exemplify a particular *attitude* to art and life, one with which McLean identified in the fullest sense of the word. It deeply influenced his philosophical development and helped incalculably to shape his aesthetic. Quite apart from anything else it initiated McLean's lifelong preoccupation with the uses and misuses of architecture, a fascination with the effect of designed and designated spaces upon social behaviour and with the nature of human manoeuvres in such spaces.

What also had a lasting effect upon the young McLean was that at the School he enjoyed the company of real artists, following their own interests and making their own work. At ordinary school, especially his secondary school, he had had little interest in what had passed for art classes, being already aware that his teachers' commitment was of another kind from what he was seeing every week at the Art School. Especially important was the example of Paul Zunterstein, whom McLean encountered first when, at the age of nine, after two or three years of drawing and painting, he decided to try sculpture. Zunterstein, a Polish emigré, took a special interest in the boy (becoming the first of many teacher-artists to respond to his enthusiasm and seriousness with encouragement and friendship). McLean learned modelling in clay and plaster, making wire armatures and modelling with plaster bandage, pottery techniques in terracotta, wood and stone carving, and metalwork techniques. When the boy was about twelve Zunterstein showed him Brancusi's photographs of his work and studio and introduced him to the work of Giacometti (whose *Spoon Woman* made a strong impression), Richier and other European artists. At thirteen he struggled to make a version of Brancusi's severely formalized *Torso of a Young Man* and by his early teens he was deeply involved with sculpture. It was already the mode of art to which he felt the deepest commitment and he had already had a wealth of practical experience.

Other things, nearer home, were helping to shape the personality of the potential artist. McLean's work is of a kind that uses everyday contacts, memories, private experience, jokes, gestures, sartorial fashions, word play, saws and sayings, the habits and rituals of ordinary life. Given his sharp eye for the banal, it should come as no surprise that he was born and brought up in Clarkston, a respectable suburb of Glasgow: 'just about the most suburban place on earth'. In a very ordinary bungalow the McLeans (Bruce was an only child) led a life that was remarkably un-ordinary. From his mother McLean may be thought to have

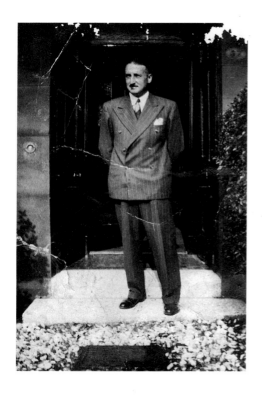

6. Peter McLean, the artist's father, c. 1939

inherited his determination and stamina, and from her especially he derived the strength of will and confidence so crucial to his extraordinary sense of the possible. She was ambitious for him and confident in him from early on and has continued to be clear-eyed and unsentimental in her support of his work. It was her idea that the six-year-old should attend the Art School and she who took him at eight to see Huston's film, *Moulin Rouge*, presumably to increase his perception of what art might be about.

There is no doubt that his father was a major figure in the development of McLean's distinctive outlook on life, though not necessarily in direct terms. Peter McLean paid close attention to matters of style; 'getting things right' was of primary importance to him so that carefully chosen wine arrived at the bungalow by the case, there were regular lunches in the best restaurants and annual holidays were spent at the best hotel on the Isle of Arran, with fishing and golf. He lived a simple and more or less routine life, spending money on good shoes and stylish suits, meeting with his small circle of friends in particular bars at particular times,

7. Early Works in the Garden, Clarkston, Glasgow. 1957

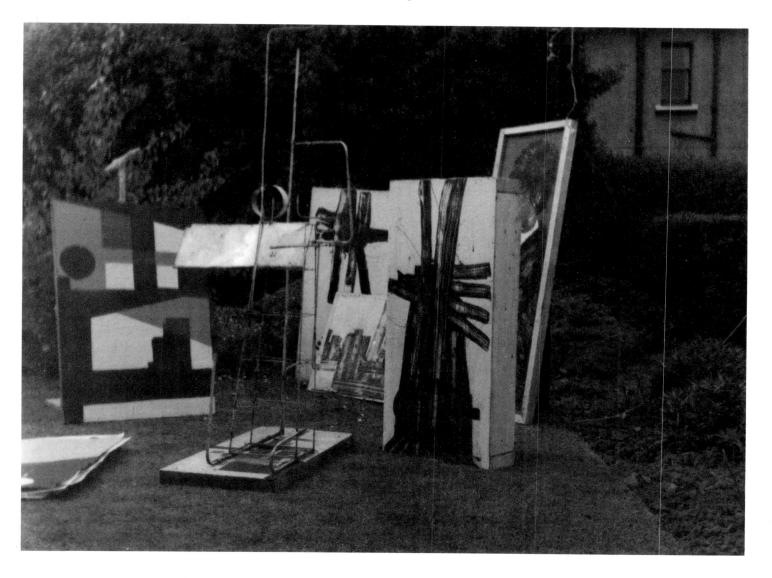

taking solitary constitutionals with his habitual walking stick. Such dandyism, however modest its manifestation, is always a mask. Peter McLean was a complex and temperamental man, undoubtedly intelligent and talented, who had somehow decided upon a quiet life and the Voltairean cultivation of his own garden. Throughout his twenties and thirties, before his marriage, he had been one of a party that had permanently booked ten seats every Saturday night in the front row circle of the Glasgow Empire. Virtually every major variety act in the world played the Empire and Peter McLean saw them all. He loved jazz and dancing; he had a collection of records dating back to the beginnings of the disc; he could demonstrate the subtlest variations of tap. In short he was a master of pose: for his son his continuous performance was to be an important clue to the significance of the behavioural and sartorial nuance in the presentation of self in everyday life.

As an architect McLean senior had humanely advanced ideas for the regeneration of the Gorbals slums. He would have preserved the physical character of working-class Glasgow while providing the tenements with decent facilities and maintaining a genuine community life centred on the block and courtyard, comprehensible and defensible structures and spaces for living in. He watched in dismay the destruction of the Gorbals and the construction of high-rise blocks miles from the centre of the inhabitable city, and predicted their inevitable and rapid decline into irredeemable vertical slums. With a close friend and long-term professional colleague he shared a fascination bordering on obsession with the paraphernalia of air extraction and the disguising of ducts and flues in enclosed spaces. That behaviour is a function of environment and of the limited space we must sometimes share with others became one of his son's principal themes. 'My father filled my head with a lot of ideas and set going a lot of my obsessions,' McLean has said. 'And he never stopped me doing what I wanted to do.'

McLean acknowledges one other crucial influence within the family. Peter's own father was a Magrittian accountant, respectable and pipe smoking, whom Bruce was taken to visit every Sunday during his early childhood. While his father and grandmother talked, Bruce was entertained with a series of pataphysical activities specially prepared and introduced by a set of ritualistically repeated word-plays. At some time in the past the grandfather had created, for no discernible reason, a complete pianoforte front, featuring cherubim and flowers, modelled in chewed bread dried and blackened with boot polish. One of the Sunday activities was to teach Bruce to vamp at the piano, himself blacked up with vaseline and cocoa. Grandfather would produce a cardboard rectangle the precise size of the Glasgow Herald's Spot-the-ball competition photograph, with a pinhole through which the arbitrary mark could be made. Tiddlywinks was introduced to the enthralled grandson with the unvarying words 'Some play ping pong, and some play tiddley tiddley winky!' At some point in the proceedings the sketchbook would be produced, and before free drawing could begin the infant artist would be asked the invariable question: 'What shall we do this week? Shall it be *a potato against a black background, or a scone off a plate?*' It is not surprising that this inspired and bizarre performance made a deep impression. Aspects of its forms and themes can be traced directly in the work of the mature McLean.

At sixteen McLean began the Two Year General Course at the Art School, his

8. *Painting* c. 1965. Oil on cotton duck,
72"×72" (183×183 cm)

studies following a more or less time-honoured academic pattern whose chief benefit was that he was able to extend his knowledge of medium and technique. Of his teachers McLean chiefly remembers Sinclair Thompson, whose enthusiastic and unprescriptive approach to teaching he took as something of a model for his own practice later. Thompson introduced him to the work of Joan Eardley, whose robust landscapes McLean has continued to admire while deploring the sentimental and hypocritical attention paid to the Glasgow slum children pictures. Before the course was completed, as we have seen, McLean was already determined to leave Glasgow. He knew that what he needed was to be found elsewhere and he felt no sentimental attachment to Scotland. Indeed he had come to find a certain middle-class-Scottish emotional tightness and mean-spiritedness pervasive and constricting: he can still mimic with appalling precision the rounded vowels and sing-song modulation that characterize the snobbish accents of particular Glaswegian and Edinburghian suburbs.

St Martin's, in Charing Cross Road, on the edge of Soho and in the very centre of London, was another world. McLean arrived at the zenith of its reputation as a forcing ground for the New Sculpture. He was taught by, among others, William Tucker, David Annersley, Isaac Witkin, Michael Bolus and Philip King, all of whom figured in the epochal *New Generation* exhibition organized by Bryan Robertson at the Whitechapel in the spring of McLean's second year at St Martin's, and all of whom had themselves studied at the School under the prevailing influence of Anthony Caro. In an open but rigorous atmosphere, absolutely serious and professional – even solemnly so in some respects, of which more later – presided over by Frank Martin, this group of young artist-teachers (King and Bolus, the oldest, were not yet thirty) were establishing an approach to sculpture derived largely from the work and teaching of Caro, who still visited the department but was already becoming an international figure who seemed somewhat distant from the younger students.

Caro had taught that sculpture could be made without regard to any of the conventions that had traditionally governed its production, that any material was potentially valid, that questions of scale and placement could be rethought, that colour had diverse roles to play in the formal dynamic, that the formal presentation, *the framing*, so to speak, of sculpture by plinth and pedestal, was a matter of conventional device with implications that should be treated critically *and taken into account in the process of sculptural conception*. For Caro himself all this had led to certain decisively influential creative actions which for the generation that followed him seemed to be crucial breakthroughs: he had taken sculpture off the plinth and he had introduced flat non-referential colour. Above all he had taken the post-Expressionist *cool* of hard edge painting and applied its findings to sculpture.

These things suited the mood of the moment, especially for those younger artists who wanted to move beyond the expressive and emotive figuration of the post-war years, the spiky broken-surfaced *personnages* and the spidery metal work of what Robert Melville called the 'new linear school of attenuators and cage constructors' engaged upon what Herbert Read had described as 'the geometry of fear'. That work, influenced above all by Giacometti and Richier, had reflected the bleak political experience of the late 'Forties and the 'Fifties, the new age of anxiety

and of psychic tension, of the A-bomb and the Cold War. It was made by a generation of artists only too aware of war's realities, a sculpture of commentary and engagement addressed to a public in an urgent and readable language. These sculptors (Armitage, Butler, Chadwick, Clark and Meadows among others) had shown with great critical success at the Venice Biennale in 1952. With the continuing rise in international standing of Moore and Hepworth, and the growing reputation of a middle generation that included Dalwood, Adams (both of whom showed at Venice in 1962), Turnbull and Paollozzi, British sculpture was held in official circles and by an older generation of critics to be at an historical high point. All those artists were committed in some way to anthropomorphous, biomorphic, animal and organic or totemic forms, images with a recognizable history in the established sculptural languages of the twentieth century. They looked to European examples, especially to the figurative or near-figurative.

With the turn of the decade a different feeling was in the air, new directions were indicated. Much nonsense has been written about the 'Sixties, but whatever the exaggerations of politicians and the hyperbole of journalists there was without doubt during the period 1960 to 1966 an exhilarated sense of creative release, a widely shared feeling that new beginnings were possible and that somehow the 'post-war years' were now over. The extraordinary convulsions of 1968 may be seen now as a frustrated reaction to the disappointment of those hopes, the dashing of early 'Sixties illusions. For those artists starting out in the late 'Fifties, that 'new generation' whose work was to be showcased at the Whitechapel exhibitions (painters in 1964, sculptors in 1965), it was the creative energy and ambition of contemporary art in the USA that was of first importance. The first big exhibition of American Abstract Expressionism was put on at the Tate in 1959, and in the following two years the 'Situation' exhibitions signalled the awareness of younger British painters of the developments of post-painterly and hard edge abstraction in the States. The only sculptor to contribute to the 1961 'Situation' show was Anthony Caro. In 1960 he had gone to America and made contact with Clement Greenberg, David Smith and Kenneth Noland, with decisive consequences for his own work.

At St Martin's it was Caro who formed the critical link that enabled a receptive and talented group of students to see the implications for sculpture of the newest American painting, with its inexpressive, neutral, anti-heroic stance, concerned above all with formal issues and with questions about the irreducible nature of the art object itself. It was not so much a matter of formal style that Caro had brought to St Martin's as a process of a rigorous and open-minded questioning, the notion of the forum of enquiry as a mode of teaching, plus a powerful example of single-mindedness and originality. *Sculpture no longer had to fulfil its traditional historical purposes, either referential or monumental: anything was possible.* Powerful teachers inspire strong reactions. Most of Caro's immediate students turned to materials other than his favoured painted steel and lacked interest in the real sources of his art, notably cubism through David Smith, and the transformed figure/landscapes of Henry Moore, to whom he had been an assistant.

When McLean arrived at St Martin's he was allowed no doubts as to why he was there: 'We are here to enquire into the nature of modern sculpture; what it could

be, what it is, what it might be.' The place was responsive to a great deal else: Alex Trocchi and Raymond Durgnat taught at the School and poets, film makers and critics, as well as artists, visited. 'You felt,' McLean recalls, 'the place was totally alive; you felt part of something that was vital.' Down the Charing Cross Road was Better Books, a constant supply of what was new in American writing and of international art magazines, with its sometimes chaotic *happenings* and events. A walk away was the British Museum's inexhaustible sculptural treasures. McLean especially enjoyed the Syrian and Egyptian galleries, but when he realized he was making pastiche archaic carvings he consciously decided to stop seeing them. There was also, of course, the Tate, while at the Whitechapel Bryan Robertson was organizing a phenomenal series of seminal exhibitions, including retrospectives of Johns, Rauschenberg and so on. At the ICA in Dover Street there were artist-initiated events and readings, and in Soho were pubs and cheap restaurants like Jimmy's in Frith Street, and strip clubs where McLean made countless drawings and enjoyed the more comically imaginative attempts at drama and pose.

He threw himself into his work at the college with gusto, using a variety of media with more energy than direction. 'At St Martin's I was stumbling, I was struggling hard: all you could do was to emulate things that you liked. I knew I hadn't got a direction.' Yet being at St Martin's and in London was for McLean a liberation. He was free to explore materials and ideas in an atmosphere that encouraged experiment and chance. When he left the college in the evening it was more often than not to return to his flat, where he made several large-scale paintings. Because of the arrangements that Frank Martin had made to enable him to attend the School McLean, unlike many close contemporaries on the Vocational Course, was obliged to undertake Printing as a subsidiary. This had the advantage of bringing him into close contact with Ian Tyson, a man of great style and aesthetic understanding, with whom he studied lithography, etching and engraving. Among others with whom he formed collaborative friendships at St Martin's were the photographer Dirk Buwalda and the sculptor Andrew Hall.

While his teachers and contemporaries looked most intently at American abstraction, and to Brancusi as a proto-abstractionist, McLean was much more interested in American Pop Art, particularly that of Oldenburg and Warhol, and in the assemblage and mixed media work of Rauschenberg, Kienholz and Stankievicz. He was particularly aware of the fact that many of the American artists he admired seemed to be working in a more dynamic situation than existed in Europe, with a much greater emphasis upon the possibilities of collaboration across artistic barriers. Rauschenberg's work with dancers and Warhol's unrestricted activities encompassing film and music were important pointers. American Pop seemed to suggest that art might be involved with life in ways both critical and celebratory and which, above all, could actually employ humour. Oldenberg's great text for the catalogue of the exhibition 'Environments, Situations, Spaces' at the Martha Jackson Gallery in the Summer of 1961 sums up a great deal of what McLean was beginning to feel about art and life towards the end of those formative St Martin's years, though he didn't in fact encounter that text until some time around 1970, when he recognized immediately a consonance of spirit. Here are some statements from the text:

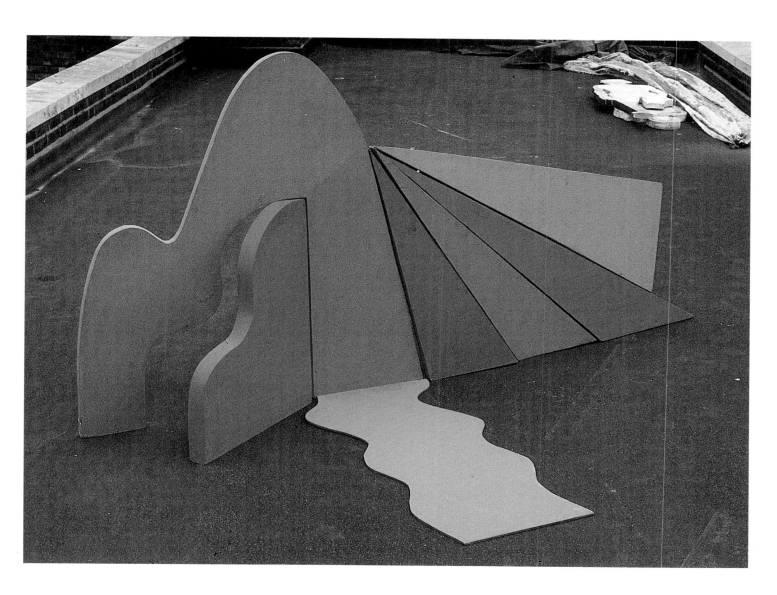

9. *Untitled Sculpture.* 1966. Painted plywood,
72″×36″×36″ (183×91·5×91·5 cm). Destroyed

I am for an art that is political-erotical-mystical, that does something other than sit on its ass in a museum.

I am for an art that embroils itself with everyday crap & still comes out on top.

I am for an art that imitates the human, that is comic, if necessary, or violent, or whatever is necessary. . . .

This is to anticipate. At St Martin's McLean was seriously engaged upon the sculptural experiment and exploration that the School encouraged with such critical rigour. He admired much of the work of his New Generation teachers, especially that of Philip King, whom he felt as an important influence at the time. During his second year he worked as a fabricator for William Tucker; he greatly respected Caro's genuine originality and he was impressed by the earlier, totemic stackings of Turnbull. His own work at the School was eclectic, and began with assemblage and carved works. For some of his teachers the apparently unfocussed variousness of his initial efforts occasioned early doubts about his suitability for the course, and at the end of his first term he was asked by King and Tucker, in a spirit of kindness, whether he felt he should 'go home and consider the situation'. The suggestion and its implications were quite incomprehensible to McLean. His confidence undented, he continued to work as frenetically as ever, without the slightest doubt that he would discover his true direction in the fullness of time.

McLean's later School work included a number of epigonal pieces like *Raspberry Ripple* and *Big Rock Candy Mountain*, very much in the coolly abstract, un-engaged, formalistic mode of the mid-'Sixties moment. One of these was a work very much influenced – and consciously so – by the quirky presence of Philip King's *Twilight*. It was a coloured floor piece, formally complicated and, in McLean's opinion, rather daring. At a forum some trickily crucial questions were raised: *could the piece be viewed all round? was it truly three-dimensional? was it sculpture? if it wasn't a sculpture could it be a painting if it was standing in space?* It was decided: *it was too thin to be a sculpture.* In that case, McLean retorted, *it's too thick to be a painting.* It may be that this moment was something of a turning point. The sculpture had not been intended ironically – it's *important to remember that very little of McLean's work at St Martin's was ironically or satirically intended* – but the discussion had seemed fundamentally unserious, one in which intelligent and talented people had stood around and debated in utter solemnity questions that seemed of no moment in the world beyond the art school seminar or the *avant-garde* gallery: 'The St Martin's sculpture forum would avoid every broader issue, discussing for hours the position of one piece of metal in relation to another. Twelve adult men with pipes would walk for hours around sculpture and mumble.' McLean now acknowledges that this much quoted recollection is a comic exaggeration but it nevertheless contains an essential truth. He realized that the sculpture itself might be secondary to something else, might be simply the focus for the real object of the exercise – pose.

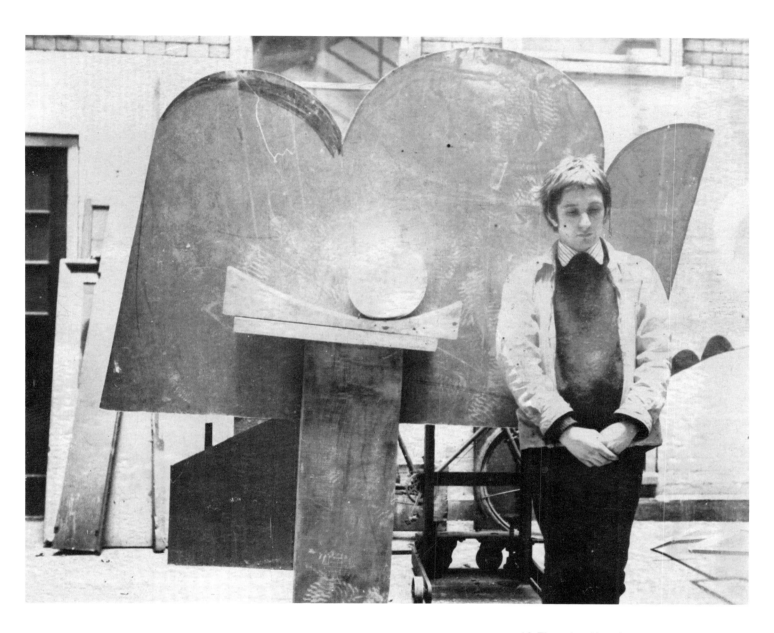

10. The artist with sculpture,
St Martins School of Art. 1964

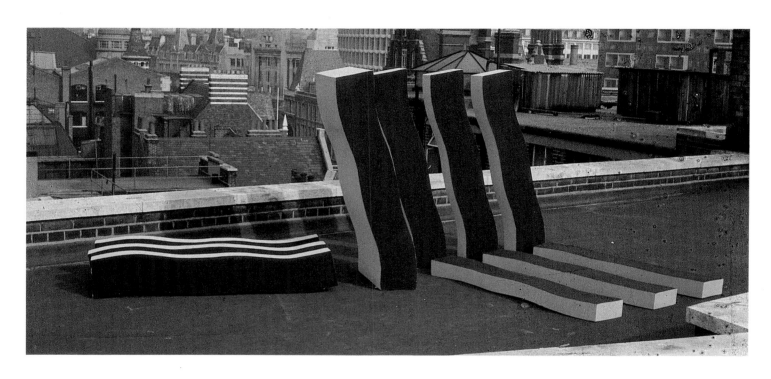

11. *Big Rock Candy Mountain.* 1966. Painted
plywood,
144″ × 144″ × 144″ (366 × 366 × 366 cm). Destroyed

12. *Raspberry Ripple.* 1966. Painted plywood,
78″ × 42″ (198 × 107 cm). Destroyed

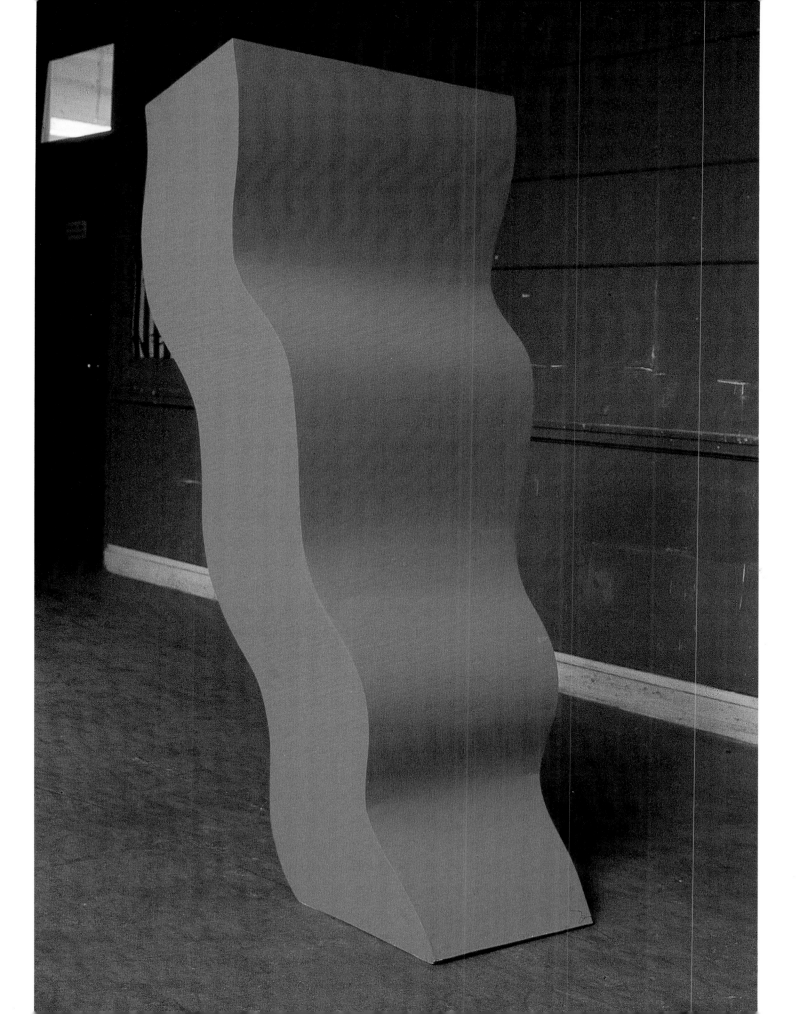

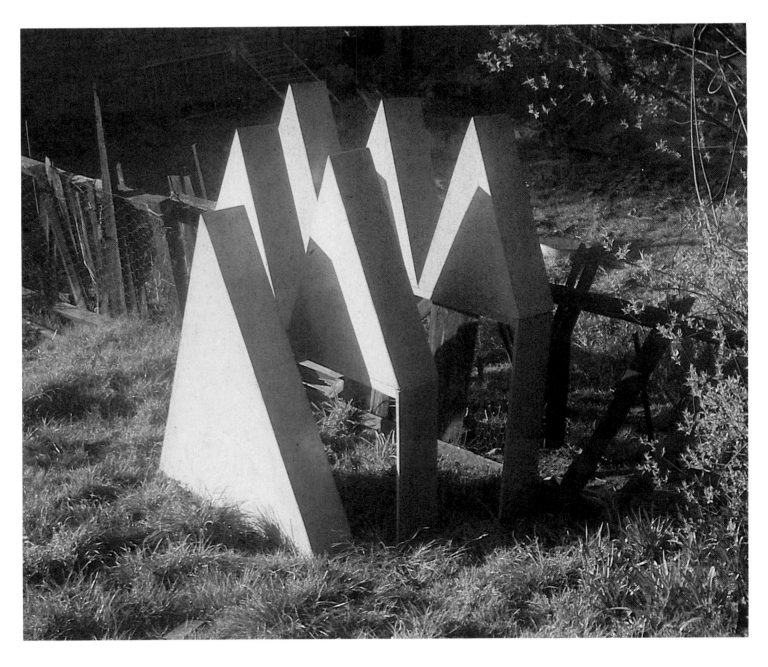

13. *Untitled* c. 1966 painted plywood. Dimensions
unknown. Destroyed

14. *And Broke His Crown.* 1966. Painted plywood,
60″×36″×24″ (152·5×91·5×61 cm). Destroyed

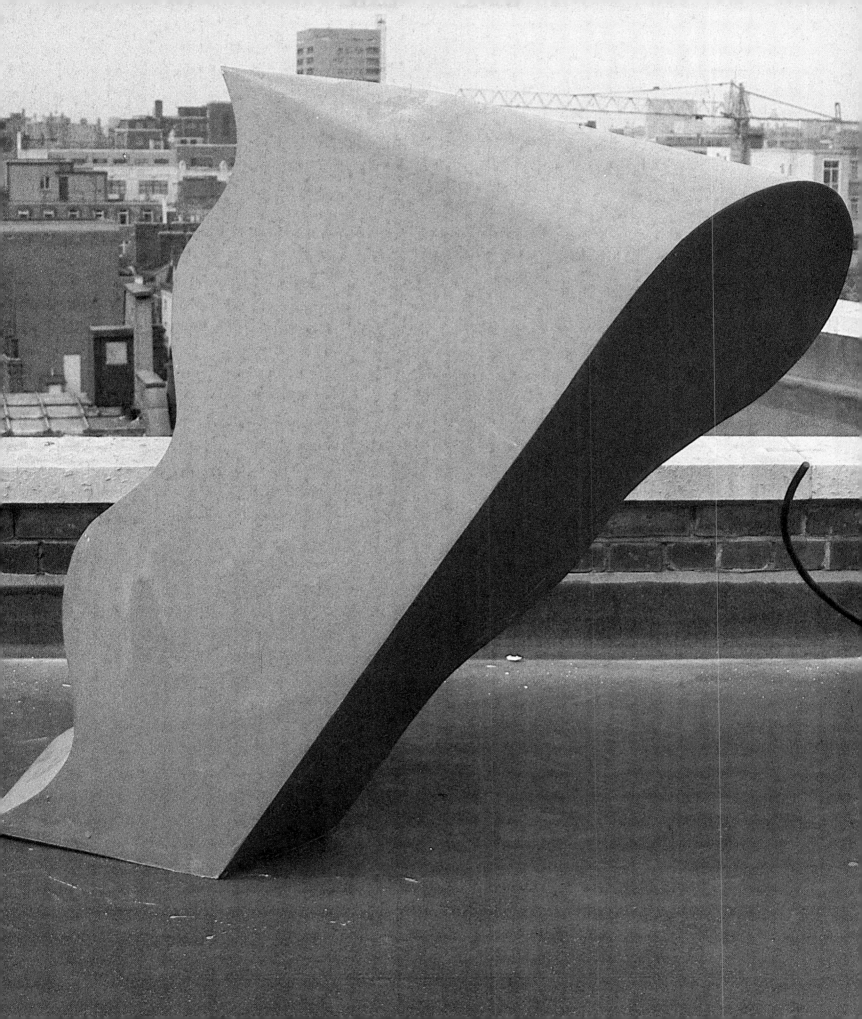

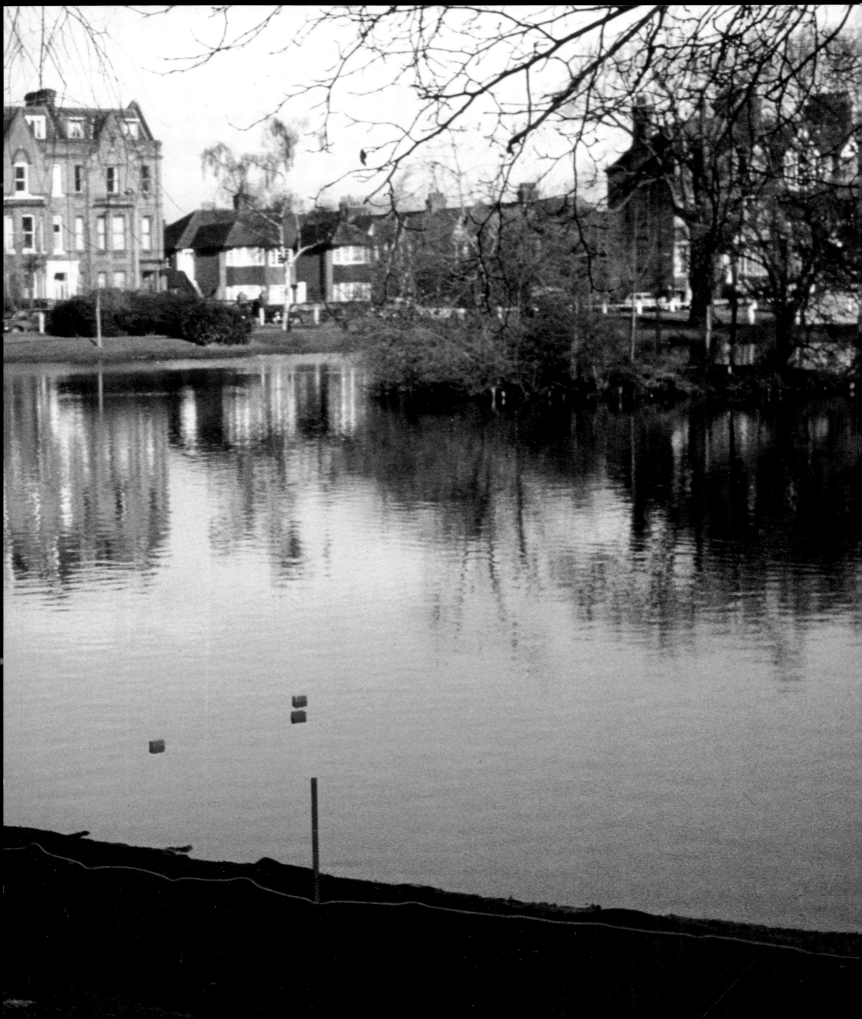

Deepening the Game

Barnes and Croydon

'. . . what is fascinating now is that it's going to become much more difficult for the artist, because he must really deepen the game to be any good at all.'

Francis Bacon

D URING his second year at St Martin's McLean collaborated with Andrew Hall to make *Mary Waving Goodbye to the Trains*. On the roof they assembled a number of materials and objects not necessarily associated with St Martin's sculpture: cut-out cardboard, plaster, domestic objects like curtains and a mattress, and silhouette figures. These were positioned and repositioned in an entirely arbitrary way by McLean on the roof while at ground level, outside the School on the Charing Cross Road, Hall similarly moved around two cut-out figures. Passers-by could not know that a component of the work was in progress on the roof, and up on the roof McLean could not see what Hall was doing in the street below. The significance of the work lay entirely in certain half-formed ideas about sculpture that McLean would develop as a counter to the aesthetic assumptions that were the critical hard currency at St Martin's during that period. Most significantly it was an event in time.

Mary Waving Goodbye to the Trains raised the possibility of a *sculpture* consisting of both objects and actions and that could exist without being seen as a whole. McLean had already pointed out that the School itself 'framed' the works made within it; and that the sculpture department was housed on the sixth floor, itself a hidden plinth. By placing part of a 'work' on the roof McLean and Hall were ironically proposing the whole building as a pedestal. Meanwhile, in the Charing Cross Road, another part of the work was *actually* on the real ground, in the open, on the street.

It is possible to see in *Mary Waving* a great many of McLean's later ideas in embryo: it was *live*, a sculpture in time and space; it emphasized the relation of people to objects; its partial invisibility and its impermanence made the documentary record of it our only means of knowing that it ever existed; it challenged assumptions, current at St Martin's, about the properties of sculpture, ironically reflecting on art dogmatics of any kind; and it used familiar objects and materials as signs, in imitation of their semiotic function (as distinct from their practical use) in real life. Especially it anticipated McLean's emphasis on the idea and the action as distinct from the object and his habitual focus upon non-esoteric, common activities as subject matter.

Though it indicates the way McLean's thoughts were going some time before

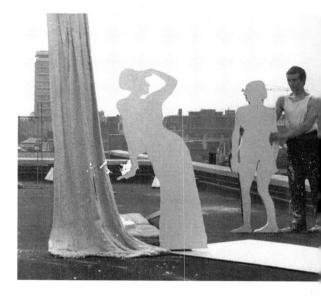

16. McLean preparing *Mary Waving Goodbye to the Trains*, St Martin's roof. 1965

15. OPPOSITE: *Three-part Floataround Sculpture*. Barnes Pond. 1969. Plastic blocks on water.

Not even crimble crumble

'British Sculpture out of the Sixties,'

ICA London August-September 1970

18. OPPOSITE: *People Who Make Art in Glass Houses.* 1969.
Photowork to accompany *Not even Crimble Crumble*
(originally published Studio International,
October 1970). Photographer: Dirk Buwalda

British sculpture out of the sixties doesn't sound too exciting an idea, and the general feeling is that it should have remained a pretty bad idea.

I think at this point I should explain what, in fact, crimble crumble is or isn't.

What it is, in fact, is an attitude, ease, panache, that some people have and some people haven't.

The only person in the show getting near to having a touch of the crimble crumbles is Tony Caro.

It is a sort of ease, style that some people have, cultivate a bit because they know when they've got it, work on it; it has to do with 'craft' tricks, then perpetuating the tricks, never quite letting them become completely boring.

Those who possess this talent have the best chance of becoming the International con-men who make up the 'Art scene'.

I wouldn't object so much to the show if it had a bit more crimble crumble in it, but there's hardly one con man out of the sixteen artists in the show.

Sixteen artists and not one bit of excitement in the whole of the gallery. Some critics say that the space is not too good and that it's very difficult for sixteen artists to do anything with the space. Isn't that what some of them, at least, are about: dealing with space?

I find it terribly sad that sixteen artists, some of International stature, can't do more with the space which they've all chosen (knowing its limitations or possibilities) to show together in. How can it be possible to make the ICA situation so dull? Some say talent, maybe. British sculpture out of the sixties. What questions are these artists asking themselves? Any? They make things, or do things; where are the pieces going to be seen? Is it important?

Do they consider this at all: are the works going to be seen in an open situation, with other artists' works, or are they going to be seen privately, one work one white-painted room? Not considered, I don't think.

Are they concerned with the communication of 'non ideas'? If so, where and to whom? And why?

It's unfortunately all a bit private; it's all done for the few who understand and know, whoever they may be. I think mainly rich and fat American ladies straight out of Marx Brothers films. It seems, for them, to have something to do with status; having conned a few thicks they're immediately conned themselves.

Why don't they take a few chances, smash up the little scenes they've carefully built up like a military operation for themselves over the last five years and have a go at setting towards making or doing something worthwhile.

They all get a little scene going because they were the first to use blockboard for a sculpture; 'flip flops' and that's their lot; it's doubtful whether they'd even move on to marine ply.

United Rug Piece, Space Frame; when will British sculptors get a few ideas; even the titles are chestnuts.

I think they ought to sling the lot out of the window, but not fall into the other trap of calling *that* 'sculpture' either, or the mark left on the pavement, or the absence of it after it's been cleared away, and not the clearing away of it either.

It's time for a re-think, or a think. ●

17. From 'Not Even Crimble Crumble'. *Studio International.* 1970

24

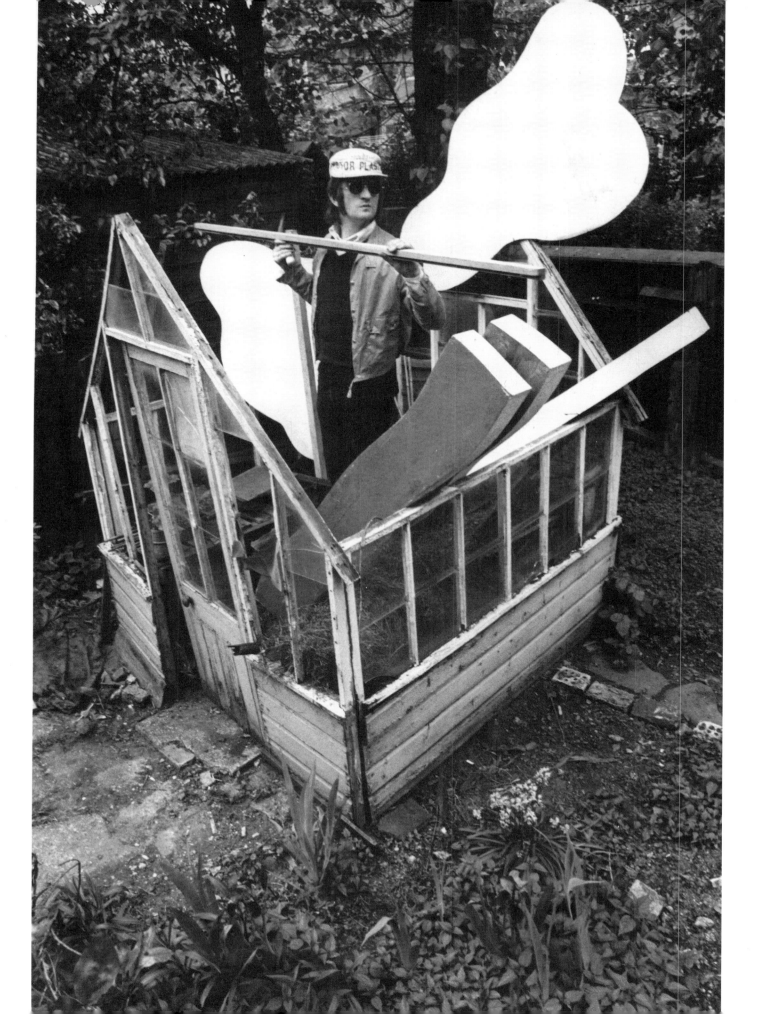

he left St Martin's it was an isolated action, and for the most part his time at the School was spent making object sculpture, exploring its formal possibilities, and experimenting with materials. This solid groundwork within the given conventions of object-centred art was essential to his development. The humour, the insistent irony, the mockery of art-world pretensions that were to become a famous part of his own activities as an artist were to be based upon a deep inside knowledge of what he was satirizing and upon an uncompromising commitment to art itself. But how was art to be defined? That was the crucial question.

McLean was already sceptical of the insular circularity of the aesthetics that dominated the sculptural practice of his teachers at St Martin's and which provided the basis of their critical discussions and those of the students. As time went by he became less and less patient with the persistent formalism, the self-contained, self-referential criteria for sculpture prescribed by Tucker and his colleagues: that it should be ground-based, 'human' in scale, formally coherent in three dimensions, arbitrary in its use of material (preferably not 'traditional'), non-figurative and with non-associative colour.

In his Introduction to the *New Generation* catalogue Ian Dunlop had written: 'Colour is perhaps the most obviously new thing about this sculpture, with a variety of uses. It can set the mood of a piece, it can help underline some feature in the structure that needs emphasizing, but more often than not it acts like a skin. *The point being that an even colour applied to an even surface helps rob the surface of all value as an expressive feature in sculpture.* The skin helps to rid sculpture of relying on tactile associations for its effect and *concentrates attention on its visual significance alone*' (my italics). *Not even crimble crumble*, McLean's review for Studio International in October 1970 of the ICA exhibition 'British Sculpture out of the Sixties' was a devastating comic send-up of this sort of arbitrary dogmatism:

> In the early sixties, under the direction of Frank (come into my office, Jock) Martin, the sculpture school at St Martin's was making one breakthrough after another. Now, in retrospect, none of these were, in fact, major breakthroughs.
>
> 1. Put-a-sculpture-on-the-floor piece.
> This came immediately after take-that-sculpture-off-that-base-and-don't-ask-questions piece.
> . . .
> Paint-a-sculpture piece was another not-to-be-quickly-forgotten breakthrough, when everyone was rushing about buying clever shades of paint, secret mixes, painting every sculpture in sight, calling sculptures magical names like 'Paripan', 'Dulux', 'Panfastic', without anyone thinking why they were painting up the tatty floor pieces and off-the-base works.

In the excitement generated by the Whitechapel exhibition of 1965 little attention was paid to the reservations expressed in the final paragraphs of Bryan Robertson's Preface to the catalogue:

> Great painting and great sculpture can only come from feeling. This alone produces a true vision. We cannot expect young artists to have had either the degree or the extent of any experience of life which can transform feeling into a mature vision. A sense of urgency, easily understandable, and a craving for immediate success, are opposed to the idea of a gradual, carefully nurtured, artistic

evolution. But it is possible to wonder whether this younger generation of painters and sculptors are trusting their reactions to life sufficiently to allow for that depth of feeling which leads to creation. . . . And the 'cool' approach, the 'anonymity' of touch, the 'non-association' of colour, the elementary formal pursuits, experiment as opposed to genuine exploration – all this may be a necessary progress towards an extension of abstract sculptural language. But it seems also to touch upon that 'distancing' ploy used by young people now when they are talking to someone else in a room. . . . And the fear of silence. A distrust of commitment, engagement, the future, or even perhaps of feeling.

It was a measure of Robertson's critical generosity, and of his extraordinary flair as an exhibitions organizer and general enabler in art, that he did not allow the misgivings he expressed so eloquently to prevent him setting up a show that was necessary for its time and that provided a brilliant platform for the young artists represented. But the note of doubt he sounded was salutary: for the exhibition was hugely successful as a spectacular demonstration, in nearly ideal circumstances of space and time, of a *school* coming into being and defining itself with great confidence. The confidence now looks misplaced: St Martin's was the very ground on which a counter-action was under way. 'Once sculpture was on the floor,' McLean remarked much later, 'it could go anywhere.'

The students of a remarkable second wave at St Martin's in the early to mid-'Sixties, who were taught by 'the new generation' sculptors there, quickly became impatient with what they perceived as the formalist dogma behind the production of a 'sculpture . . . to be seen as sculpture only, and that is its sole function – and challenge'. It was a sculpture 'that is not ornamental, which can neither sit on a desk-top nor relate to an architectural setting. . . .'; made by a 'new kind of sculptor . . . who now *conceives* sculpture as a fixed entirety . . .' (Dunlop). William Tucker was the leading theoretician and advocate of this particular brand of sculptural modernism, which placed a high-principled – some might say high-minded – emphasis on the autonomy of the art *object*, on its separation from the world, on its self-contained reality. It was properly susceptible only to formal analysis and should deny any sort of 'literary' association or sentiment; it was 'sculpture as direct physical and visual fact'. The word '*object*', he wrote in 1972, 'came to denote an ideal condition of self-contained, self-generating apartness for the work of art, with its own rules, its own order, its own materials, independent of its maker, of its audience and of the world in general'.

Before the end of the 'Sixties that 'second wave' of St Martin's-trained sculptors, breaking with the idea of the sculpture as an hermetic object, 'privileged only by its unique configuration, its lack of recognized type or function', had already made radical shifts in a number of directions. They were working in an international context of art activity that challenged this privileging of the object and looking beyond the sanctioned media, forms and practices of contemporary academic and gallery art. It was perhaps precisely *because* that particular form of reductive 'modernism' associated with Clement Greenberg, and combatively developed in relation to abstract sculpture by Michael Fried, held such powerful sway at St Martin's during the period in question that so strong and determined a reaction was set in motion there. (In 1966 John Latham, who was teaching at the School,

instituted the *Distill and Chew* event, in which Greenberg's book of essays, *Art and Culture*, was chewed to a pulp, fermented with yeast, and returned to the library in a screw-top bottle. Even St Martin's found this hard to take. Latham was sacked soon after.)

Certainly the rigour with which an entirely non-referential art was championed – Tucker's 'sculpture as thing-in-itself', whose 'visibility' is 'an active quality in the work' which 'goes out to meet, is made to attract and hold our sight' – stimulated a whole range of radically opposing definitions. What might hold our *thought* or be *imagined* as possible; what might enter the real space of house and street, or in a gallery respond to the specifics of the given room; what might exist in real time, pass away, be remembered and merely recorded: what might be heard as well as seen; what might be one thing in one place at one moment and another elsewhere, at another time – these were asserted as being among the infinite number of potentially legitimate manifestations of sculpture. Among the students on the vocational course at the School during that extraordinary period were Barry Flanagan, David Bainbridge, David Dye, John Hilliard, Jan Dibberts, Richard Long, Hamish Fulton, Gerard Hemsworth, Roelof Louw, Braco Dimitrijevic, Tim Head, and Gilbert and George. It was a brilliant generation.

Though little of what he did at St Martin's was ironic in intention McLean experimented from early on with alternatives to the tight formal syntax of Caro-influenced sculpture. Whereas that was very much about the elegant realization of *pre-existent* ideas and emphasized the witty interplay of separate parts in an articulated and integrated whole he was more interested in the possible permutations offered by free-standing elements in unfixed relation to each other. This leaning to the provisional, this preference for the improvised, has proved a compulsively habitual aspect of McLean's procedures in any medium he takes up. Whatever may be its psychological determinants it has been the impulse behind a resourceful and variously creative critique of object sculpture and the philosophy supporting it. It has been the driving force behind a practice that is essentially operational and exploratively open-ended, an art of propositions and proposals that has recognized the need to negotiate with the audience the status and meaning of any act or object that declares itself art.

In place of those imperative Duchampian acts of nomination or displacement – the art of the *ready-made* – McLean has raised questions whose answers are in no way predetermined. His work has been distinguished from the beginning by a complete lack of rhetoric, a single-hearted and incorruptible belief in the indispensability of art and a determination to avoid exclusive dogmatics about what it was and what it wasn't.

In 1965 McLean set up house in Cleveland Road, Barnes, South West London, with Rosy Ogley, whom he had met on holiday on the Isle of Arran several years previously. They were married the following year and have lived in the same house ever since. At first they had shared a small flat with Andrew Hall, and Dirk Buwalda, the photographer, lived nearby. As often happens, the day-to-day proximity of creative friends led to collaboration and the sharing of ideas. Barnes is a quiet suburban enclave, with a mixture of middle-class and working-class housing centred on a green with a village pond, bounded on one side by the River

Thames, which loops round it to form a peninsula, and on the other by a wooded common that extends to the borders of Putney. In recent years Barnes has become something of media-persons' retreat, but in the 'Sixties it was unfashionable, unsnobbish and rather staid, with a settled population and a High Street offering a good mix of ordinary local shops. There was nothing 'arty' or intellectual about the place (though Schwitters had lived there for some time during the war, in Westmoreland Road, before settling in Westmoreland proper), which was one of the reasons why it appealed to McLean. It had a couple of decent pubs, in one of which, *The Bull's Head*, well-known as a modern jazz venue, he worked on and off for several years as a barman. The village pond, the green, the local streets and Beverley Brook, which runs unobtrusively across the Common, are the sites of various works that McLean made in the next few years. For twenty-five years Barnes has been the quiet base from which he has conducted a hectic creative life.

In the autumn of 1966 McLean took up his first academic post, teaching sculpture part-time on the Foundation Course at Croydon College of Art. At this stage the teaching programme was conventional, and McLean found himself conducting the sort of academic exercises through which he and countless other artists had first encountered the basics of form. He realized immediately that teaching provided opportunities for collaboration and experiment that could be creatively productive for everyone involved. At Croydon McLean established his practice of teaching parallel to his own work as an artist, regarding it as a creative activity and a means to test ideas. He is less interested in teaching as instruction than as a process of stimulating and motivating. He believes students should learn specific technical skills alongside professional craftsmen and regards it as a form of creative collaboration: he has no time for snobbish hierarchies in the making of work. By adopting openly collaborative methods, exposing himself to risk alongside his students, asking questions – *will this work? what will happen if . . .?* and accepting that outcomes are unpredictable he has made teaching a part of his own creative project. In return his students have had the benefit of his formidable energies and undivided engagement with the work in hand, have found them-selves imaginatively liberated and made aware of unthought-of possibilities and opportunities. Many have been among his closest collaborators, continuing to work with him long beyond their student days.

The mid-'Sixties was a time of experiment and innovation in the Art Schools. The potential for experiment was greater than it had ever been, and McLean entered teaching as an arena of possible action. A situation had developed that was receptive to influences from beyond the boundaries of art as hitherto conceived. The ground was shifting as cross-currents of aesthetic, political and moral energy changed the contours of the landscape of art itself. In different places – Italy, Germany, the USA, as well as in England, and in many different manifestations (*Fluxus*, Land Art, Minimal Art, Conceptual Art, *Arte Povera*, were some of its designations) – common assumptions were being questioned and given defini-tions and categories of art were in contention. Accepted ideas about the traditional media and materials of painting and sculpture, about art as the production of commodity, about the necessary visibility of art and of its permanence were all being challenged. At a time of social and political idealism, however unfocussed

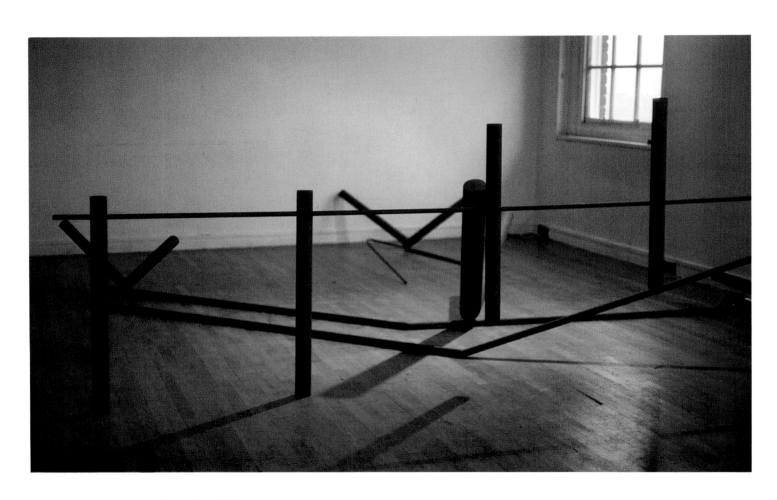

19. *Fence Sculpture for Interior Space.* 1967. PVA and steel,
144″ × 180″ × 48″ high (366 × 457 × 122 cm). Destroyed

and ill-defined, *what is art? who is it for?* were questions that had a special pertinence in the Schools where art was taught.

At Croydon, in 1968, under the direction of Richard Sladden, who had first invited McLean to teach there, a completely new sort of course was set up as part of the Diploma programme. *Environmental Studies* was an imaginatively ambitious cross-disciplinary venture in art education involving collaboration between artists and teachers from quite other fields of investigation. Among those who taught on the course were Gavin Bryars, the composer (who worked many years later on performances with McLean and David Ward at Albert Dock, Liverpool, in 1987 and 1988), Stephen Black, whose field was ergonomics (the relation between people and the furniture of their environment has been an abiding interest of McLean's), Edward Taney, a behavioural psychologist, Marcello Salvatore, architect and kinetic artist, and Duncan Smith, an artist with academic interests in botany and ecology. The underlying premise of the exercise was that art is one activity among many by which human beings relate to the world in which they live, a dynamic interaction with the world and a means to knowledge and pleasure. It connects in ways that are complex, various, and essentially unpredictable the natural and the social aspects of human existence. Its special and indispensible function lies in its harnessing of the faculty of the imagination, its exploitation of the resources of human creativity.

For McLean thinking through and teaching on this course was formative. 'It was a shift, after St Martin's, from one dynamic situation to another'. Here again he was in constant touch with people whose interests, pursued at a high level academically, touched closely upon his own preoccupations as an artist, and whose openness towards art as explorative activity, *a means to research what it is to be alive in the world at large*, confirmed his own developing philosophy. The experience helped him to clarify his conception of art as a form of creative behaviour that takes its place alongside other forms of behaviour equally definitive of humanness and whose lines of contact with other modes of experience can be maintained in an infinite variety of ways. The story of McLean's life in art from then on can be properly understood only in terms of that realization.

Open space and undeveloped sites around the School's studios in Albert Road encouraged a lot of working outside using found materials, rubble, junk. Sculptures were made that existed only on site, that had no permanence as objects. Others used only light and shadow, or changed with the wind, or were washed away by the rain. The implications of permanence and impermanence, of tangibility and objectivity were considered; the consequences of interventions in the natural world, of the displacement of natural objects by made things, were examined; there was a continuous effort to define the meanings of scale and of placement, big or small, indoors or outdoors, prepared site or found site. Such issues, and many others of a like kind, were discussed, in the broadest critical context, in relation to the problems of how art was to be defined. Above all what was questioned was the conception of the artist as a uniquely gifted individual, alone in the studio, engaged upon the crafting of privileged objects whose significance was inscribed within a narrowly special, even sacral, field of meanings.

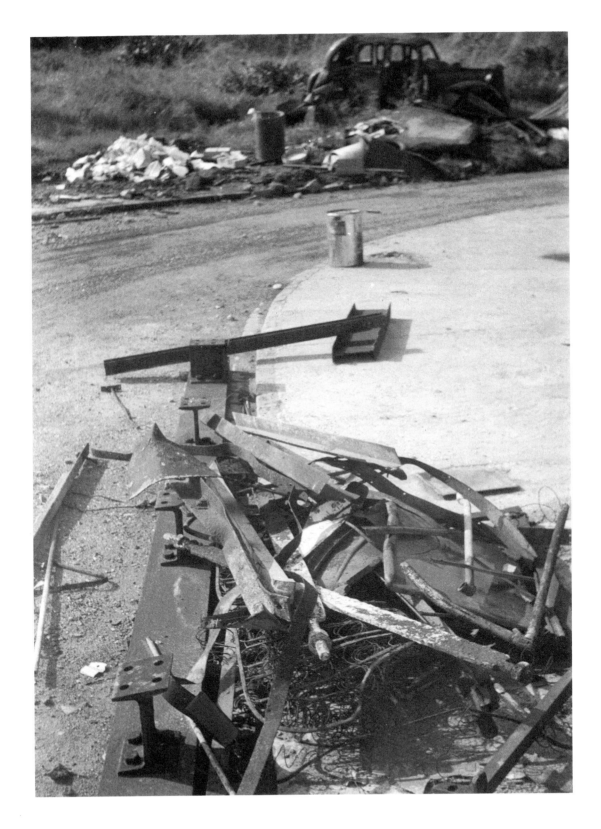

20. *Found Steel Girder and Scrap Sculpture.*
on curved pavement and gutter site.
Croydon. 1968. Steel scrap

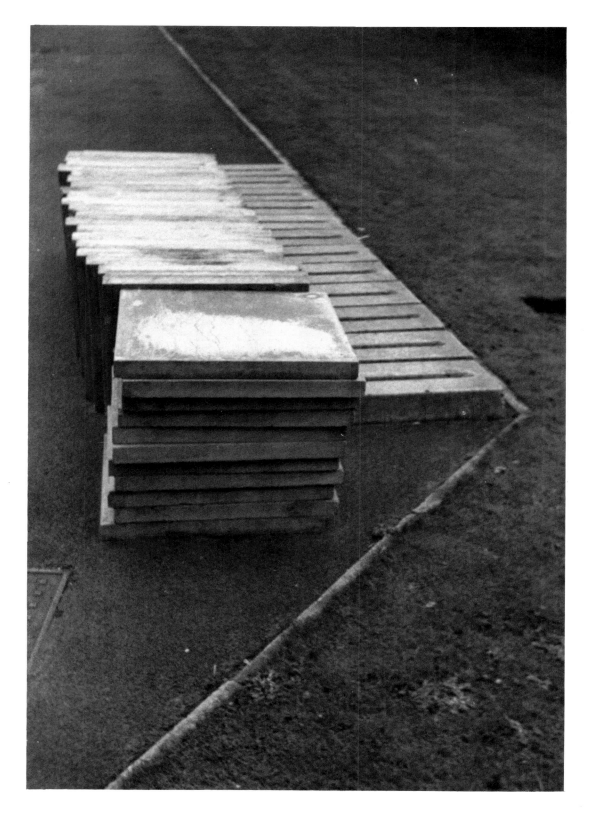

21. *Found Concrete Slab Sculpture, Barnes.* 1968

McLean's own work during this period ran alongside this pedagogic activity, both drawing on it and feeding it, and was very concerned with those processes of definition and problems of category that were its principal themes. In retrospect his activities through the middle and late 'Sixties can be seen as a remarkably coherent and sustained project to determine for himself – not in discursive terms but through inventions, interventions and discoveries in the real environment – what might be defined as art and what might be its uses. Much of this investigation was conducted in association with close collaborators like Rosy McLean and Dirk Buwalda and without regard to possibilities of public showing. Indeed its point in some cases was to test how far a work might be private and still be art, its only audience the artist himself or his family and those who encountered the work casually, in the street, on the common, by the brook, without expectations or prior assumptions. Most of the work was in any case impermanent, sometimes even momentary; in many cases it was to all intents and purposes, except when photographed, invisible.

During the first months in Barnes McLean continued to make sculptures involving the free interplay of independent formal elements such as flat sheets and rectangular blocks. Unable to photograph them adequately inside the house he rearranged them in the street. At this moment he realized that in certain crucial aspects he was still working within the limitations of a sculpture that, whatever its forms, was conceived for the rarified white-walled empty space of the art gallery or collector's room. It had no place in any specific site or unprotected environment; it was not designed for the places where people live. He saw at once that he could work in the open and make works that existed in real time, for actual places, with real floors and walls, for ordinary rooms and ordinary streets. For McLean it was a moment of decisive insight, far more important and far-reaching for his practice than the notion that sculpture didn't need a plinth. *Sculpture for Wall* and *Floor Sculpture* (both 1967) were among his first exercises in the new direction, works that challenged the presumptions of the currently fashionable gallery sculpture to permanence and mocked its implicit pretensions to protected status, to a right to be seen only in conditions the artist determines or considers appropriate. These pieces, whose disparate elements were precariously leant against each other or a supporting wall, or were of a material, like linoleum, that will not maintain a given shape, were at once casual and deliberate in composition and were made in immediate response to the given, unique situation. Their allusive irony was an aspect of their significance (all art is in dialogue of some kind with the art that precedes it), an aspect moreover that is given greater point and poignancy in the manner of their record (we have only photographs to prove they existed). But they were not brought into existence merely as ploys in a campaign of critical reflection. They enjoyed a substantive life as sculptures, *works that themselves invited a critical response within the discourse of art, its meanings and its history.*

Making these works outside prompted McLean to reconsider what sorts of sculpture might be made specifically for indoors. His first essay in this direction was to devise a number of works for domestic interiors. Instead of the self-contained sculpture conceived to be seen in a clean white space, the implied destination of the 'modernist' work of his teachers, he imagined works that might

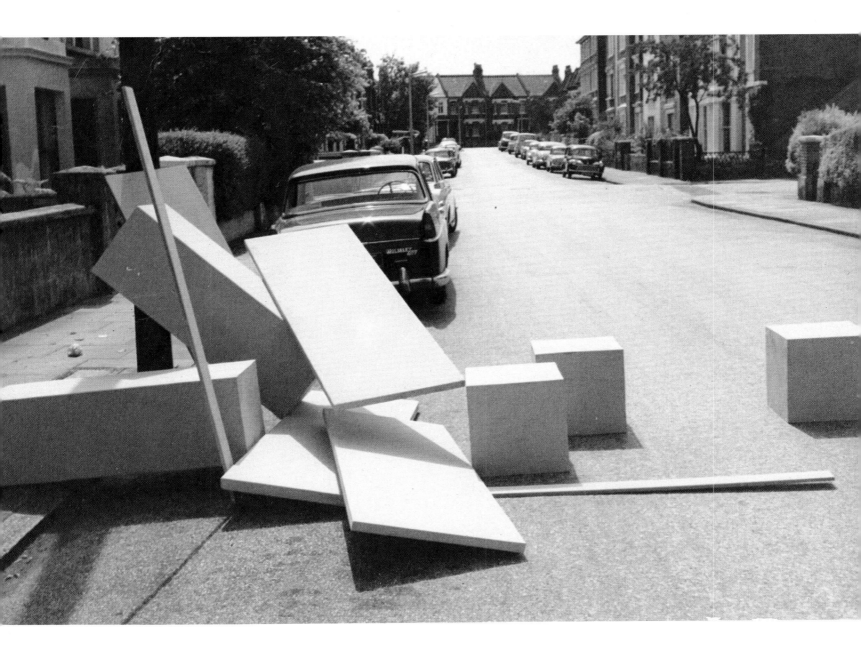

22. *Sculpture for Interior Space.* 1967.
Painted wood and hardboard
(photographed by the artist in Cleveland Road, Barnes)

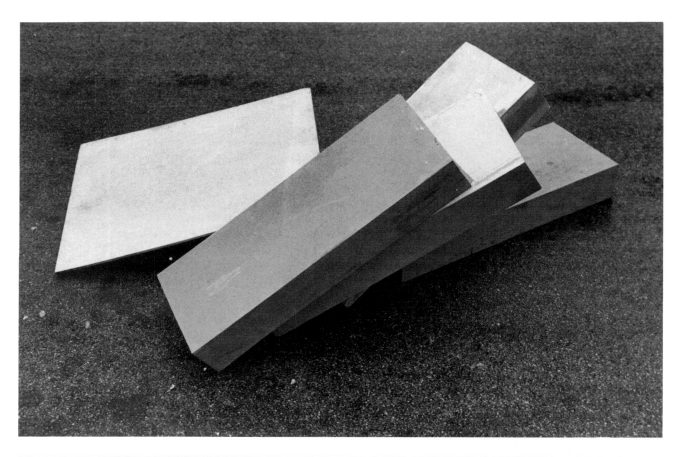

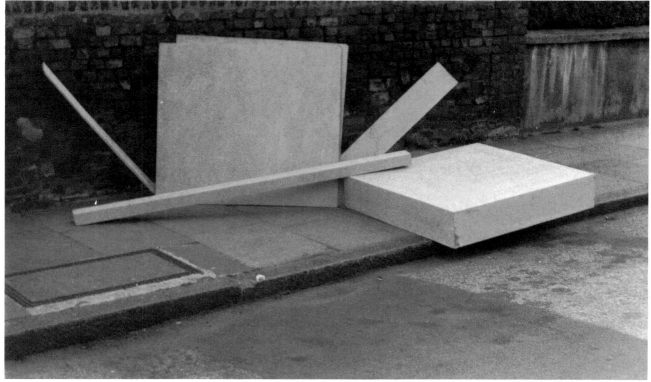

23. *Pushed-over Sculpture.* 1967.
Polyester resin-coated wood and chipboard, 96″ × 72″ × 36″
(244 × 183 × 91·5 cm). Destroyed.

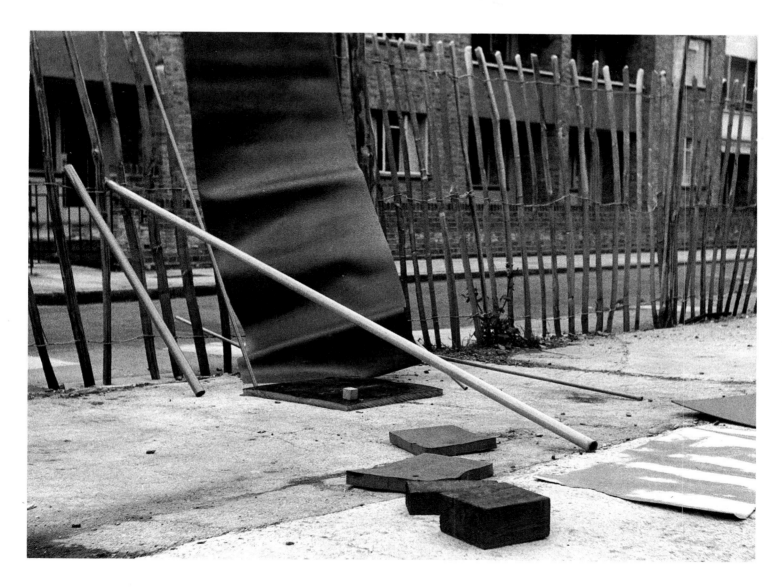

25. *Sculpture for Vacant Lot, Fence and Street,*
Stanton Road, Barnes. 1967.
Lino, steel tube, foam rubber and wood

24. *Sculpture for Wall and Pavement,*
Cleveland Road, Barnes. 1967
Polyester resin-coated wood and chipboard

unobtrusively, even secretly, take their place in an ordinary room. These took their forms and titles in ironic reference to the idea of the multi-part monumental outdoor sculpture that Moore was making with great public success in the late 'Fifties and 'Sixties: *Two Part Sculpture for Sofa, plus One Part for Coffee Table, and One Part for Easy Chair* (1966–7); *Five Part Piece for Three Windows, One Curtain and a Rug* (1966–7). McLean had never seen anything incongruous in using humour as part of a creative and critical strategy. Other works made for interiors at this time experimented with the typical formal components of post-Caro sculpture but subverted the principle that its *gestalt* was established by the fixed interrelation of its constituent parts, that it should be read as a whole, each element part of a completed sentence. By contrast, McLean's sculptures were composed provisionally, the parts kept separate, re-arranged at will and assembled with no intention of permanence. In some cases the works were made to relate to the whole space of a room as temporary installations whose principle purpose was to be photographed.

In Stanton Road, Barnes, near his house, a large rectangular slab of concrete, the floor of a demolished lockup garage, provided McLean with a found plinth – or an arena, to be more exact – for sculptural play. It was a situation offering numerous sculptural possibilities, ironic and otherwise. Above all it was an unregarded site, a real place that provided a formal setting with defined boundaries but whose purpose was in every sense undetermined and undesignated. Within this framed field he placed objects, some of which were found and some, like the small wooden blocks in *Installation for Concrete Slab*, were made by him specifically for the site. The sculpture made here, like all traditional sculpture, was composed of three-dimensional physical elements organized into formal relations. But it could be changed at will and it existed only so long as nobody but the artist altered it. His own rearrangement of its components constituted a sculptural act, a creative intervention. A work having been made, or re-made, McLean left it to its fate. A sculpture might be destroyed by the gratuitous kick of a passing schoolboy, blind to the existence of the art work. Other pieces, like *Installation for Street and Fence* (1967), defined themselves in opposition to the formal boundaries of the site in a process (with ironic undertones) analogous to the act of taking a painting out of the frame or a sculpture off its plinth.

The Stanton Road works were among the most severely minimal sculptures ever made. Their formal elements were utterly simple and often entirely random, though their components may have had definite formal *properties*, being brick-like or tubular for instance, and their disposition casually intuitive. In this they differed radically, of course, from Carl Andre's more famous *Equivalent VIII* (1966) – the bricks that caused such a fuss when they were bought by the Tate in 1972 – whose conceptual armature employs mathematical constants and is anything but random.

It was to be expected that the oppositional procedures already characterizing McLean's approach should lead to work in reaction to the structured compositions, however transient and precarious, just described. Of course the definition of those works as *art* was radically problematic, deliberately calling into question received notions about permanence, about siting and framing and, crucially,

26. OPPOSITE: *Three-part sculpture for window, floor and skirting board.* 1966–7. Painted steel. Destroyed

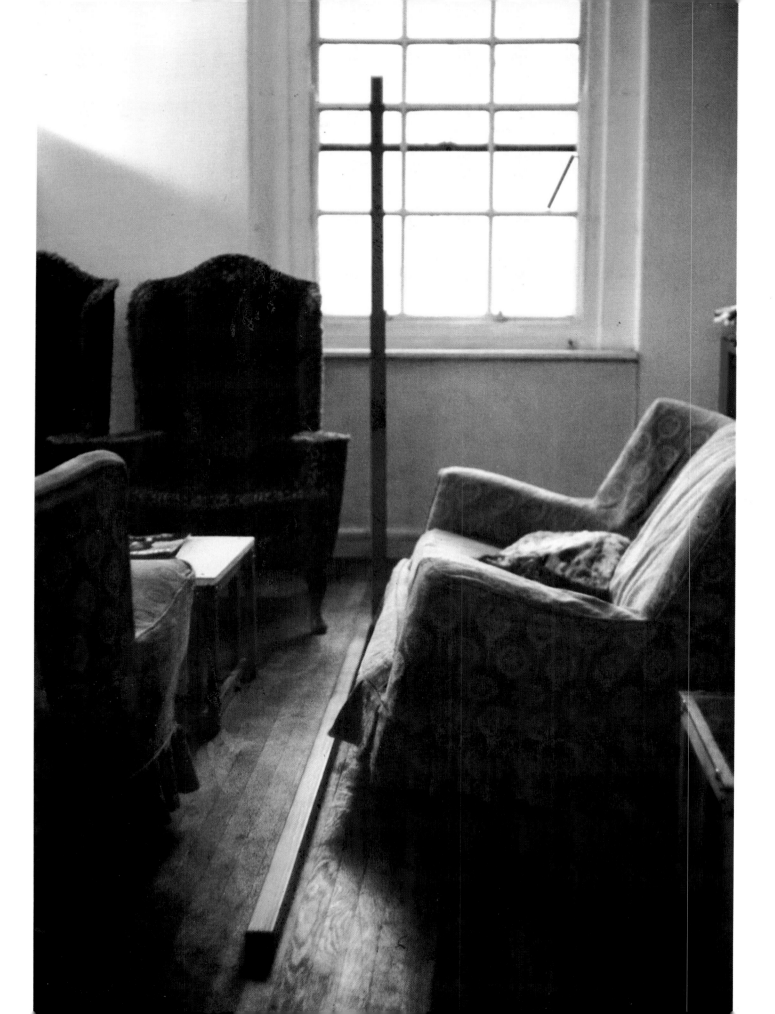

about the audience. They were entirely provisional and temporary, brief manifestations in places that had no status as settings for the experience of art; they were seen, *as works of art*, by nobody but the artist himself, his wife Rosy, and a few friends. But in making them McLean was working with prefabricated materials and objects, devising constructions whose formal identity was determined by the artist as an act of creative will. In both these aspects the work was entirely within the traditional conventions of artistic production, and it was these conventions that McLean was also determined to challenge.

27. *Two-part installation for concrete slab,*
Stanton Road, Barnes. 1967.
Wood block on concrete.

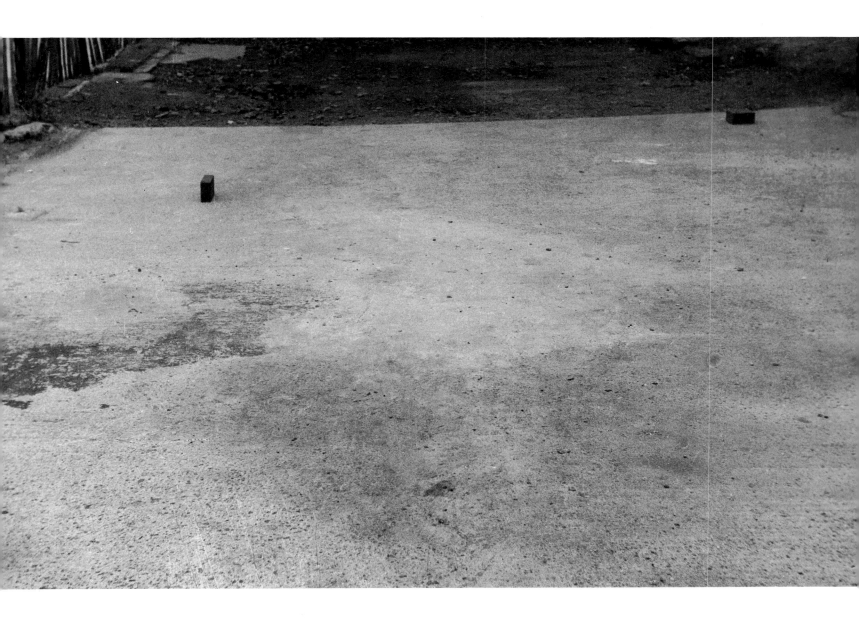

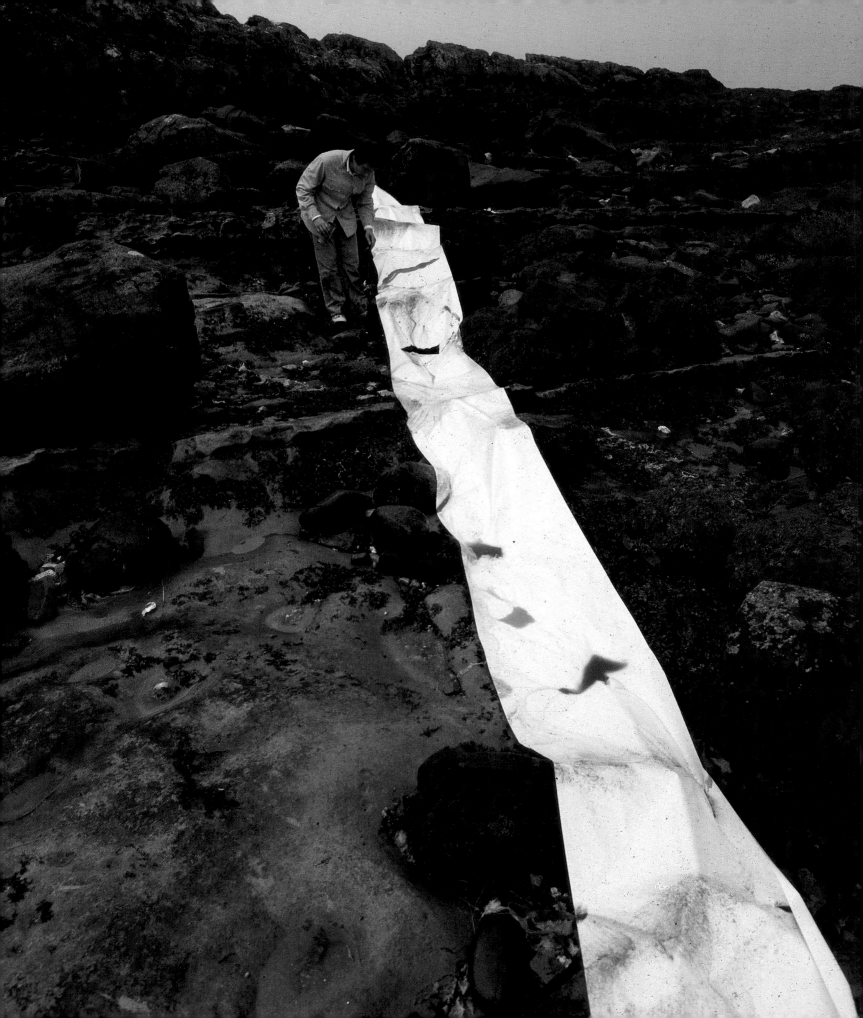

King for a Day:
Taking a Line

I N 1967 McLean made a series of works that took him beyond any prior sculptural convention: their components were found in nature as tangible materials and intangible dynamics; their forms were unpredictable and given, and, as matters of natural fact, unstable and mutable. Many modern artists have used chance and accident as means to revelation, most notable among them being Hans Arp and Sophie Taeuber, Duchamp and the Surrealists, especially Masson and Miró. These have all at times deliberately relinquished formal control, allowed a work to take the unpredictable forms that natural forces, including the unconscious, might determine and brought into play previously untapped energies as resources for art. Unlike those earlier artists McLean was not concerned with using chance and contingency to make works that would be accepted and inscribed within the recognized categories of art and shown in its conventional settings. The works he made at this time were extremely shortlived and appeared in places far from the specialized spaces sanctioned for exhibiting art.

The conceptual space for these pieces was cleared in the making of the *Floataway Sculptures*, which immediately preceded them and which utilized some of the materials of the loosely structured sculptures for the street described in the previous chapter. By reassembling those components into consciously sculptural arrangements – the artist's final act being to launch them to their fate, knowing that the vagaries of wind and water will deconstruct and scatter them forever – McLean made a definitive gesture rejecting *gestalt* sculpture, the art of the static, elegantly indivisible object. Other 'floataway' works at this time were freer in conception and lacked even the most elementary formal organizations, consisting of sawdust and wood shavings scattered randomly on the surface of Beverley Brook. In another work pieces of hardboard and blocks of wood were thrown into the Thames from Barnes Bridge, a creative act that drew the attention of the local river police, who were at first understandably sceptical of the artist's explanation. Each of these sculptures was conceived as consisting of the arrangement or scattering of the materials and the process of their dispersal; in combining action, materials and time they incorporated into the work itself the actualities of change and transience.

McLean's next works, in early 1967, carried this concept of sculpture to its logical conclusion. In these he used natural materials he found to hand on the common, at the brook and the pond, in Barnes. Working now in the open, in settings that were given and in no way designated as sites for art, he determined that a puddle might be regarded as sculpture, that a pile of mud shaped by the

28. OPPOSITE: *Shoreskape*, Largiebeg, Isle of Arran, 1969. Water-based paint on paper. Photographer: Dirk Buwalda

30. *Ice on Ice Piece*, Barnes Pond. 1968.
Photographer: the artist

29. *Ice on Grass Sculpture*, Barnes Green. 1967.
Photographer: the artist

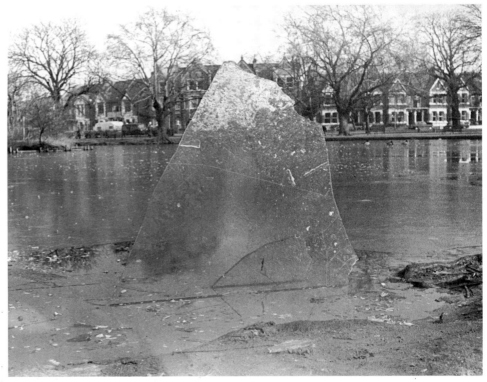

31. *Vertical Ice Piece*, Barnes Pond. 1968.
Photographer: the artist

32. *Floataway Sculpture*, Beverley Brook. 1967.
Hardboard, lino, woodblock.
Photographer: Dirk Buwalda

34. *Mud Sculpture*, Beverley Brook. 1967.
Photographer: the artist

33. *Splash Sculpture*, Beverley Brook. 1967.
Photographer: Dirk Buwalda

action of the brook had a sculpture's defining properties, that a splash created by a thrown stone had formal sculptural qualities and potentialities of meaning. On a winter's day he made a glittering sculpture by scattering ice fragments across the frozen surface of Barnes pond, placed sheets of broken ice on the bank to make the *Ice on Grass* sculpture, and propped a dramatically shaped broken sheet upright to create the *Vertical Ice Piece*, a structure of immediate and obvious sculptural presence.

Intrinsic to each of these works' meaning was its actual evanescence: it signified what it enacted, its own dissolution. By allowing a sculpture visibly to demonstrate its entropic destiny, by making works not through the exercise of skill – though craft of the other kind is certainly in evidence – but with the most minimal of interventions into the natural situation, McLean was commenting ironically and with a degree of humour upon the fate of all art and by extension upon the fate of those who make it, by whatever exercise of technical virtuosity. For these works went beyond critical reflection; they were more than an ironic commentary upon object sculpture: they were *poetic* images of natural and therefore human mutability, metaphors for transience. Their claim to the status of sculpture increased the resonance of their irony, for sculpture is, of all the arts, that most associated with monumental permanence: 'I like the idea of a puddle as a sculpture, because it is not eternal, it only exists when it rains. The sun takes away the sculpture because it makes another situation.'

McLean photographed some of these works as a reminder of their brief existence and a number of others were photographed by Dirk Buwalda, who collaborated with McLean on the common and by the brook, seeking out creative possibilities, chances for works to be made. The photographs were not themselves to be regarded as art works but as *documentation*, as a record of the sculptures, whose physical actuality was specific to their site, to the moments of their realization and their visibility to those who perceived them as art. (Many of these works were never recorded in any form, and exist only as memories in the minds of those who saw them.) Some photographs had captions typed directly on to them in a manner clearly indicating their documentary status. In this McLean was anxious to avoid the quickly established conceptualist convention of document-as-artwork by which the record of a work, or the instructions for it, were registered as the work itself, and as objects, in thin black frames, adorned the walls of the art galleries from which the 'the new art' had supposedly made its escape.

These documents were not inscribed or signed in such a way as to suggest that they were original art works, and the captions were precise and deadpan, as in the Tate's *Six Sculptures 1967–8*:

> *Floataway sculpture sawdust and wood shavings 1967*
> *Mud sculpture 1967 Beverley Brook Tidal bruce mclean*
> *Vertical ice piece Barnes Pond 1968*
> *Mud sculpture using board and tidal stream 1967 bruce Mclean*
> *Ice on grass 1968 sunny day. bruce McLean*
> *3 wooden blocks on concrete plinth 1968*

The Tate catalogue note scrupulously observes: 'All the sculptures recorded in

these photographs were made near McLean's home in Barnes, south-west London. All were transitory in physical form'. Undeniably time has inscribed these documents with a poignancy that was never intended, the more so in that the photograph is itself a trace of the event it records, touched by it. In the words of Roland Barthes: 'What the Photograph reproduces to infinity has occurred only once: the Photograph mechanically repeats what could never be repeated existentially. In the Photograph, the event is never transcended for the sake of something else . . . a photograph cannot be transformed (spoken) philosophically, it is wholly ballasted by the contingency of which it is the weightless, transparent envelope'. Thus the photographs of these sculptures act as *reminders* of their meaning. As Susan Sontag remarks, 'All photographs are *memento mori*'.

Given the nature and location of McLean's work during this period it was to be expected that photographic documentation would necessarily be one of the possible ways in which its brief existence might be registered and its meanings entered into the wider discourse of art. Teaching, of course, was another, as was conversation. Many of the key figures in conceptual art over the years of the late 'Sixties and early 'Seventies (including Seth Siegelaub, Willoughby Sharpe, Lucy Lippard, and Dick Bellamy among others) visited McLean in Barnes during that period. Other events around this time contributed to the process, notably Barry Flanagan's gathering of materials and documentation in 1968 in response to Walter De Maria's 'Earthroom' article in *Time* magazine, which had celebrated the arrival of a new conceptual movement in the States. Flanagan took this material, including photo-documentation of some McLean works, to New York to demonstrate that work as original and vital as that of Morris, Smithson and De Maria was being made in Britain. The American obsession with scale, a feature of American 'land art' in the late 'Sixties that was satirized by McLean in his film *A Million Smiles for One of Your Miles, Walter* (1971), and the photographic works that accompanied it, were among the reasons for the disproportionate publicity that the work attracted.

In October 1968 McLean delivered a lecture at St Martin's. He prepared for it by shooting several rolls of slides of such simple and mundane things as garden edges, hedges, brick walls, flower beds, park benches and kerbstones. His new work, he declared to a partly sceptical audience, consisted in observing these things and recognizing their existence as sculptures, or as the sites for sculpture. Sculpture was to be rethought in relation to real environments, actual places. The examples had much in common with works by Dan Graham, photographs of so-called 'minimal forms' found in the 'nature' of suburban landscapes, and with photographs, 'taken under the instructions' of Carl Andre, of materials, wood blocks, steel plates, bricks and so on abandoned in the streets of New York (pieces made sometime later than McLean's). The emphasis upon real contexts for sculptural intervention or discovery was entirely at odds with the concept of sculpture taught at St Martin's and the implicit critique was very much part of McLean's intention. But there was an element of deliberate pretence in the exercise, and it is tempting to see the St Martin's lecture, which McLean remembers as an opportunity to sort out ideas, as a proto-performance, an exercise in pose, a lecture-sculpture precisely devised for its context. It was an early

35. *Reclining Figure (Fully Draped).* 1969.
Photographer: the artist

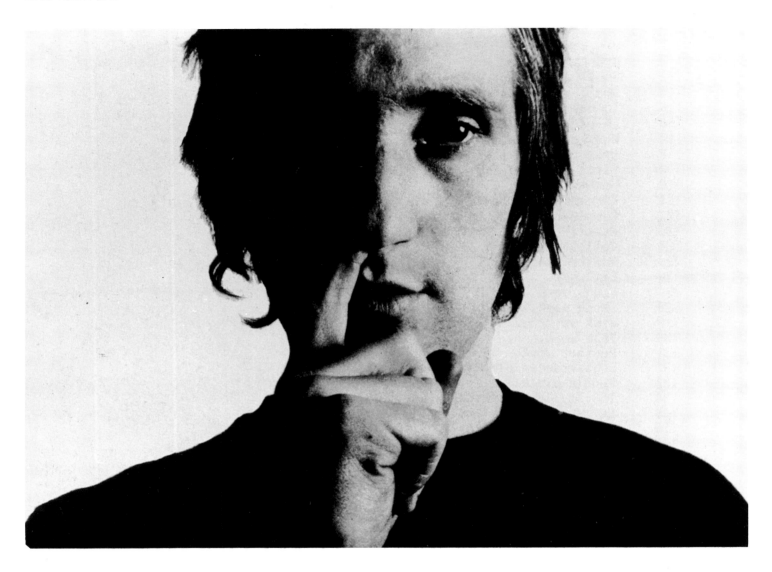

36. *Installation for Various Parts of the Body (The Nose).* 1969. Photographer: Dirk Buwalda

37. OPPOSITE: *Taking a Line for a Walk.* Cleveland Road, Barnes. 1969. Photographer: Dirk Buwalda

demonstration of McLean's disconcerting tendency to ambiguity in his work, of his habit of blurring distinctions between actions in one category and another, thereby challenging the basis of the distinctions themselves.

It was a tendency exemplified in a number of works made in 1969, again in collaboration with Dirk Buwalda. In certain of these, notably *Stand*, *Walk*, *Run*, *Installations for Various Parts of the Body (Nose)*, *Installations for Various Parts of the Body and Pieces of Clothing (Jumper)*, McLean mocked the absurdities of so-called 'Body Art' in which the artist's body is solemnly regarded as the medium for plastic expression in art actions separable from dance and performance. Intentionally comic as these works are they have an underlying seriousness as a continuation of the programme by which McLean was attempting a radical redefinition of sculpture. Other works at this time adopted imitative and literalist parody as tactics to undermine categorical certainties and the mystique of the great artist: *Fallen Warrior*, photographed by Buwalda by the Thames at Barnes, was not the first nor by any means the last of McLean's commentaries on the critical veneration of Henry

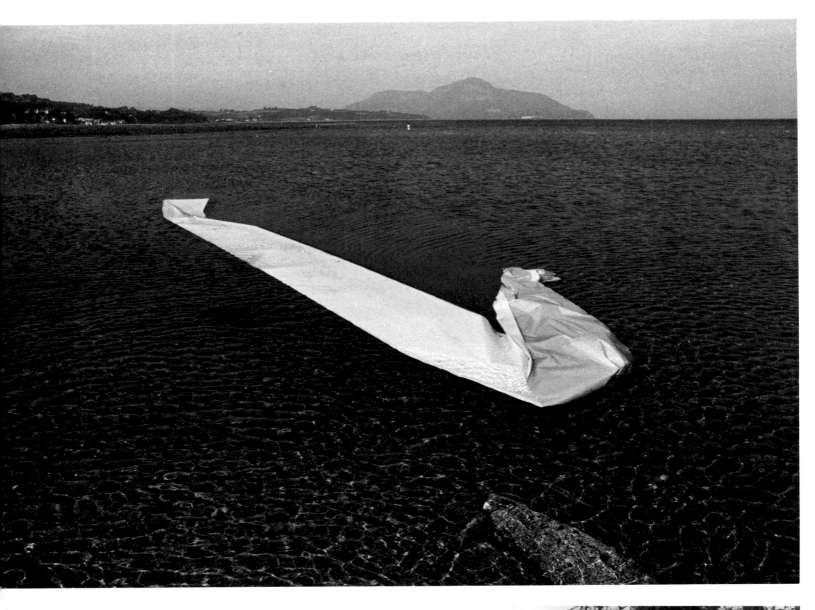

38. *Seascape*, Largiebeg, Isle of Arran. 1969.
Photosensitive paper on water.
Photographer: Dirk Buwalda

39. *Treescape*, Barnes Common. 1969.
Water-based paint on paper.
Photographer: Dirk Buwalda

40. OPPOSITE: *Rockskape*, Largiebeg, Isle of Arran.
1969.
Paper and water-based paint on paper.
Photographer: Dirk Buwalda

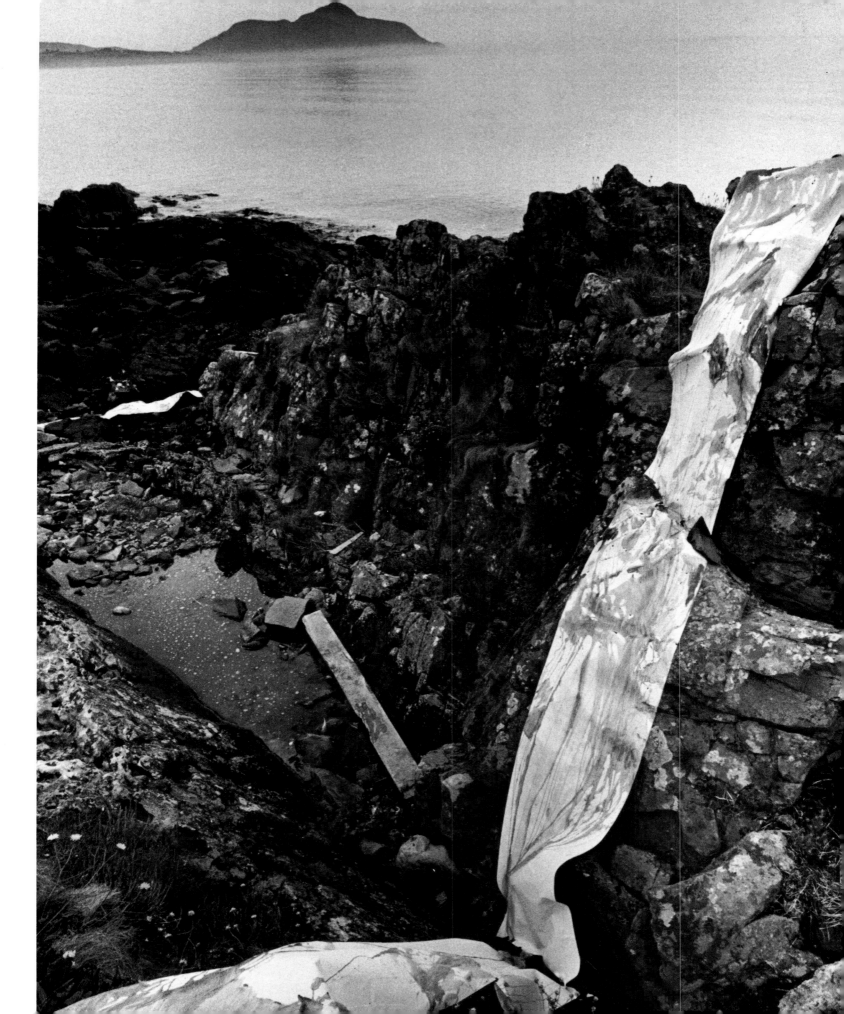

Moore (that, rather than Moore's work itself, is of course the satiric target of the piece); *Taking a Line for a Walk* shares a joke with Klee at the expense of those who solemnize his pedagogics.

McLean's ironic awareness of the speedy assimilation of various forms of the 'new art' into the conventional commercial structures of dealer and gallery – documentation acquiring commodity status and a validating critical industry keeping pace – and his sense that some of the new 'land art' was as essentially sentimental in impulse as old 'landscape art' led to several works on these combined themes. On the shoreline and rocky coast of Largiebeg, on the Isle of Arran and in and around Beverley Brook he made the *Seaskapes*, *Shoreskapes*, *Rockskapes*, *Treescapes* and *Watercolour Under Water*, 'painting' made at just the moment when painting might seem to be finally eclipsed and in ill-repute. These were executed on long strips of sensitized photographic paper in colours that were *faux naif* attempts at the naturalistically particular but doomed by the manner of the working to run, fade and neutralize. Their forms were similarly unstable and bound to dissolve. They were, of course, uncollectable and unsaleable. In some cases they were disposed of immediately in nearby litter bins; and in the case of the painting recorded in the Tate's double photograph 2 *Rock and Shoreskapes, Largiebeg* 1969, it was shown laid on the floor at the 1969 I C A exhibition *When Attitudes Become Form*, and then was destroyed.

How photography itself might be used as a sculptural medium, rather than as a means merely to record and document ephemeral works, was bound to interest McLean at some point. (His cross-category shifts have been problematic for others, but McLean himself has a sharp sense of true and logically necessary distinctions.) The *Mirror Works* and the versions of *People Who Make Art in Glass Houses* and *Walking Man* pieces are examples of original works which exist in photographic form. The point of their making, the arrangement of the objects and of the poses, was that they were to be photographed, and they had no existence independent of that fact.

In *Mirror Work* the 'artist' holds a 'landscape' of Barnes Common under his arm, as if his work (in both senses) is complete; of course the integrity of his rendering of the *motif* depends entirely upon its inscription within the still life, the moment of the photograph. Outside this fiction the slightest move would result in the infinite number of alterations in its composition that so agonized Cézanne: 'A minute in the world's life passes! To paint it in its reality! . . . To become that minute, be the sensitive plate. . . .' In *People Who Make Art* the 'artist', pictured *unmaking* one of his own epigonal 'new generation' sculptures (with all the implications of that act in the light of Tuckerian aesthetics and art-world economics and politics), an ironic inversion of the allegorical *artist in his studio* theme, symbolically frees himself to throw the well-aimed stones of *Not even crimble crumble*. The 'Walking Man' pieces, which could exist only as treated photographs, begin as references to Rodin's great sculpture (itself famously headless and armless) and to the highly influential idea of truncation and fragmentation in twentieth century figurative sculpture, and pick up sideways on the serialism that had become a cliché of late-Modernism.

Pose Work for Plinths of 1972, perhaps his most famous photowork, was made as a 'version' of the performance of that name McLean made at Situation in 1971. The

poses were repeated specifically to be photographed, and the prints were then arranged and multiple-mounted as a free-standing work. These pieces were satirically directed partly at Henry Moore's obsessively repeated reclining figures, parodying the endless morphological repertoire of those monumentally dignified maternal forms with images of a young male figure with difficulty holding a variety of ridiculous poses. The necessity of the plinth in this absurd procedure was a laconic acknowledgement of its persistence as a device in mainstream sculpture (its presence as a base for Moore's *Fallen Warrior* had always seemed especially incongruous to McLean). *Pose Work for Plinths*, though made later than those works of 1969, was in fact anticipated in the extensive list of projected works that constituted the 'proposal work' *King for a Day Piece*, the 'Retrospective' that McLean conceived and created in 1969 and which was 'realized' first at the Nova Scotia College of Art in 1970 as a wall piece and at the Tate Gallery as a sculpture-performance on March 11 1972.

McLean's multifarious sculptural work of the late 'Sixties adds up to a formidably searching critique of the condition of modern sculpture at that time and to a brilliantly original set of creative moves across, between, and beyond the given categories and terms of modernist practice. The invitation from *Studio International* in late 1970 to review the ICA show organized by Gene Baro gave him the opportunity to expand discursively on his disaffection not only with 'new generation' sculpture but with British sculpture in general. Had the show been international in scope it is likely that he would have widened his fire to take in much else of what was happening, especially in the USA. During this time McLean was working on the films *In the Shadow of Your Smile, Bob* and *A Million Smiles for One of Your Miles, Walter*. These addressed themselves satirically to the heavy photographic posing of Robert Morris (no smiles, heavy girderwork in background) and Walter De Maria (intense look, hand raised in alignment with mile-long line-in-desert work) as found in the catalogue of *When Attitudes Become Form*, the major international conceptual exhibition organized by Harald Szeemann at the Kunsthalle, Bern. His own page in the catalogue featured a youthful, strictly no-pose photograph, and responded to the obsession with scale that had become a feature of American sculpture and 'land art', with the droll understatement of four banal postcards of Barnes bought in a local shop. To the London showing of the exhibition, in September–October 1969, McLean contributed documentary photographs of the Largiebeg *Seaskapes* and *Shoreskapes*, with one of the disposable paintings laid on the floor.

Invited by Konrad Fischer to make a show in Dusseldorf in the August of that year, McLean travelled there with Richard Sladden, and for his part made a *Rubbish Reallocation Piece*. This consisted of 100 white carrier bags filled with rubbish from the streets of Dusseldorf and placed on the gallery floor. This manifestation was supported by drawings executed on the graph paper that had become *de rigeur* for the projection and documentation of conceptual and land art pieces by American artists. Fischer was himself an artist, and as a gallerist he had a keen sense of what was happening at the outer edges of art in Europe and America. His gallery in Dusseldorf, though small, was known at this time as a centre of energy, a key site for the presentation of *avant-garde* work by internationally recognized artists.

41. *Three-part Installation for Body*, Bulls Head, Barnes. 1969. Photographer: Dirk Buwalda

42. *Mirror Work*, Barnes Common. 1969.
Photographer: Dirk Buwalda

43. *Mirror Work*, Barnes Common. 1969.
Photographer: Dirk Buwalda

44. *Fallen Warrior*, Barnes riverside. 1969.
Photographer: Dirk Buwalda

45. OPPOSITE: *Pose Work for Plinths*.
Documentation of performance at *Situation*, 1971.

Fischer was co-organizer also of the *Konzeption-Conception* show at the Städtisches Museum, Leverkussen, which featured Keith Arnatt, Victor Burgin, Hamish Fulton, and Gilbert and George as well as McLean, who on this occasion showed a drawing and a photograph which together proposed a *Rubbish back to Rubbish Pile Project*. By this time McLean was deeply sceptical of much of the activity going on around him in the national and international art arenas. Pretensions of scale, absurdities of documentation, the persisting commercial gallery, art market, art-critical and publicity mechanisms that maintained an insular and self-contained 'art world' with its own circularities of philosophical and political reference, all these were targets of the various interventions McLean was making in a mood becoming persistently satirical.

In fact McLean was already in 1969 at work on *King for A Day*. This was a comprehensive compendium of proposals for sculpture, an imaginary retrospective catalogue containing no fewer than a thousand projected works whose titles, subjects and classifying modes – installation pieces, homage works, serial works, 'studies', etc. – parody the nomenclature and categorizations of contemporary art-world practice in a virtuosically sustained comic inventory of its obsessions,

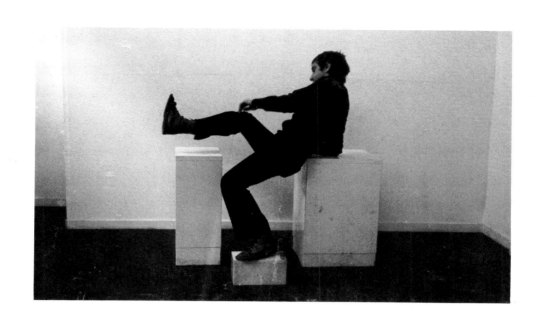

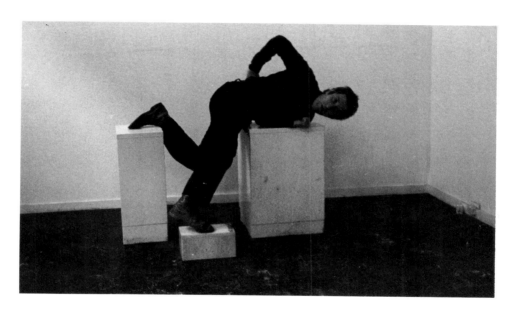

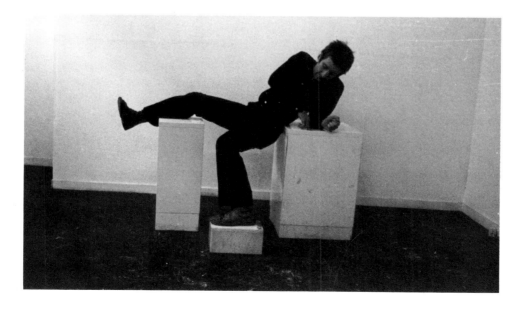

pretensions, vanities, fantasies, cynicisms, plagiarisms, appropriations, inveiglings, ingratiations, vogues, insincerities, follies and fashions. The work, though it contains a prospective *oeuvre*, was in fact valedictory. As the title suggests, it celebrates a Warholian moment of unaccustomed acclaim and indeed builds up to a triumphant penultimate *999 Bruce McLean 'Superstar' piece 999 1st version* before making its farewell:

> 1000 *Goodbye sculpture, art pieces – things/works/stuff/everything, piece (incorporating the Fastest 1,000 pieces work in the World, Show, 'Song and dance art'. Love pieces, etc. etc. etc. piece/work/thing/stuff.*

After its showing at Nova Scotia in October 1970 *King for a Day* was not seen again until Michael Compton invited McLean and a number of other artists to present work as part of *Seven Exhibitions*, a showcase of conceptual art at the Tate Gallery in February and March 1972. For this he prepared the work as a catalogue, bound in black card, sealed with a white label on which was roughly stamped *Another Major Breakthrough Piece Note Casual Tat*, and with a green luggage label attached by string. This gave the title and date of the performance/manifestation and added *Another Minor Pre-Dated Piece*. On the title page the date for the work was given as 1969. One thousand of these were arranged in systematic late-modernist grid formation on the floor (thereby parodying, among much else, the ordered configurations of Carl Andre's *Untitled* 1966 and *144 Magnesium Plates, Spring* 1969, to be acquired amid great controversy later that year by the Tate). Copies were sold throughout the day, indicating with perfect ironic economy that conceptual art-as-documentation was a saleable commodity; as a further 'conceptual' ploy, the 'sculpture' was thereby diminished and deconstructed by its audience.

King for a Day was a brilliant gesture of renunciation, a spectacular leave-taking. As we have seen, it had been in preparation for two years, the very period of McLean's first successes on the international scene, and the Tate Gallery had with wonderful appropriateness given him the perfect stage for his act. Those who bought the 'catalogue' would have found inside, on squared paper of course, a scruffy diagrammatic drawing projecting a work of some kind in preparation, entitled *ironed drawing piece*. This may have been one of numerous works executed by McLean at his first London one-man show, *Objects no Concepts*, at Situation in 1971. (Situation, which did not designate itself as a 'gallery', was a small outfit with rooms in Horse Shoe Yard, Brook Street, W1, devoted to the promotion of 'difficult' and unconventional work, and was London's principal venue for home-grown conceptual art.) The exhibition, whose title reversed that of a conceptual show in Leverkussen earlier that year, consisted of a cluster of plinths of various heights, on each of which was placed a magazine photograph of a domestic consumer item. The implications were complex and, as always, crossed the lines drawn between art and non-art, between objects of protected and special status and those of common usage. On the one hand the art-world-confined activity of so many conceptual artists was being exposed to ridicule (for their preoccupation with 'concepts' without object, ie *purpose*); on the other hand the consumer world's unseemly and thoughtless (conceptless) elevation to cult status of luxury objects (putting them on pedestals) was neatly satirized.

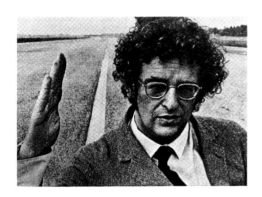

46. Photographic work accompanying film
A Million Smiles for One of your Miles Walter. 1971

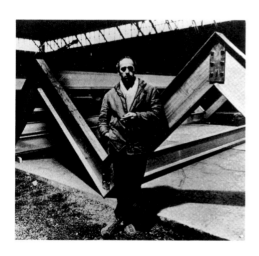

47. Photographic work accompanying film
In the Shadow of Your Smile Bob, 1970

```
1   King for a Day piece.
2   Wear a Hat with a silver lining piece.
3   Fools rush in and make the new Art, piece.
4   Art is a many splendoured thing, piece.
5   McLean and the nude, work.
6   McLean and the Still-life piece.
7   McLean and the portrait piece.
8   McLean and the Landscape, lakescape, piece.
9   Take a line for a walk piece.
10  Piece for specific part of the Body, piece.
11  Head work.
12  Foot work.
13  Leg work.
14  Arm work.
15  Mouth work.
16  Caro revisited work.
17  King revisited work.
18  Tucker revisited work.
19  A fresh look at Henry Moore (piece).
20  Impression work.
21  Face pieces (smiling) piece.
22  Face piece (smiling laughing simultaneously) sound.
23  Multi-facial expression work.
24  Put yourself in my place piece.
25  Joke piece (visuals sounds) multi/mixed media.
26  Peep toe piece (wearable).
27  Skliff, skluff, clomp piece (wearable).
28  Run, jump, stand piece.
29  Sound piece for wearables, (shoes?).
30  Portrait of Barnes Pond by Alexander Saville work.
31  Taking it easy piece work/piece.
32  Disposable piece.
33  Throwaway piece.
34  Kickaway work.
35  Blowaway work.
36  Goodbye London Piece.
37  Hallo New York, piece.
38  Round the World in ½ an hour work.  J. Saville.
39  Selection from the last day of the decade work piece.
40  Medley work from the last day of the Decade, wearables again.
41  Sculpture of the seasons.
42  Painting of the week, work.
43  Piece for Mecca Ballrooms (Moonrock shuffle).
44  My latest offering piece/thing.
45  9 postcards of the Barnes Pond Area.
46  Torn tit book piece, (crimble crumble) found.
47  Painting piece (floor), portrait.
48  Wall painting piece, portrait.
49  Portrait of some people, work.
50  Song, joke and dance piece/thing/work.
```

48. First page of catalogue *King for a Day*. 1972

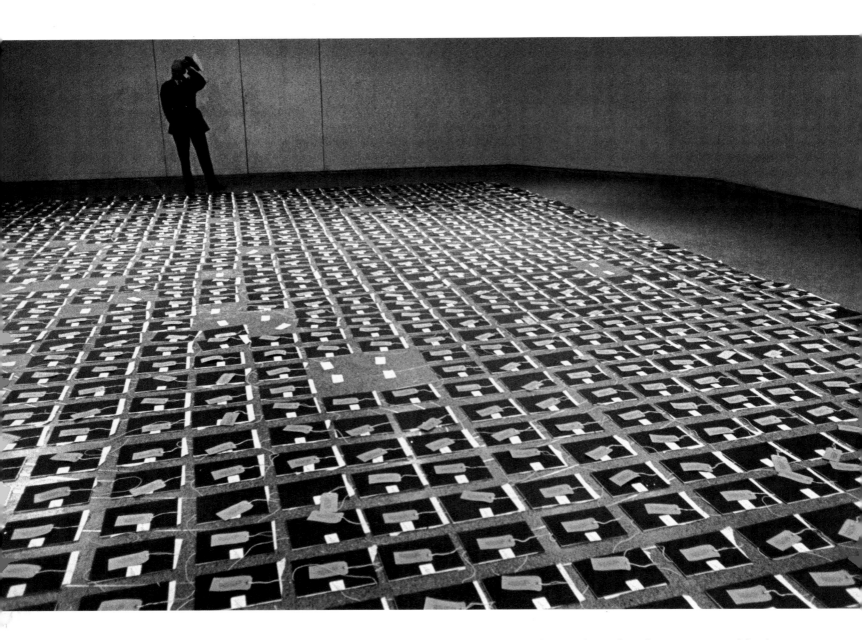

49. *King for a Day.* One-day 'retrospective' at Tate Gallery, 11 March 1972. Photographer: Dirk Buwalda

During the show McLean presented a number of performances, notably *There's a Sculpture on my Shoulder*, in which slides of well-known sculptures were projected on to a wall behind a progressively weighed down McLean; after each slide the outline of the artist was drawn on the wall, and labelled with the sculpture's title, to leave at the end a diagrammatic measure of successively more crushing art burdens. In another piece McLean sat at a table, making and then screwing up the rapid drawings that were to end up in *King for the Day*; these were recovered from the floor by the Situation director, who sorted them and then ironed them back to respectable collectability. (Situation published the *King for a Day* book, which contained the priceless items.) These were not the first of McLean's performances but they indicated a direction for his talents at a time when making art objects in an art context seemed to him less and less supportable as an activity. With the Tate farewell he finally 'gave up art' and turned to collaborative performance, to problems of positioning and the quest for the perfect pose.

951	Transmission of visual sensitivity piece.
952	Art is only a memory anyway piece.
953	The Institute of Contemporary Aromas present "Spring" piece.
954	The instantaneous impression piece.
955	Money grows on trees piece.
956	Index Card piece.
957	The Retrospective "piece" "The Piece" work.
958	The picture window piece, 12 photos.
959	The suburban growables, 1 conifer piece/work.
960	12 suburban objects piece (photos).
961	The window box work piece.
962	Installations work things etc., suburban domestic thing piece.
963	McLean in Argyll Street, work possibility? work.
964	Suburban earth? art work piece.
965	Mrs. Rae coming out of Mrs. Dewar's house piece.
966	Mrs. Rae going into Mrs. Dewar's house piece.
967	The Big storm door syndrome piece (suburban).
968	The next piece really is going to my greatest piece/work.!
969	Another breakthrough piece.
970	Dazzle piece/work.
971	A sculpture of the undergrowth, work.
972	I predict piece.
973	Well it's not really a painting piece.
974	Sculpture of the seasons piece I spring piece.
975	The Institute of Universal International Ideas, presents: - "Spring" piece.
976	Hallo, hallo, hallo, hallo piece.
977	Little blue nude revived piece.
978	Henry Moore revisited for the 10th time piece.
979	There's no business like the Art business piece (sung).
980	Painting those blue skies blue piece.
981	Mr. Sculpture lend me your art piece.
982	Large lavatory glass door works a selection.
983	Conte works, "A bonny drawin' piece" work.
984	This is it piece; no? piece.
985	Place and process piece.
986	Love made a sculptor out of me piece.
987	I'm just a love sick sculptor piece.
988	A quick song and dance piece "Scottish version".
989	Another masterpiece piece 3rd piece.
990	Live in your head piece/work.
991	Rosi starts a rumour piece, thing.
992	10 steps to heaven and the new art piece.
993	Somewhere over the rainbow that's where it might be piece.
994	Domestic light pieces "shades" etc. work.
995	Project for suburban pub, lights, piece.
996	Sculpture for the pocket (tactile).
997	£1,000,000 sculpture piece.
998	998th piece a look at the last 998 pieces, piece/work.
999	Bruce McLean "Superstar" piece 999 1st version.
1,000	Goodbye sculpture, art pieces - things/works/stuff/everything, piece (incorporating the Fastest 1,000 pieces in the World, Show, "Song and dance art". Love pieces, etc. etc. etc. piece/work/thing/stuff.

50. Final page of catalogue *King for a Day*. 1972

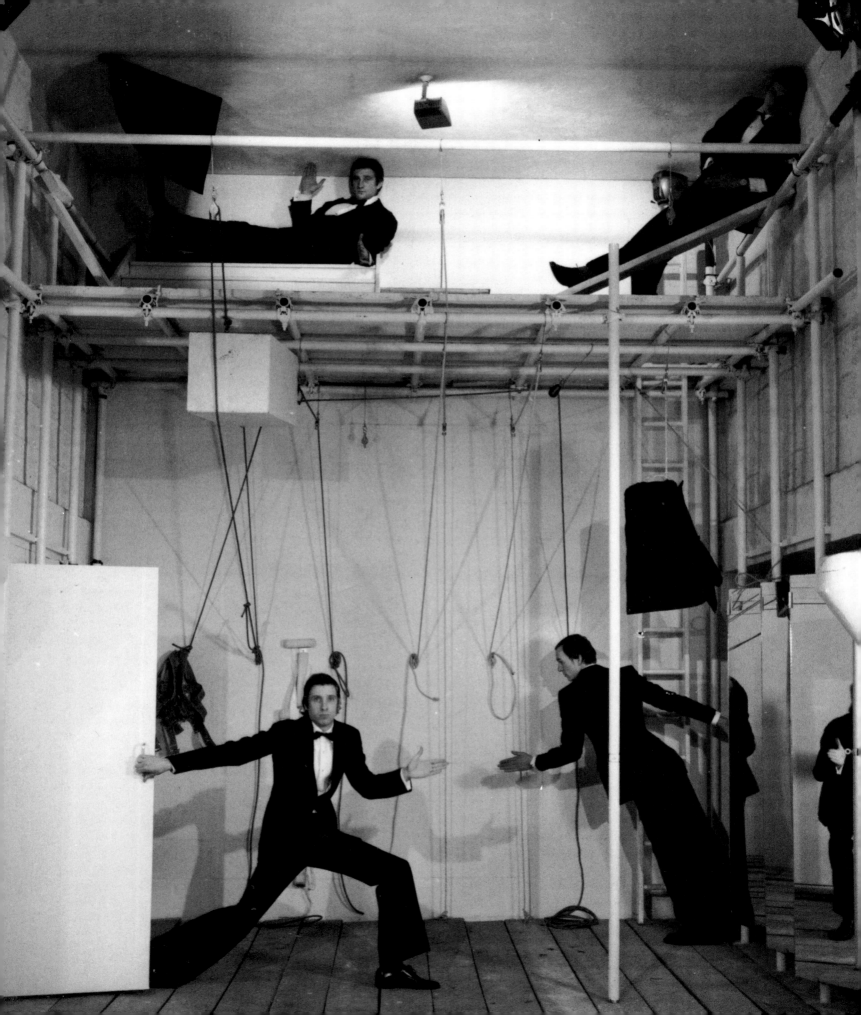

CHAPTER 4

Nice Style:
The Art of Pose

IN April 1969 McLean made *Interview Sculpture*, a public performance work with Gilbert and George, in which he responded to their earnest enquiries about the work of contemporary sculptors by physically mimicking the characteristics of the works in question. This performance, which took place first at the Royal College and was also presented at St Martin's and at the Hanover Grand Banqueting Suite, where it was billed as *Impressarios of the Art World*, was McLean's only collaboration with the 'Living Sculptures', who devised it in the knowledge of his talent for the inspired send-up and of his attitude towards British sculpture in the 1960s. In the audience at St Martin's was Paul Richards, a student on the Foundation course at the School, who was to play a crucial role in McLean's subsequent performance work. Richards went on to Maidstone College of Art, where he was instrumental in getting McLean invited to teach for one day a week, from the Autumn of 1970. At Maidstone their interaction precipitated the concept of pose performance and the ensemble that would bring a new art to public life: *Nice Style, the World's First Pose Band.*

Richards was from the beginning a subversive and original force in the College, interested in problematic interventions and actions calculated to disrupt comfortably received notions about how sculpture was to be defined. He was particularly open to ideas of collaboration, to the possibilities of an art that would be the unpredictable outcome of a group dynamic, of improvisation and spontaneity within a conceptual rather than a predetermined formal frame. McLean has no doubt that Richards was a decisive influence in his own efforts to define what performance might be capable of doing, how it might be a means to extend the concept of sculpture. Neither was interested in the narcissistic theatricalities of so-called 'body art', nor in direct political or social commentary, didactic acts of demonstration and exposition or dramatic spectacle. Both conceived of performance as an extension of the possibilities of plastic art, considering it a form of *sculpture* with satiric potential.

Nice Style was in every sense a collaborative venture, the invention and work of its principal members, and its performances were the outcome of a process of interaction that continued even as they were in progress. Whatever their script and programme, and whatever their preparation in rehearsal, anything could happen. Paul Richards, for example, unilaterally assumed the role of a conducting director of events, seated in the audience, for performances of *High on a Baroque Palazzo* only minutes before the piece was presented for the first time. The collaboration was at times stormy, and after three somewhat chaotic years the band broke up after the

51. OPPOSITE: Publicity photograph for *High up on a Baroque Palazzo*, Garage, London, 1974. Photographer: Craigie Horsfield

performance of *High on a Baroque Palazzo* at Garage in October 1974.

Nice Style's public career had begun as support band to The Kinks at Maidstone College of Art on May 26, 1971; appropriately, as the idea and name of the 'pose band' was in deliberate *pastiche* of those rock bands that had proliferated through the 'Sixties and early 'Seventies and exemplified the significance of pose and collective *persona* as the necessary and identifying adjunct to whatever music they performed. *Nice Style* isolated those *essentially visual* aspects of the identity and performance of bands and brought their meanings into sharp focus. Not surprisingly those audiences that expected music as well as pose were disappointed, and the early performances as support to rock bands were not greatly successful. In spite of its genuine efforts to find a setting for its performance that was outside the art world its greatest successes were within that ambit, and it is as art actions, albeit of a highly original and categorically difficult kind, that *Nice Style* performances must be considered. The scope of its satire soon broadened beyond the posturing of rock musicians, which anyway had been merely visible exemplary targets.

What made *Nice Style* unique was its consistent ironic exemplification of what it attacked, maintaining its pose with an impenetrable rigour of self-awareness. This had certain antecedents in Dada performance, which at times was similarly characterized by po-faced and imperviously self-contained maintenance of pose (see Richter on Schwitters). This was an essential aspect of the *Nice Style* act. The band's name ambiguously signalled as much. It had been chosen partly because over-use had rendered both words in certain contexts feeble and imprecise, redolent of the characterless and derivative fashions of the mail-order catalogue; and partly because both words have stronger connotations, the adjective of exactness, as in the joints of good carpentry, the noun of distinctive characterization, a specific precision of presentation. What was implied was that a front with the latter qualities could mask a reality as morally mediocre as the debased uses of the words suggested. Conversely, to complicate matters, a lack of precision, a slack solecism in the stylistic presentation of appearance, might betray lack of grip, a failure to grasp the importance of what Erving Goffman has termed 'impression management': '. . . the attributes that are required of a performer for the work of successfully staging a character.' Goffman is, of course, referring to 'performance' in the everyday world of social interaction.

The contextual framework of *Nice Style* performance was *pose*, and in defining that concept, with all its connotations of gesture, posture, proximic positioning relative to persons and things within a given room, the stance, the glance, the look, the attitude, etc., no critical text gets closer to the heart of the matter than Goffman's classic report *The Presentation of Self in Everyday Life*. Goffman's own term for pose is 'front' which he defines in the following passage: 'I have been using the term "performance" to refer to all the activity of an individual which occurs during a period marked by his continuous presence before a particular set of observers and which has some influence on the observers. It will be convenient to label as "front" that part of the individual's performance which regularly functions in a general and fixed fashion to define the situation for those who observe the performance. Front, then, is the expressive equipment of a standard kind intentionally or unwittingly employed by the individual during his performance.'

52. OPPOSITE: *Nice Style at Hanover Grand.* 1973.
Photographer: Peter Mackertich

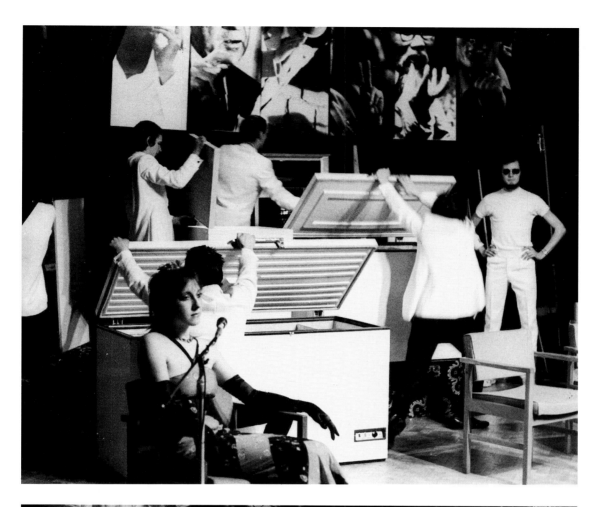

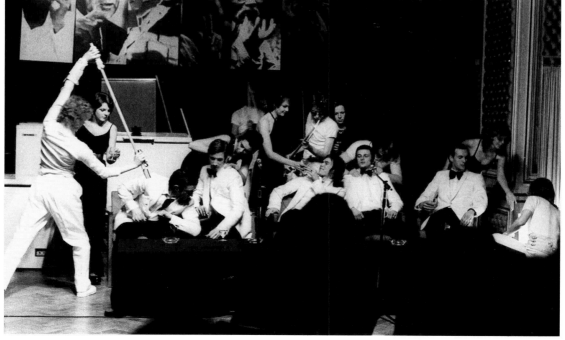

He goes on to distinguish the 'standard parts of front': 'First, there is the "setting", involving furniture, decor, physical layout, and other background items which supply the scenery and stage props for the spate of human action played out before, within, or upon it. A setting tends to stay put, geographically speaking, so that those who would use a particular setting as part of their performance cannot begin their act until they have brought themselves to the appropriate place and must terminate their performance when they leave it. Second, one may take the term "personal front" to refer to the other items of expressive equipment, the items that we most intimately identify with the performer himself and that we naturally expect will follow the performer wherever he goes. As part of personal front are: insignia of office or rank; clothing; sex, age and racial characteristics; size and looks; posture; speech patterns; facial expressions; bodily gestures; and the like.' Of course, certain of these 'vehicles for conveying signs' (for example sex and racial characteristics) are invariant, while others are provisional or mobile.

For Goffman, 'front' is a complex component of the performance by which self is projected in social situations, and as a concept it can be further refined by a distinction between 'appearance' and 'manner', where the former refers to aspects indicative of status or temporary mode of functioning (formal, informal, official, personal etc.), and the latter to the interactional intention or expectation of the performer within a given situation, what he intends to convey by a specific sort of performance. Goffman quotes Orwell on waiters, whose 'appearance' is, of course, a function of their distinctive uniform, and whose 'manner' is carefully constructed at the moment of their entrance into the arena of performance: 'It is an instructive sight to see a waiter going into a hotel dining-room. As he passes the door a sudden change comes over him. The set of his shoulders alters; all the dirt and hurry and irritation have dropped off in an instant. He glides over the carpet, with a solemn priest-like air. . . .' (It was McLean's second ambition, after artist, to be a Head Waiter: he is still fascinated by the stylized precisions and aptitudes of the profession.)

Nice Style, in rehearsal, in performance and in scripted projections, constructed an elaborate repertoire of 'front' mannerisms and impression-management ploys, incorporating precise and detailed attention to details of dress and angles of stance appropriate to particular strategies of effect. Within the constraints of a collective demonstration of the niceties of stylistic pose the individual members of the band defined their personally distinctive approaches to posing (the other members referred to are Gary Chitty and Robin Fletcher):

> 'Each member of *Nice Style* has his own particular style of pose illustrated by his impeccable personal posture.
>
> Bruce: A man with a posture aid for every occurrence. Bruce's pose hinges upon paraphernalia.
>
> Gary: Survives by the sheer audacity of his transient gesture. Always to be seen in the right place at the right time and always in the right light.
>
> Paul: Relies on much publicized and accentuated excessiveness in certain areas; e.g. a 36-inch trouser leg width. Renowned for his daring charismatic entrances.

Robin: Specializes in the silent and static poses which he executes with the correct amount of panache.'

Behind all this is an ironic reversal of the representation of gesture and posture in historical iconographies, where a congruence between the outward appearance and the inward spiritual and emotional state of a depicted figure is assumed, and where the visible actualities of stance, gesture and expressive movement are all indicative of inner realities. Richards found important clues to pose possibilities, and to a contextual antecedence in the visual arts, in Michael Baxandall's brilliant exposition of the relation of painting to experience in fifteenth-century Italy. Published in 1972, just as Nice Style was getting under way, Baxandall's book treats of the use of an expressive language of gesture and movement that reflects a 'sense of close relation between movement of the body and movement of the soul and mind'. He cites Alberti and Leonardo on the importance to painting of the appropriate depiction of physical movement and gesture to correspond with the spiritual and mental condition of the subject portrayed, and proposes the existence of a 'Renaissance language of gestures'.

The art of Nice Style delineated a world in which there is no such trusting to consonances of outward sign and inner meaning. Nice Style was about calculated and codified inauthenticity, about the disjunction between appearances in social behaviour and real desires and intentions; it was concerned with the projection of persona, with style as mask. It held a mirror up to the age, reflecting the elaborate strategies of insincerity and dishonesty that are the characteristic behavioural modes of modern society: 'We deal with problems of bad style, superficiality and acquisitiveness in a society that holds pose to be very important.' Its adoption of the anonymous uniform of formal attire, dinner jackets, white shirts, black bow ties, had the effect of concentrating attention upon those mobile aspects of front such as movement, gesture and posture, and upon the signifying potency of nuance, the minor adjustment of cuff exposure and trouser crease, for example. It also eliminated any hint of anarchic bohemianism, any suggestion of 'artiness'; and it emphasized the general and exemplary nature of Nice Style demonstrations.

The highly successful culmination of Nice Style's activity ('three years of getting it wrong' in McLean's laconic summary) was High up on a Baroque Palazzo, performed at Garage in Covent Garden. The title was taken from that of a feature in House and Garden, one of a number of magazines read assiduously as part of the band's continuous programme of research into aspects of modern pose. Domestic posing in particular had become a major preoccupation. Much of Nice Style's late work was aimed at the obsessive attention paid in countless specialist magazines to the problems of preparing the home as a setting for the perfect pose: acquiring the right appliances and accessories, the right house-plants, managing the right angle of light from window to seating arrangements and so on. In this Nice Style were addressing themselves to the question asked in the title of Richard Hamilton's famous collage, Just what is it that makes today's homes so different, so appealing? (itself taken from a magazine article) which had been the basis of an earlier short performance called Semi-Domestic Poses in 1973. That piece, and Deep Freeze, another performance of 1973, in which the lids of five deep freeze refrigerators were raised

and banged shut in rhythmic counterpoint, underlined what was implicit in Hamilton's picture, that appliances were essential not only as utilities but as props and signals, aspects of Goffman's 'setting' in a major arena for 'performance': 'In thinking about the scenic aspects of front, we tend to think of the living-room in a particular house and the small numbers of performers who can thoroughly identify with it.'

High up on a Baroque Palazzo, conducted with verbal *panache* by Richards at the front, offered a compendium of poses and postures within a tightly choreographed non-narrative scenario that involved multiple doors for varieties of entrance and exit; ladders, ropes, pulleys and other equipment for ascents to a higher level; props of all kinds necessary for the achievement and maintenance of pose; angle brackets and other measuring devices; posture aids, stance moulds etc.; lighting arrangements and manipulations of light source for specific effects; and, of course, mirrors for the checking and adjustment of correct positions. Each of these elements was metaphorically charged. The entire performance, involving their manipulation in the quest for the perfect pose at the highest level, was in satirical parallel to those modes of social and ethical behaviour that are directed and shaped by the fashion makers and 'stylists' of modern life. It was the last and best performance of *Nice Style*.

It is not hard to see many of the preoccupations of McLean's paintings prefigured in the themes and formal dispositions of *Nice Style* performance, just as the concept of pose itself elaborated and refined ideas that had become part of McLean's distinctive view of the world and of art's place in it. It was during a critical 'forum' at St Martin's that he had first realized that the sculpture under discussion fulfilled a powerful unacknowledged function: as an object it provided the occasion for performance and what Goffman calls 'teamwork', where a 'set of individuals . . . cooperate in staging a single routine'. The lack of a referential element in the works discussed had two immediate advantages: in the first place it meant that the discourse could be safely framed within the ambit of formal aesthetics; in the second that this limitation, itself crucial to the keeping up of 'professional' front, maintained the exclusivity of the situation. McLean felt disinclined to take either advantage: he was impatient of an art exclusive of so much of reality and uninterested in the exclusive places where it was to be found. To find or to make new contexts, conceptual and situational, has been a consistent part of his project.

Nice Style was one such attempt to shift context, and its 'training sessions', ritualistic Press conferences, experiments with records and projections for film were as much a part of that aspect of its significance as its collaborative *modus operandi*, its elaborated definitions of pose and its actual performances. In the mid to late 1970s, McLean worked, again collaboratively, on a number of more complex performance pieces, which had a range of reference at once wider and more explicit than his work with *Nice Style*. In these works satirical attention was paid to institutional games playing, political inauthenticities, the rituals of bureaucratic routine, the insularities and insincerities of the art world, the absurdities of domestic and social behaviour.

In the pieces McLean developed the ironic, and the comic, implications of two

53. OPPOSITE: Entry Pose: *High up on a Baroque Palazzo*, Garage, London. 1974. Photographer: Craigie Horsfield

54. *High up on a Baroque Palazzo*, Mickery Theatre,
Amsterdam. 1980. Photographer: Dirk Buwalda

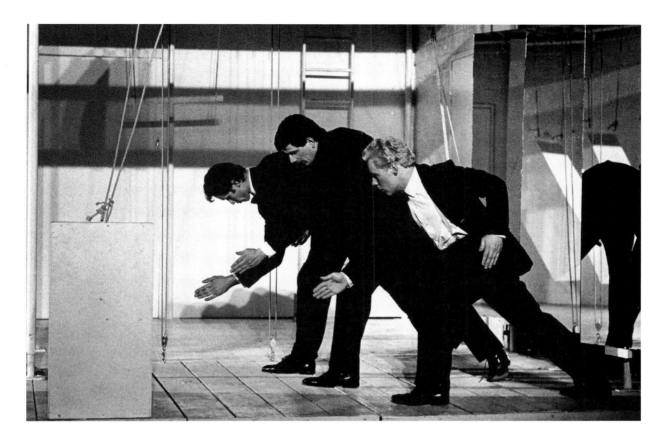

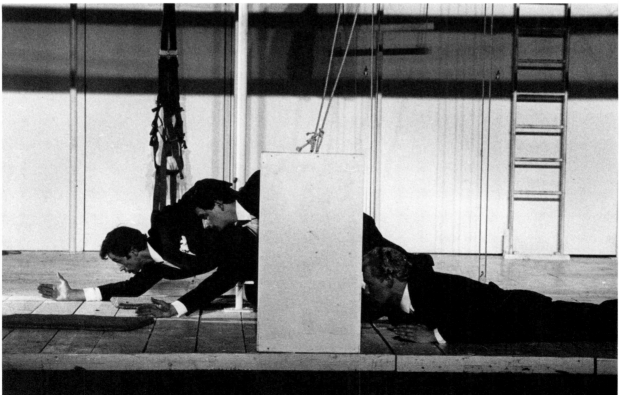

55. Moving into coordinated pose: *High up on a Baroque Palazzo*,
Mickery Theatre, Amsterdam, 1980. Photographer: Dirk Buwalda

perceptions central to his vision of modern life. First, that the objects, appliances, and physical settings that multiply and are modified endlessly in our political, social and domestic environments signal meanings separable from their ostensible purposes. They constitute media for behaviour, being the components of a language through which affairs are conducted and impressions managed. They are essential to conduct of the institutional and administrative arrangements that proliferate in the modern world. Second, that much of our behaviour is merely reflexive, a set of responses conditioned by expectations encoded in a language of cliché and repetition.

Academic Board, A Procedure, the first of these performances, was scripted by William Furlong, whose tape magazine *Audio Arts* had featured recordings of *Nice Style at Garage* in 1974. The Board in question, the body charged with responsibility for academic affairs within the educational institution, was visibly symbolized by the steeply-raked bare grey table around which it had gathered, its hierarchies enacted in terms of actual height from the floor. (At the top of the table, in both senses, the Chairman was actually standing on a ladder concealed by the table itself.) Its proceedings were devoted entirely to discussion of the specifications for alterations to the caretaker's house. Each member engaged in solipsistic disquisitions on matters of his or her own interest, and the entire exercise demonstrated that the objects that were the focus of the Board's attention (and irrelevant, in any case, to its proper concerns) were merely the occasion of a set of behavioural ploys, characteristic of institutions, whose real purpose is the perpetuation of the institution itself.

Bureaucratic ritual of another kind was the subject of *In Terms of, An Institutionalized Farce Sculpture*, in which Furlong and Duncan Smith worked with McLean, and which was performed at Documenta 6 at Kassel and at the Serpentine in the Summer of 1977. In this a long grey structure with five doors on either side was the

56. *In Terms of . . .* at the Serpentine Gallery, London. 1977. Photograph: courtesy Audio Arts

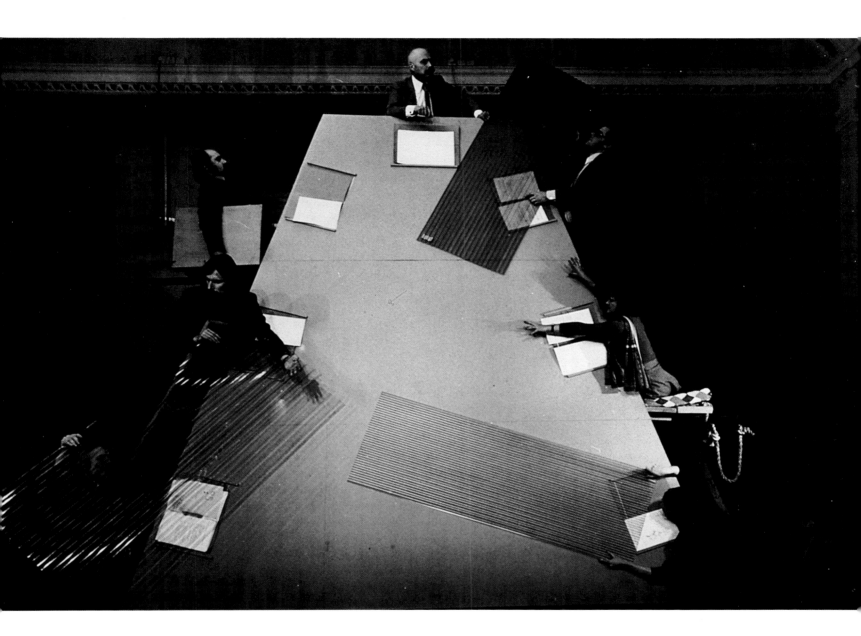

57. *Academic Board* at Battersea Arts Centre, London. 1976.
Photograph: courtesy Audio Arts

58. *Blue Acrobat against Grey Background on Thin White Line.*
1977. Acrylic on paper, 96″×144″ (244×310 cm). The artist

59. *Chinese Balancing Act against Blue Background on Thin Red Line.* 1978. Acrylic on paper, 84" × 108" (214 × 274 cm). The artist

setting for three grey-suited figures to perform a sequence of obsessively repetitious actions: walking in a manner signifying urgency and purpose, punctiliously checking the time, officiously waiting by the doors, entering them and exiting from them as if on important business.

At this time, 1976–77, McLean took a studio in Faroe Road, behind Olympia in Kensington, and here he made a series of large works on paper inspired by magazine photographs of Chinese acrobats. It was a sideways move, typical of McLean's creative mode of procedure. Performance and pose had increased his already extraordinary sensitivity to the ways in which physical behaviour conveys meanings, intended and unintended. Poise, balance, precision in movement, footwork and coordination, correctness of trajectory, flying high, somersaulting, landing on your feet: McLean realised that acrobatics – the apotheosis of pose, being the outcome of extreme artifice and *signifying nothing but itself* – presented a richly allusive vocabulary of metaphor for political behaviour. It was a marvellously apt image of that profession whose public performances are most assiduously rehearsed and self-consciously delivered to appear spontaneous. (The circus was later to provide McLean with other images appropriate to political commentary – jugglers, tightrope walkers, tumblers.) The large acrylics, executed on photographic paper, were themselves gestures, signifying a way in which art might engage, not without wit and humour, and with a degree of ambiguity, with the political. What is political in McLean's work is never propagandist or analytic. It works by indirection, irony, metaphor and implication.

The paintings were actually extremely simple and direct. In planes of a single undifferentiated colour the figures and their launching platforms were imaged in negative configurations; sometimes of untouched paper 'reversed out' as in printing, sometimes in-filled with another colour. In these works McLean first began to exploit the potentialities of emblematic colour in relation to political symbolism. The acrobats of politics were depicted as engaged in their self-absorbed feats in arenas of performance suspiciously uncomplicated, against backgrounds that signified, in the way that flags do, certainties of value and allegiance; such certainties come in different colours.

It was very much to the point that the paintings looked like flags, with simple motifs on large, boldly signifying colour grounds: red, blue, yellow, grey. McLean exhibited these works under the collective title *Political Drawings* at the Robert Self Galleries in London and Newcastle in 1977. This was the year of the Jubilee, a period of orgiastic patriotism and political self-congratulation during which the union flag was ubiquitously reinstated as a national emblem unattended by the ironic irreverence it had attracted in the 'Sixties.

The *Political Drawings* anticipated McLean's commitment to drawing and painting as major activities by at least a couple of years, but they were clearly a response to a desire he had begun to feel in the mid-1970s: 'I decided in 1975 that I wanted to touch the work again. You know, to get back to the possibility of making something with your hands.' In their almost abstract formal structure and self-contained pictoriality these works anticipated those later paintings by McLean that can be considered works in their own right with no projective relation to performances or films. Even so he continued to put much of his energy into

Ways of viewing mackerel and mandolins, methods of discussing mackerel and mandolins, proposing ways of viewing mackerel and mandolins. Mackerel and mandolins as the model/s for compulsory state (substitute essential for compulsory; see socio-political art, quasi. Rights for lefts and lefts for rights), controlled art (subject matter). Subject matter being the subject under discussion, question discussion, substitute control. Choice, variety of subject matter as opposed to object matter or for that matter, concept matter, no matter what matter. Treatment of matter, what form, shape, style should the matter take or for that matter discussed/controlled? The importance attached to viewing the mackerel and mandolins, with whom, with what, what with what for, why how and when, how far/near, a question of distancing, positioning and getting the subject/matter into *perspective*, actual, conceptual. The nature of viewing mackerel and mandolins and the importance of understanding the meaning of the *model*. The position of the model, geographical, social, financial, historical; is of prime importance. The connections made, misinterpreted, between the understanding of the term Ways of Viewing Mackerel and Mandolins and the perception of the *tea cup*, what the positioning of the tea cup might or might not mean. What are the references there, if any. Why that height, what for, how is it to be viewed how is it to be interpreted; esoteric: problematic tea cup references, future; minimalism? Interpretations are valuable when the nature of the choice of subject/mainly object matter is ill considered and is treated as if it doesn't matter. Choice/control of objects to fabricate the subject are continually pre-determined in the minds/hands of the art makers (artists). Substitute stuff for art. The 'stuff' of art, the sort of stuff you need to make good art, the stuff that art's made from, the stuff that stuff's made from, the art of stuff. Presentation of stuff, positions of forms of stuff, the sort of stuff that good stuff's made of. A focus of attention on stuff, the subject matter being stuff, and stuff being the substitute for art. Object stuff/concept stuff, stuff object, stuff concept, importance of subject matter in fabrication of stuff. Systems of categorising stuff/art, maintaining a mackerel and mandolin point of view/viewpoint. Not ways of viewing mackerel and mandolins but ways of seeing mackerel and mandolins. A set up still-life. ●

60. From *Ways of Viewing Mackerel and Mandolins*. Aspects 4. 1978

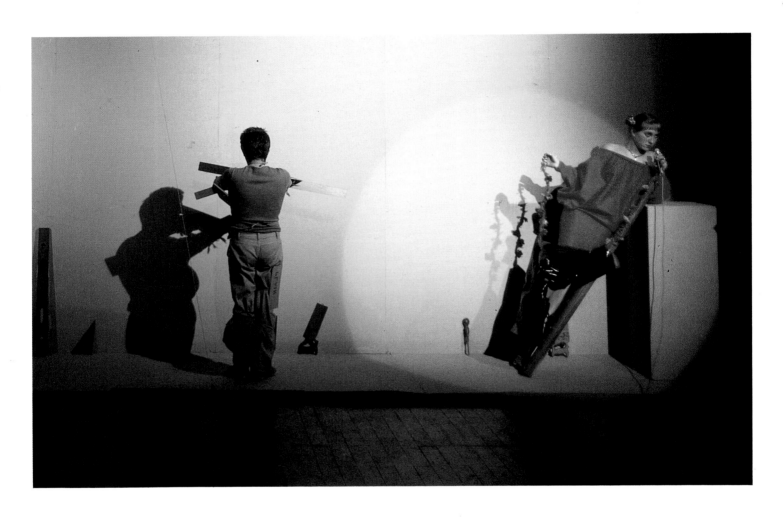

61. *Sorry. A Minimal Musical in Parts* (with Sylvia Ziranek),
Battersea Arts Centre. 1977

62. *Sorry. A Minimal Musical in Parts*, Battersea Arts Centre. 1977

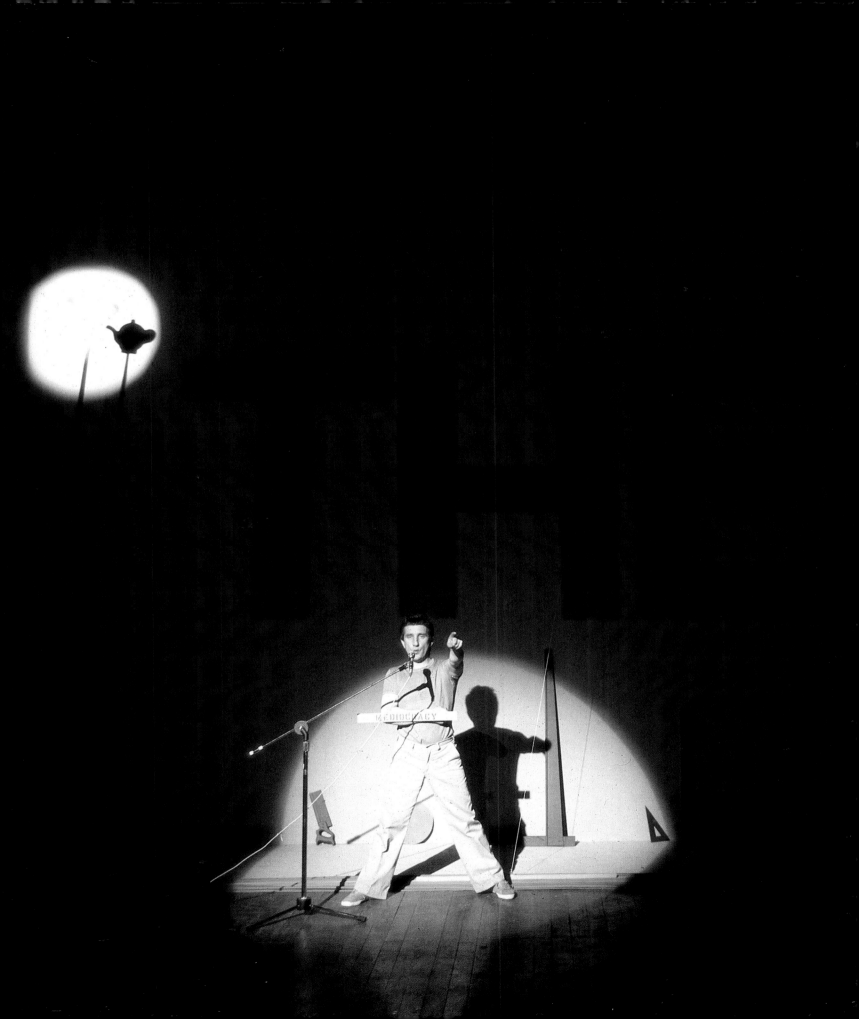

SORRY, A MINIMAL MUSICAL IN PARTS BY *BRUCE MCLEAN* WITH *SILVIA ZIRANEK*

SOME OF THE PARTS ARE:

1. A NATIONAL ANTHEM (WITH PARTS)
 A PROBLEM OF LOWERING STANDARDS

2. COMPETITIVE GYMNASTICS,
 THE MECHANICS OF ATHLETICS,
 (THREE MAINS VAULTS AND UPSTARTS,
 STANDARD 1)

3. A STILL-LIFE, WAYS OF VIEWING
 MACKEREL AND MANDOLINS

4. RIGHTS BY LEFTS/LEFTS BY RIGHTS

5. TRYING FOR GREY, BRITISH STANDARD

6. SUM OF THE PARTS/SOME STANDARDS

7. GOING FOR A SONG FOR EUROPE

8. SORRY

63. Programme for *Sorry. A Minimal Musical in Parts.* 1977

performance works, using them as a form of idiosyncratic and enigmatically humorous commentary on 'over-seriousness, solemnity, social and political constraints, the way in which we all seem to be governed by committees, safety committees, regulations, rules, *correct procedures – and so on.*'

In *Sorry, A Minimal Musical in Parts*, presented at Battersea Arts Centre in November 1977, he 'wanted to make something that was a whole but which you saw as a lot of little bits, not as lots of separate bits making up a big whole. More like Brancusi than Rodin'. *Sorry* was very much about the conventions and constraints that determine the habitual ways in which we view reality. The 'Sorry' of the title referred to the restrictive tendency of all bureaucracies to control the potentially anarchic untidiness of human behaviour: *sorry, you can't do that*; *sorry, you can't go there*; *sorry, that's not how it is.* It extended in the piece to a projection of conventional critical response – *sorry, that's not art* – by making elaborate fun of the solemn conventions, of arrangement and subject matter, of still life painting: in a section, later abstracted and entitled *Ways of viewing Mackerels and Mandolins*, McLean balanced precariously on a ladder attempting to hang fish and instrument from a tall pole. In another part the shadow of a teapot was projected on to the wall behind him as he whistled the banal and repetitive tune of *My Way*, proposing this incantation of self-regard as a new national anthem. Whether the 'little bits' did indeed cohere is an historical question of no great consequence; the parts were separated by McLean sweeping across the performance area with a broom-like instrument that terminated in a giant cuff, in physical enactment of something like a film wipe, and the performance ended with a *tour de force* sequence of verbal and visual punning on ideas of 'the standard' and 'standards'. As usual with a McLean performance, the audience had been amused and disconcerted by a set of actions that seemed sometimes precisely judged, sometimes utterly haphazard.

Reflecting later on performance in general and *Sorry* in particular McLean said 'I think I'd like (the audience) to go away perhaps smiling and thinking. I like the idea of something being amusing but not entertaining, also the performance seeming quite easy at the time, but on reflection not as explicit as first assumed. I want questions to be raised in people's minds, for instance "*why should he want to suspend a mackerel and a mandolin from a thirty foot pole?*" "*why should there be a jug and a pound of pork sausages placed on a shelf?*" "*why should there be a song for Europe or a broken mantelpiece or someone tying a large knot?*" '

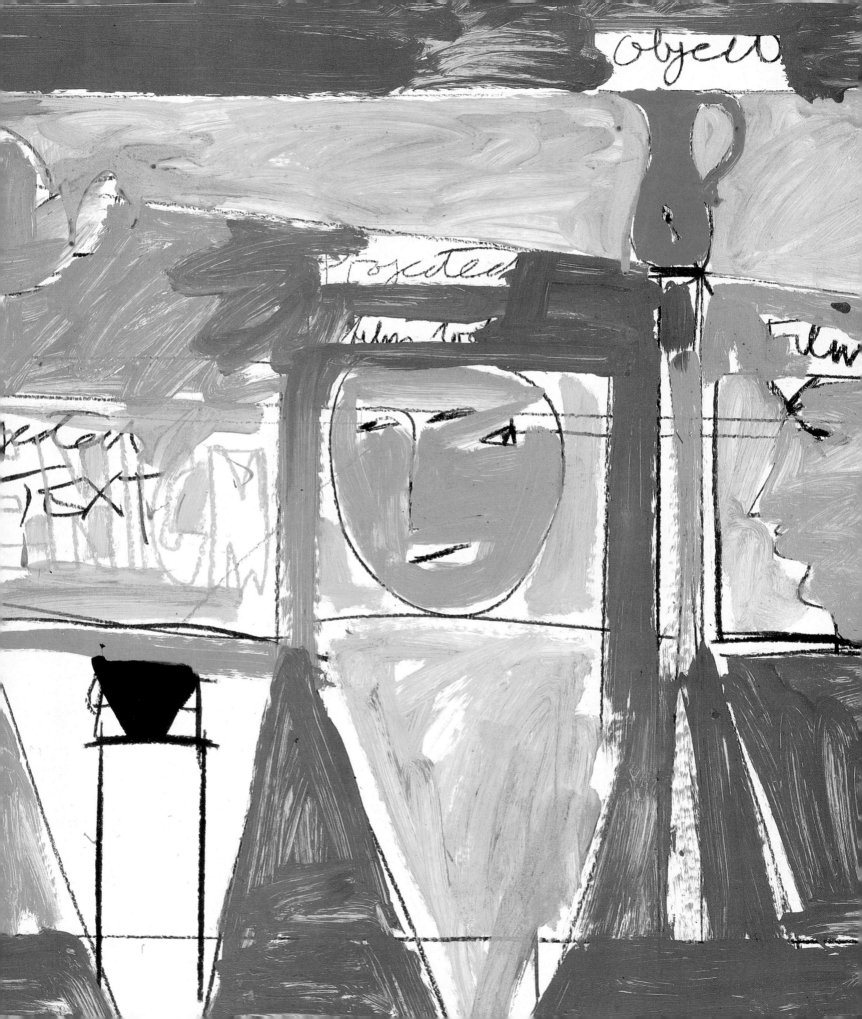

The Masterwork:

The Object of the Exercise

Research is a key word to key works free paper free attitude nonpermanent, always done towards something else never done after the fact/s mostly after the event. Event is the catalyst. . . .

McLean: Drawing (1982)

64. OPPOSITE: *The Object of the Exercise* Drawing for projected film (Detail). 1981. Acrylic on photopaper, 83″×54″ (210×137 cm). The artist

FOR Bruce McLean drawing is a natural mode of expressive performance: immediate, effective, communicative, pleasurable. But for a considerable period, from the late 1960s to the late '70s it was a pleasure he largely denied himself. During that period he worked with impermanent structures and received materials, used photography as a medium in itself or as a means to document transient works, made performances, collaborated on texts, tapes, uncommercial films and videos, and maintained his commitment to teaching. He had deliberately put himself at a distance from directly expressive autographic activity. Instead he engaged with the problematics of definition, made things difficult for himself, experimented and researched.

Refraining from the exercise of a considerable native gift, he had the courage to ask 'what *else* can be done?' In publicly 'giving up art' in 1972 and taking up collaborative performance McLean had adopted a combative stance of creative interrogation, speculation, and satiric demonstration. This was the more disconcerting in that his philosophical and political propositions were implicit and oblique, disguised by parodic humour, absurdity and reflexive irony. His activity during that period was critically provocative and witty, uncluttered by discursive justification, and unaccompanied by any production of saleable objects.

It was inevitable that McLean would return at some point to drawing and image-making. The 'political drawings' of 1976–7 were made in spontaneous reaction to the public events of that period, but also in response to a personal imperative. The drawings of the later 1970s certainly related more directly to the idea of performance, at first as projection and notation but soon as works in their own right. Something he said in 1981 applies to much of his drawing in the previous four years: 'The new drawings are in the first place "working" drawings for future performances but I think they are becoming more works in themselves. . . . The subject matter is action as the performances are, with habitual modes of seeing things or *not* seeing . . .' Drawing is a way of breaking habits of seeing, not only describing objects but making visible the dynamics between things. It may be diagrammatic, illusionistic, fantastic, reductive, conventionally symbolic. Drawing may cross or confuse those categories and others, it may be pictorial or calligraphic or both: it is infinitely various and versatile.

Drawing has become increasingly central to McLean's work and connects at the deepest level with everything else he does. He writes and talks about it with a particular vehemence: 'It's the most direct means of communicating – like dancing, like making a move, like unstriking a pose: it's a different mark each time, modified by many things, unpredictable. It raises consciousness. It's to do with timing, like dance. It's like a life force . . .' For McLean drawing is more than a way of projecting possibilities, conceiving things visually, imagining events and objects, though it is all those things. The intensity with which he speaks of the activity suggests that at times the act of drawing becomes for him something akin to the disciplined concentration of the ecstatic.

Referring to the Tantric emphasis upon inner visualization, the Indian writer Sukracarya wrote: 'There exists no form of concentration more absolute than that by which images are created. Direct seeing of a tangible object never allows of such an intensity.' McLean rarely draws directly from the figure or from objects: 'I don't want to look at trousers in order to paint trousers. I want another means to get at the way things really look.' At St Martin's he particularly valued freedom from the traditional academic disciplines of copying and life drawing. An ingrained antipathy to perceptual empiricism underlies his indifference to the meticulous and cautious realism associated with Euston Road, Camberwell and the Slade, with its emphasis on accurate and detailed observation, its measurements and location marks, its absolute lack of spontaneity. 'As a matter of fact,' Baudelaire remarked, 'all good and true draughtsmen draw from the image imprinted on their brains, and not from nature.'

For McLean drawing is an imaginative activity dynamically subject to contingency, to the chances and risks that operate upon the instrument – brush, brush handle, pencil, charcoal stick – as it moves across the paper. As such it is analogous to the act of moving through space; an analogy pedagogically remarked by Klee, and wittily enacted by McLean in a number of works in 1969. It is a way of discovering the relations between people and objects within the spaces they inhabit, an exercise of the imagination that is a component of a creative project that goes beyond the activity itself. 'It's another way to find out what I'm thinking; it gives clues to what things might look like.' In this McLean can be seen to work in accord with what Coomaraswamy observed (again in relation to Tantric practice) as certain psychological preconditions for imaginative discovery: '. . . the setting aside of the transformations of the thinking principle; self-identification with the object of the work; and the vividness of the final image.'

In a passage closely relevant to McLean's approach to drawing Philip Rawson has written of what he describes as 'the nuclear idea encapsulated in all good drawing since pre-history', the idea of *imitation*. 'Imitation is emphatically *not* copying either of a master or nature. Nor is it mere mimicking, an attempt to "duplicate" nature. It is the performance of an act, or series of acts, which appear structurally and rhythmically analogous both to acts of perception and acts in the perceived world . . . *Imitation in this radical sense is done by the drafting hand as an extension of the participating body.* The consequence of such an act of imitation, the graphic shape, does not have to be filled out and completed so as to compile a duplicate of "natural appearance". It constitutes an act, in some sense, *of naming and praising at*

once something which is not necessarily an exact tally match with any categorical object of the commonplace world. . . . It realizes previous rehearsals of numerous comparable physical, mental and emotive acts, with their associated analogy-functions, crossing the categories of commonplace reality.' (My emphasis)

While working on *Nice Style* performances and other projects McLean had used pencil and crayon drawings as a means to plot settings and moves. These drawings were sketchy schematic diagrams, usually executed on graph paper, and were never intended for exhibition. Those who bought a copy of the catalogue book of *King for a Day* at the Tate in March 1972 would have found enclosed an 'ironed drawing piece', a serious-looking diagram for an imaginary work, ironically salvaged with the collector in mind: a perfect ironing out of the dealers' problems with 'conceptual art'. The use of drawing as a means to think about performances was extended by McLean towards the end of the 1970s in a series of larger-scale projections involving elements of collage, text and colour.

This phase of work began with drawings made in 1977 towards *The Object of the Exercise* which McLean performed at The Kitchen in New York with Rosy McLean in 1978. At this point McLean realized that drawing could itself be regarded as an extension of what he still regarded as his primary activity – sculpture. A performance is a three-dimensional *event* located in time; but what if it remains merely *potential*, nothing more than a proposition? It is nonetheless *imagined* as existing in three dimensions and taking place as a series of actions in time. Though McLean's drawings during this period continued to explore ideas for actual performances they became increasingly free of that restriction. Drawing became a way of *conceiving* performances, ballets, events impossible of realization. It became a means to imagine and describe relationships between people and things, Rawson's 'performance of an act, or series of acts, that appear structurally and rhythmically analogous both to acts of perception and acts in the perceived world.' Like the photographs of earlier works the drawing could be regarded as a record of the event but one bearing the direct mark and gesture of the artist; and it may achieve an autonomous status as a work in its own right.

In a flurry of activity following his new beginning in 1977 McLean made many drawings, using acrylic paint and wax crayon on photographic paper (which he acquired free in large rolls), and working with the 'free attitude' that came with having no thought of exhibiting the work. The purpose of the activity was to work out ideas – 'paper, wax crayon, paint tossed on and used as a large visual notebook, no pressure . . .' – to provoke himself into new ways of thinking. In the spring of 1978 Bryan Robertson visited McLean in one of the temporary studios he occupied during that period (he had left Faroe Road Studios, unable to pay the rent, in the winter of that year). The 'studios' were in fact empty houses or shops awaiting redevelopment by a local builder. During the visit, whose purpose was to discuss an Arts Council bursary towards the preparation of a performance, Robertson suggested that the drawings themselves should be shown. McLean remembers the moment as a turning point in his career: 'It was a real response from somebody. I thought why not do what I can do, but do it as best as I can and enjoy it and have a bit of fun with it and hope that maybe somebody else can get a bit of that energy and fun out of it.'

I use the medium because of a relaxed attitude to the work/ activity/action that it affords me and who can afford them? Paper, wax crayon paint tossed on and used as a large visual notebook, no pressure just total flashness in the approach, complete avoidance of the neo-knicky knackys although recently I have been accused of using the post ponderous Caroesque crimble crumbles line rub line rub line rub struggle, affected strugglist techniques struggle struggle towards perfection attitude.

. . . the reason to draw the playing of games *vis à vis* the relationship with, to the art scene/ seen, the control, the shifting relationship to known or unknown activities the switch the playing of games the role changes, pulling out a few aces, moving, shifting the energy the attitude on, is all the reason to do it.

65. From *Drawing*. Aspects 16. 1981

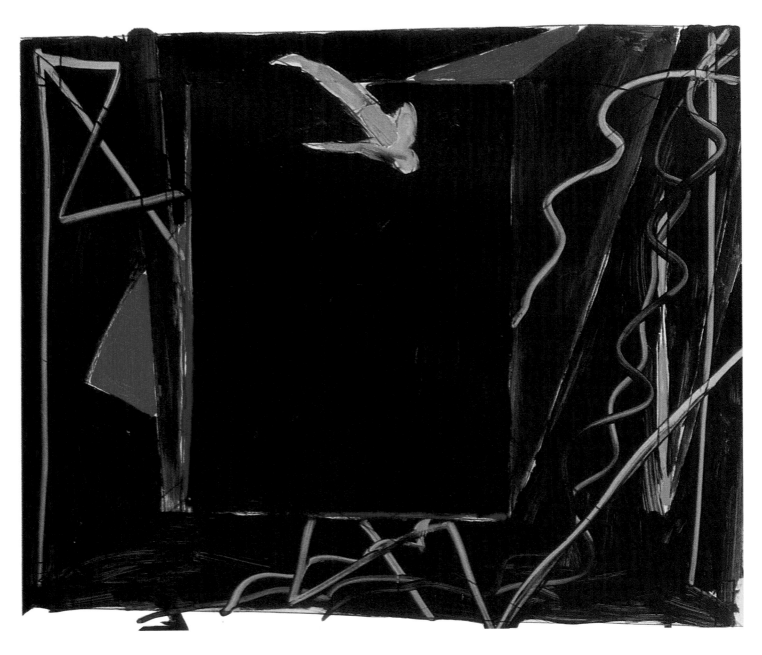

66. *The Masterwork*. Drawing for projected performance. 1978. Acrylic on photopaper, 54″×63″ (137×160 cm). Private Collection, Switzerland

The first significant showings of McLean's drawings were at the Hayward Annual in the summer of 1979 in a section generally designated as 'mixed media performance', and at Barry Barker's gallery in Great Russell Street at the same time. All of the Hayward drawings related directly to two performance works: *The Object of the Exercise*, already mentioned, and *The Masterwork/Award Winning Fishknife*, which had been under construction on and off since 1975. A revised version of *Sorry* was presented during the exhibition, and the interview conducted by William Furlong for the catalogue largely concentrated on McLean's activities as a maker of performances. It was clear where he was seen to belong at that moment. This was not surprising: 1979 was a year of extraordinarily energetic activity, even for McLean. *The Masterwork* was in the offing; at the Hansard Gallery, Southampton, and then at **Ink**, in Zurich, he had made installation works around the text

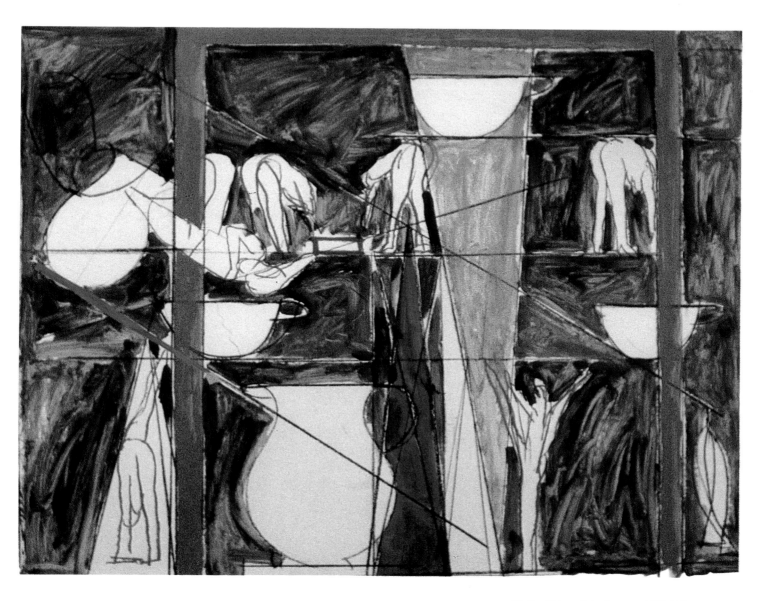

67. *The Object of the Exercise.* 1978. Whereabouts unknown

SYNOPSIS

The Architect has completed the Masterwork of the century. The work begins with the ceremonial unveiling of the piece. The Architect has built and conceived of the piece through his own very personal and highly structured work processes, 'the hard-edge principle'. All components are of the accepted standard, and all existing components conform to European Council Specifications (absurd). The Architect believes that the Masterwork will survive as a great work because of the limitations that he is imposing on it. This is the definitive work in mediocrity. Using mediocre parts he believes that he can (because of his personal style and wit) build 'the building model', a work of great beauty that will be a dictate for civilisation. He has limited knowledge and experience due to his standard institutionalised education. However, he is aware to some extent, of the 'needs' of the community and, of course, he designs with the use of computerised information. The work is built from computerised information. Having completed the Masterwork for the individual 'needs' of the community, it is unveiled. The Architect can then move through four positions, four elevations, that reveal the unbelievable magnificence of the work. As a Masterwork it is totally dependent on the Architect's view of himself being totally integrated in the building. No distance exists between Architect, building and the ultimate political, social, historical architectural statement. All these factors are built into the concept and actual structure and operation of the building. The work has immediate international recognition and the Architect has his age lowered to 23, the highest award for creativity. The work is unveiled in four sections. The four sections are the four viewpoints that the Masterwork operates within, front elevation and end elevation, plan view and perspective view. The Architect has four major positions within his structure. His positioning in these four strategic positions acts as a catalyst to the structure, he moves through these four positions in all elevations, each elevation contains his view of the relative relationships between the building, himself, occupants and observers, audience (which level, social/intellectual/physical he is viewed/heard on).

68. *The Masterwork Synopsis.* 1979

A Teacup, a Jug,
a piece of Floor
a Certain Smile
a New Front Door

and he had made performances in Paris, Vienna and Venice, and at the Royal College of Art in London. At Barry Barker's, *A lapel, a thought, a scone* presented an ensemble of objects and ideas linking conformist conventions of sartorial style with the ubiquitous teacup (poised on top of a pole) and the quintessential symbol of Scottish teatime *politesse*: a mis-en-scène familiar from the drawings.

The drawings in that show, like those 'towards' *The Object of the Exercise* and those related to *A Certain Smile*, reflected McLean's obsessions with the rituals and paraphernalia of domestic life as elements of a 'lifestyle' designed to impress others. In these drawings we witness the beginnings of the familiar McLeanian visual universe in which figures, faces and common objects are magnified and configured in enigmatic relations in ambiguous space. The teacup, the jug, the vase, the ashtray, the alarm clock, the right magazine: these are the banal components of 'the ultimate lifestyle situation, one of both visual and physical balance/harmony'. The central figure in *The Object of the Exercise* was the Hostess, who 'has spent years attending classes, getting her visual and physical balance/poise perfected. Her whole life is one of perfect posture, poise, pose, for the camera of House and Gardens . . . (she) has also been to object and people arranging classes. . . .' The figures caught in the drawings in the ludicrous postures of keep-fit callisthenics, bending, stretching and jumping, are neurotically engaged in physical exercises and feats of behavioural balance whose object is to perfect their fitness for social performance in the domestic setting. In the drawings this setting is transformed into theatrical space, complete with spotlit stage apparatus and ramps, and the props are magnified for satirical emphasis.

McLean had begun work with Paul Richards on the visual and verbal scenario for *Masterwork* as early as 1975. Together they made a huge number of systematic diagram drawings that scored the entire performance in detail, working out relations of light, space and objects. (McLean, who was never happy with the actual performances of the work, put on at Riverside Studios over six nights in November 1979, said in 1981: 'I actually think the score is the work.') In 1978–79 McLean also made a number of free drawings in acrylic on photopaper that imaginatively developed aspects of the visual scenario of *Masterwork*. These, like those on domestic themes just described, often carry verbal cues, clues and captions, a carry-over from notational drawing that McLean was to exploit with unique effect in much of his work from this time on. The verbal embellishments, frequently aggregated to create a title, often read like gnomic poems, exploiting word-play, puns, homonyms and catchphrases: *the ambition, the lies, the rock, the model, the light* (1979); *The Ties, the Post, the Pillar, the Looks* (1980); *Going for Grey* (1980); *Rock to Rock, Cheek to Cheek* (1980). They have the effect, of course, of intensifying our sense of the drawings as being more than pictures, and as having the character of dramatic events, dynamic confrontations and actions; they add explication and commentary to the business depicted.

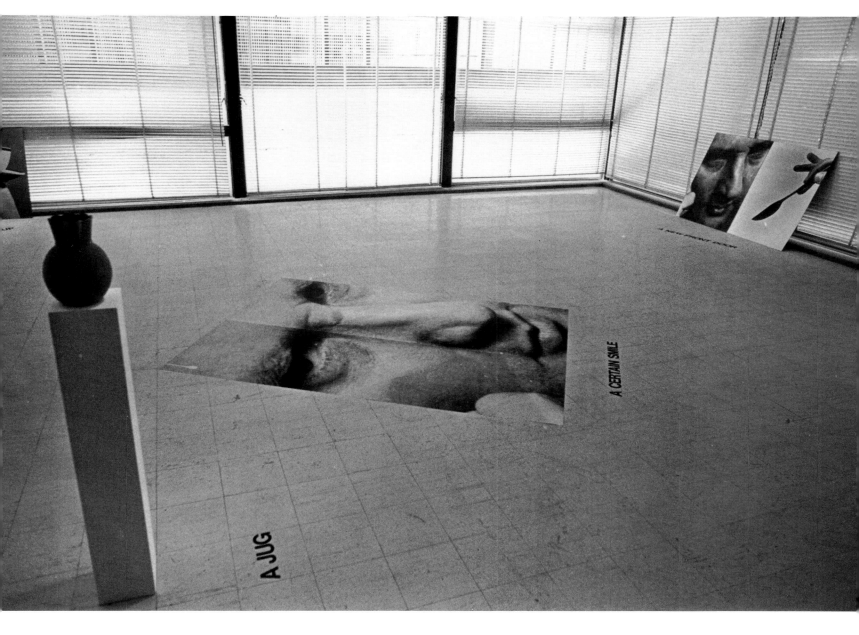

A JUG

A CERTAIN SMILE

69. *A Certain Smile*.
Installation University of Southampton Gallery.
1979

The business in *Masterwork* is that of the Architect, the principal figure in the piece, whose creation gives it that part of its title. The central metaphor, the masterwork itself, is a building, the 'definitive work in mediocrity', a monstrous projection of the limited personality and institutional ideology of its architect-designer himself, whose greatest previous triumph was an award-winning fish-knife, a true indication of his petty-bourgeois consciousness. The building is an image not only of a debased and disgraced modern architecture but also of the social institutions of late capitalist civilization in general and, by extension, of any society in which the arrogance of the mediocracy is encoded in bureaucratic formulae and manifested in social engineering/architecture for conformity. 'Using mediocre parts, he believes that he can (because of his personal style and wit)

70. *The Object of the Exercise.* 1978.
Acrylic on photopaper, 54"×66" (137×168 cm).
Whereabouts unknown

71. *Study towards The Masterwork.* 1979.
Acrylic on photopaper, 54"×69" (137×175 cm).
The artist

72. *Study for Soundtrack towards The Masterwork.* 1979
Acrylic on photopaper, 54"×66" (137×168cm).
Private Collection, Switzerland

build "the building model", a work of great beauty that will be a dictate for civilisation.'

The title of the protagonist, the title of his creation and the language of the synopsis leave no doubt as to the political anger that informed the piece: *The Masterwork* is a sustained *tour de force* of disgust at the moral pettiness and political vanity that lay behind so much of the planning and rebuilding of post-war, post-Fascist Europe and which destroyed the decent optimism of the generation that had defeated Hitler. It is not merely the depressing debasement of the Modernist ideals of architecture that is under attack; it is the cynicism that lies behind it, a betrayal of hopes at once ideological, social and political.

The Architect 'has limited knowledge and experience due to his standard institutionalized education. However he is aware, to some extent, of the "needs" of the community, and, of course, he designs with the use of computerized information.' Of course. The placing of the Architect's background limitations, the finely judged ironies of that 'to some extent', the parodic accuracy of the language, the sinister implications, ideological and otherwise, of the use in social planning of 'computerised information': we are presented here with an appallingly comic demonstration of the 'banality of evil'. 'No distance exists between Architect, building and the ultimate political, social, historical, architectural statement. All these factors are built into the concept and actual structure and operation of the building. The work has immediate international recognition. . . .'

This triumph of the dull will of the Architect is a function of the failure of moral and political intelligence in those around him. There is The Woman With Three of Everything, who represents the self-regarding middle class, whose obsessions with poise, pose and possessions leads to a snobbish intellectual and emotional vacancy: 'In a way we have accepted architecture as a new technology. We have to be fit. Intellectually and physically. . . . Like everything else skiing has got so much more expensive this year. I feel at last I'm developing a real relationship with the *au pair*. By the way, can I have my book on paralinguistics back? Quite frankly I have quite a lot of sympathy with the miners. Oh yes, we've gone completely solar with our energy. . . .' There is the Thin Performer, average and uncomplaining, whose 'personal proportions, weight, height, frame, attitude, mode of behaviour, have been computer programmed to determine the structure of the Masterwork, masterform, and who is ready to accept every constraint that is laid upon him.' There is the Fat Performer, whose shape and size are disproportionate to the computer norm that has provided the programme for the structure's dimensions and physical constraints: 'Twenty years it's reputedly taken to construct (with the aid of all the "wonders" of modern science) this "MONUMENT" to mankind, and the only people who feel at ease within the space/s are 8–9½ stone.' The Fat Performer is a complainer whose litany of moans is a substitute for political action and resistance: 'This pedestrian, mediocre space is making me, if anything, fatter. . . . Of course I bloody well wasn't consulted. . . . We are surrounded by bloody administrators/designers-cum-planners, "thinkers", and we end up with a bloody cube divided in four sets of four sets of four ad infi-bloody-nitum.'

The speech of the Architect, pre-recorded on tape, is an absurd thesaurus, an outpouring of lexically contradictory utterance that functions as a smokescreen

Nothing outside the rules. Liberty through conformity. We have seen the architecture of the world change in a way of which we were part. I can never fly over a great city or look out of a high window without seeing buildings that I feel part of. I was part of a form that swept the world as perhaps only Michaelangelo succeeded in doing before. His works now face us with haunting questions about him and his architecture. Wright never did this.

73. From *The Masterwork Score*. 1975

for his aesthetic and ethical vacuity. It is a linguistic inventory whose absolute inclusiveness is a device to occlude meaning, to destroy sense. The architect himself makes occasional live interpolations in direct speech that add up to a series of statements of intent and justification, hidden in the flood of synonyms and antonyms. These include, among other things, the true programme of the Masterwork: 'It was . . . my . . . ambition . . . to . . . build a . . . monument . . . to standardization, a celebration of mediocracy . . . a masterwork that . . . could both . . . arrest the development . . . of ideas . . . and set . . . a precedent . . . for all . . . future . . . existence.'

There is a humane irony, essentially anti-ideological in its implications, at the heart of *The Masterwork*. As the piece develops, the unimaginative ordinariness of the Performers proves obdurately inconvenient to the plans and projections predicated upon conformity to the 'masterform'. The insistence upon triple acquisition of the Woman with Three of Everything throws out the 'architectural predictions of the computer', upsetting the balance the Architect craves; the Fat Performer, at the outset not properly fitted within the structure, remains incompatible with its physical limitations: 'The lighting on this particular level is completely inadequate for some of the moves I have been training for.' Even the Thin Performer, adapting to those around him, conforming with his neighbours, begins to adopt their positions: 'People should be allowed to have three homes.' That the worm has turned, however slightly, can be heard in his final words: 'It is essential to retain an institutionalized stability on one hand, while on the other quite clearly defining the patterns of individuality.'

The verbal score of *The Masterwork* has a remarkable density, and it was inevitable that much of it parodic and ironic punch would be lost in performance, where it was enveloped in an over-complex visual spectacle and overlaid by a perpetual insistently minimal musical accompaniment, created and performed by Michael Nyman. Acrobats, jugglers and dancers moved continuously through the action, events were staged at various levels, and the performers were lifted from one to another by a fork-lift truck. The backdrop was a photograph of the Architect's shadow thrown on to the grey shuttered concrete of the Hayward Gallery walls. It was a work of enormous ambition, McLean's first attempt at a collaborative *gesamtkunstwerk*, a 'performance sculpture' created against the odds by the indefatigable joint will and energy of its two authors. It was not surprising that its multiple elements failed to fuse into a perfect unity, that certain aspects of the work lost clarity of definition, and that its meanings were to an extent obscured. The *text*, as yet unpublished, survives, and is itself an extraordinarily original document, combining visual and verbal elements in what is a uniquely original work in itself.

His work on *The Masterwork* and the related drawings was of crucial importance to McLean's development as an artist. It was concerned with many of his deepest preoccupations, especially those to do with the central importance of architecture to a civilized life. It is that which determines the nature of the spaces people inhabit, and *therefore* shapes their behaviour. The buildings, rooms and spaces that are made for domestic life, entertainment, eating and drinking, studying and working clearly indicate the attitudes of those responsible for their design and provision to those who must use them. Architecture and design are profoundly

I predict a revival of Gothic architecture. I see a future for de-architecturalisation. I predict a decrease in low level hover housing. The future of architecture without walls looks bleak. I predict the disappearance architecturally of the space between spaces. There will be new attitudes towards carport design.

The masterwork has been described as the first and last most beautiful constraint in Europe. The Masterwork stands above all other 'masterworks' in its total celebration of Mediocrity. We are able to see within its computerized units the actual physical proportions of the Architect. The ground level with its distinctive mixture of dramatic shadow and monastic restraint was the scene of the now famous architect's somersaulting entrance. The whole centre portion of the structure is circled by the memory of the new movement.

74. *From The Masterwork Score.* 1975

75. *Study towards The Masterwork.* 1979.
Acrylic on photopaper, 54″×63″ (137×160 cm).
The artist

expressive of a political culture. Conversely modifications to places by those who live, work and play in them will indicate something of their spiritual and political condition. Within a constantly changing environment, and continuously affected by it, human reality is defined by a dynamic dialectic of personal and social factors, manifested in patterns of personal, social and political behaviour. We trace its workings in spatial positioning, dress, attitudes to utensils, looks and gestures, good manners or physical violence. Making and putting on *The Masterwork* sharpened McLean's awareness that art is part of that dialectic, *a kind of behaviour within that complex reality*. The social acts of collaboration and performance were one way of doing things; the personal activities of drawing and painting were another. From now on both would be part of his project.

76. *A Certain Smile.* 1978. Acrylic on photopaper,
45″×55″ (115×140 cm). Arnolfini Collection Trust,
Bristol

77. *The Masterwork/Award Winning Fishknife*
at Riverside Studios, November, 1979.
Photographer: Dirk Buwalda

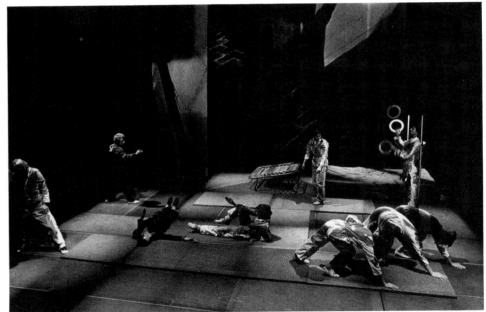

From *The Masterwork score.* 1975

I feel sure that Margaret will become Prime
Minister. I predict a decrease in our demo-
cracy. I foresee a rise in school meals. I can tell
you that there will be no revival for concept
art. I predict a new french wine. American
football is going to be bigger than German.
Organised religion will become more Politi-
cal Vote Christian. I believe that gravity will
become a memory. Movement is rapidly
becoming transistorised. I predict almost
assisted breathing on this Planet Earth. All art
will be patronised by the Church.

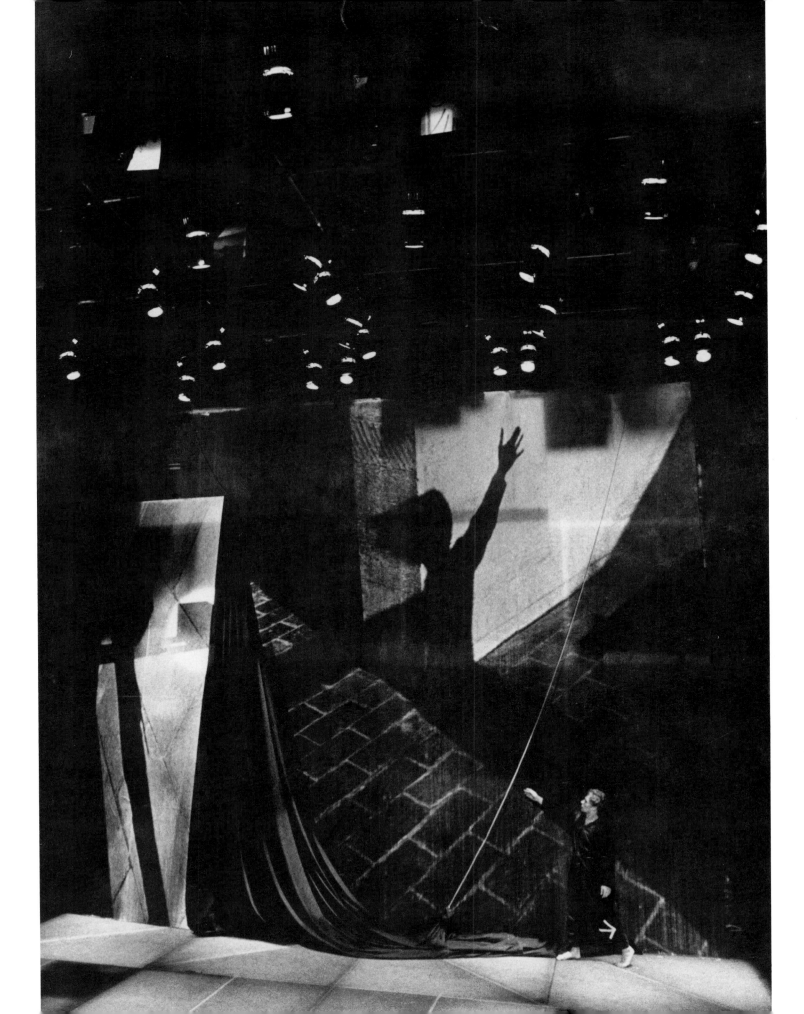

The Passionate Spectator:

The Painter of Modern Life

'. . . for the passionate spectator, it is an immense joy to set up house in the heart of the multitude, in amid the ebb and flow of movement, in the midst of the fugitive and the infinite.'

Baudelaire

'It was cold the first time I came to his studio. Really cold in London. To call it a studio is an exaggeration. It was more like a run-down hovel with a few crummy little rooms. Scattered around on the floor were some rather rough works painted on photographic paper. They were a mess, piled on top of each other so you couldn't see one thing clearly.

What should we do to view them? Stick them up on the wall one at a time? It was just too damned cold to do that. Without thinking about it I started to pull out a few from the pile at random. But there was so little space I soon gave it up . . .'

ANYONE who visited McLean in one or other of the derelict properties in Mortlake or Barnes that he was able to use as temporary studios in the period between 1978 and 1982, or found him in the tall but tiny double-cubicle that he occupied at Riverside Studios for a while in 1980, will recognize the accuracy of Jean-Christophe Ammann's description of the settings within which he worked during that time. With an absolute indifference to personal discomfort, whatever the time of year, in the most primitively served, unheated, cramped and poorly lit spaces, he worked in bursts of demonic energy on 'drawings' that became progressively more brilliant in colour and rich in handling, progressively freer of direct reference to actual performances or installations.

All of these works were executed in acrylic and wax crayon on McLean's favoured support at that time, white photographic paper, which he acquired free in large roll-ends, and used in enormous quantities, tearing off strips to whatever dimensions he wanted at any given moment. Its easy expendability allowed for a completely 'relaxed attitude' and as much experimentation and wastage as he wanted ('free paper free attitude nonpermanent . . . complete absence of the neo-knicky knackys . . .'); McLean's attitude to materials, always utterly free of any preciosity, is best characterized perhaps as a sort of easy familiarity or creative complicity. A session of work would frequently end with the tearing up of dozens of drawings that did not meet his satisfaction. Photopaper has several advantages for McLean's mode of working: it facilitates speed of execution, taking the paint quickly and directly on to the surface and registering gesture with great immediacy; its shiny impenetrability gives back the true colour of the acrylic without modulation; and its surface resistance is ideal for the sharply drawn

79. *Pillar to Pillar Post to Post.* 1980.
Acrylic on photopaper. 54"×61" (137×155 cm).
Private collection

78. OPPOSITE: *Yucca Gloriosa* (Yellow). 1980.
Acrylic and oil pastel on photopaper,
67"×54" (170×137 cm).
The artist

linearities of *sgraffitto*, a graphic device that McLean has used persistently with great skill.

The drawings of 1978 and '79 are characterized by a schematic division of surface area and by pictorial elements that emphasize the theatricality of the setting for the behaviour of the figures; within an implied interior space – circus, gymnasium, split-level stage – beams of light pick up performers engaged in various actions on acrobatic equipment, see-saw and balancing apparatus. The audience for these ludicrous antics is more often than not represented by a giant tea-cup face that benignly looks on, its minimal features permanently fixed in that certain smile of recognition and complicity. This conflation of the quizzical face – half ironical, half approving – of the spectator of domestic stylistics with the vessel that features at the heart of the ceremonies of middle-class politeness is one of McLean's most brilliant comic inventions. It is a satiric device whose visual aptness and conceptual economy McLean has continued to exploit in innumerable variations and extensions.

Drawings from this period, related to *a certain smile* and *The Masterwork*, were exhibited by McLean at InK (Hall für Internationale neue Kunst) in Zurich from September to November of 1979. This was a second appearance at the gallery in that year, and was an important marker of McLean's rapid entry into the international critical context as a graphic artist, albeit of a special kind. InK was a remarkable progressive gallery, directed by Urs Raussmuller, which from the late '70s through to its closure in 1981 presented an impressive cycle of exhibitions by first-ranking European and American artists. Beuys, Polke, Richter, Baselitz, Penck, Kounnelis, Merz, Nauman, Ryman, Mangold, Sol LeWitt, Weiner, Long, Charlton: the list goes on, and reads like a roll-call of the international *avant-garde* at the beginning of the 1980s.

At an historical moment when painting was poised to enjoy a frenetic revival InK's programme and its accompanying documentation, which included photographs of the actual exhibitions and critical essays directly related to the works shown, demonstrated a principled commitment to an art of ideas and actions. What is more, it indicated that the art that had developed out of Minimalism, Conceptualism, and the Performance project of the late '60s and the '70s was alive and kicking. In August, some weeks before his drawings exhibition, McLean had made an installation of objects and photographs as part of a group show, organized by InK in cooperation with Konrad Fischer, which was intended to make you laugh as well as think. Its title, *with a certain smile*, translated from the English into four other languages, was derived from his contribution.

In the following spring McLean made a show entitled *New Works and Performances/ Actions Positions*, organized by the Third Eye Centre in Glasgow. It opened in April at the Fruit Market Gallery in Edinburgh and moved on to Glasgow in May. This was, remarkably, McLean's first exhibition in Scotland, seventeen years after leaving his native city. (In the publication that accompanied it David Brown remarked that at the time of writing not a single private collector or public collection in Scotland had bought a work by him.) The show included a multiple object piece called *the stump, the wedge, the frying pan, the bananas* which signalled a number of new motif preoccupations, one of which, *the wedge*, was to be of central importance in much

of McLean's later work (in one of its most persistent manifestations, the piece of Brie, it was to become especially associated with him). *The stump* that interested McLean was the stylised support for classical nude statues of Aphrodite or of athletes. This device, so common a component of classical statuary that we may overlook its absurdity, is as much a convention as the plinth. Drawings in the show included several featuring the image of the discus thrower, associated by McLean with both stump as support and bananas as (boomerang-like) discus or the thrower's hand. Free association of this kind is essential to McLean's imaginative operations, leading him by chance and intuition to realize new and unexpected relations between things, new ways of exploring them.

At some point in early 1980 McLean made such a decisive shift and it was to have incalculably important implications for his development as a painter. The discus drawings may have triggered this move, picking up and developing the idea of physical exercise and elaborate posturing and bringing into imaginative play a whole range of new associations to do with sport, sculpture and open air athletic performance. As we shall see, he continued throughout the period up to his removal to Berlin in early 1982 to maintain a conception of drawing as a projective activity linked to his performance work, an activity, nevertheless, out of which original works, pictorial performances in their own right, might emerge. But during that year he embarked upon a series of drawings in which he can be seen to have radically extended his scope as an image maker and widened the field of his observations, visually, satirically, and morally.

What McLean did in these new pictures was to move outside the metaphorical circus tent and the theatre to picture the world at large, no longer reduced to the image of the staged performance. These works still trace those constraining patterns of behaviour that are manifested in terms of dress, movement, position-ing, posture and gesture and through signifying objects and activities, but the field of action is now not so much theatrical and symbolic as social and factual. The familiar schematic linearities, indicating movement, direction or connection, are freer and more fanciful, looping and zigzagging across the picture area, no longer notations for a directed performance so much as satirically exaggerated descrip-tions of actual movement in the real world. And in some works they are dispensed with altogether.

In these new-style drawings of 1980 McLean's passion for colour is at last given full play. In the *Yucca Gloriosa* paintings the holiday-makers at play in Mediterranean settings disport themselves against hot grounds of bright yellow, purple red, turqoise green and blue laid on scarlet; the swimming pools are brilliant luminous blues, the yuccas and palms a deep emerald green. In *Swimming Pool with Trellis* divers and swimmers, striving for the desirable tone of deep tan – 'going for brown' – are caught on their way through lobster red against the pure blue of the water. The use of colour in these works is exuberantly audacious and extravagant: contrasting and complementary brilliancies, what Matisse referred to as the 'pleasurable harmonies and dissonances of colour', rich layerings and subtle gradations combine to build up sensuous intensities of a kind virtually unknown in English painting.

But then McLean is not English: among other things behind this gloriously

80. *Swimming Pool with Trellis.*
1980. Acrylic on photopaper,
63″×54″ (160×137 cm). Private collection

81. OPPOSITE:
The Ties, the Post, the Pillar, the Looks. 1980.
Acrylic on photopaper, 65″×54″ (165×137 cm).
Private collection

unabashed colourism is his early experience of the Scottish painters his father admired and whose works in reproduction he studied at home even before he encountered them in reality in Glasgow galleries. McLean was familiar from childhood with his father's books on Cadell, Peploe and Hunter, the so-called Scottish colourists, who had assimilated without the academic inhibitions of their English contemporaries the lessons of post-Impressionism and Matisse. (The Tate Gallery has nothing by Cadell, and one painting each by Hunter and Peploe, rarely if ever displayed.) More important to him was the unmediated experience of the work of Matisse himself: McLean's admiration and love for Matisse is without qualification, and few artists have learnt so directly and unselfconsciously from the Master. There is nothing ironical in this relationship, and nothing by way of art-historical reflection or *pastiche*; McLean's debt is direct, and directly acknowledged: 'If things happen to look like Matisse I think that's just because I like Matisse. They are not references to Matisse.'

Colour was crucial in freeing McLean from the restrictions of notation for imagined performance, a means by which space and atmosphere could be created in two dimensions and the convulsions of social behaviour depicted without irrelevant recourse to perspective and modelling. In other words these works were conceived as another way of dealing with familiar ideas and themes; they were the outcome of that persistent, restless tendency of McLean's to set up a different creative situation, to stimulate new insights into constant preoccupations. *Affective* colour, with its capacity to associate vibrant sensations directly with inner feeling; *descriptive* colour, with its immediate reference to light and objects in the visible world; and *symbolic* colour, with its political and social significations, could be exploited simultaneously, giving pleasure, evoking feeling and provoking thought in the same complex moment. Colour freed in this way to fulfil multiple and mutually exclusive purposes, with now one emphasized, now another, and with no limiting programme, is one of the great legacies of Matisse. McLean has exploited it with a virtuosity and *panache* that are nothing short of astonishing.

82. *Going for Grey.* 1980. Acrylic on photopaper, 72″×96″ (183×244 cm). Whereabouts unknown

The pictures of this period are as remarkable for the vitality of their handling as for the brilliance of their colour. The paint is brushed on with great speed and vigour, pushed and pulled across the surface, colour layered over colour, applied overall with an expressive gestural *élan*. McLean's address to these works was deliberately and uninhibitedly free-wheeling and quick: 'Paper, wax crayon paint tossed on and used as a large visual notebook, no pressure just total flashness in the approach . . .' The point was to catch ideas on the wing, to match the frenetic dash of modern recreational life with a manner appropriate to its haste, analogous to its hectic business. Frequently scored by a criss-crossing trellis work of lines inscribed by the pointed end of the brush, or with lines and patches scraped back to the surface of the paper, or to the layer of colour underneath, the effect is of agitated atmospherics enveloping lunatic activity. The idea that these works are pages, as it were, from a continuous notebook suggests that their status for McLean was provisional and exploratory. That sketchbook pages have an intrinsic interest, transcending their immediate purposes, however informal, is understood.

All this colour and action in the handling served directly the thematic purposes of the works. In McLean's words at the time: 'Everything is action, action, nothing is looked into. Rushing from Pillar to Pillar and Post to Post, sort of sums up the concerns. The work is generally about human behaviour.' And the manner of the working had an affective purpose also, implying a theatre of physical relations and responses between spectator and pictures: 'What I'm now attempting in the newer, larger drawings is to physically activate the spectator, to move the viewer from picture to picture: never here, check there! . . . The people (performers) in the drawings or the performances are too busy adjusting their moves, their postures, positioning themselves in relation to the other performers. . . . Thus constantly changing "positions", some of the newer, larger works are also an attempt to physically move the viewer.'

These drawings were shown for the first time at InK in November/December 1980. During the exhibition McLean made a performance that drew for some of its material on a work, presented at Riverside Studios in the previous September, entitled *Possibly a Nude by a Coal Bunker*. Taken together with the related drawings these performances provide important clues to the iconography of the paintings of that period and also to McLean's associational method. The idea behind the original performance was a somewhat obscure connection in McLean's mind between *the stump* and a view he holds that Scotland is obsessed with coal bunkers. It is a complex of ideas of which his grandfather would have been proud. 'I was thinking of those beautiful classical nude figures which are always attached to a tree stump, never attached to anything like a wheel-barrow, so I thought why not attach it to a coal scuttle, well this became a coal bunker.' By a just-discernible train of associations, carrying traces of previous obsessions, McLean moves from the image of posing nude (static, sculptural and classical), to Greece and the Mediterranean (classical ruins, metonymic pillars/sun and sea), reduced to a playground (Yucca/trellis/swimming pool) for hedonistic and self-absorbed holidaymakers, rushing 'from pillar to post' in attention-seeking parodies of (ancient) Greek athletics.

The *coal bunker* drawings were done in sequences (one of which was acquired by

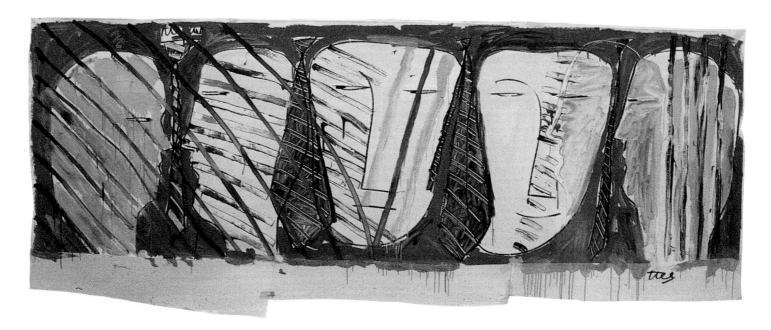

84. *Ties.* 1980. Acrylic on photopaper,
55″×122″ (140×310cm).
Mr and Mrs Martin Sanders, The Netherlands

the Tate Gallery in 1982), and were made at Riverside Studios during the day and night before the performance there. On a coal black ground in arabesques and zigzags described with gestural flourish McLean depicts frenetic figures, picked out in luminous colours – lilacs, mauves, brilliant blues and minty greens. The sequencing suggests time rushing by, as between the frames of a film, and the day-by-day perpetual motion of those caught up in the frantic ballet of modern life, their exertions a fearful response to *horror vacui*, or to a competitive urge quite distinct from that of the ludic classical *games* they imitate. They are watched impassively by two seated figures, derived directly from Moore's majestic *King and Queen*, who represent a calm repose. A clue to their significance is to be found in *Two Ties*, in which their marriage 'tie' (a contract freely entered into, a tie of love) is opposed to the halter-like neckties which are the symbols of social links (ties of social class, school ties in both senses), and to formal professional ties (being 'tied to the job'/being 'tied down'). This use of an art reference as a marker, a way of invoking affirmative values embodied in works of art in ironic contrast to the vagaries of the unconsidered life, is a constant habit of McLean's.

'The absurd "minimal" human behaviour patterns excite me: the scrabbling, the greed, the concerns, the attitudes, the hope, the suit, the dress, the choice for . . .' McLean's performance at InK consisted of the artist determinedly striding with pointless urgency from one marked point in the room to another, along predetermined lines, past slide-projected images of classical columns and of the still, calmly beautiful and unaffected nude by a coal-scuttle/stump, anxiously consulting his watch, gesturing and pointing with great deliberation in a context of teletaped babble, with no logical sequence of image or word. Comic and absurd, he presents himself as simultaneously the observer and the observed, caught in the modern welter.

Unlike many drawings McLean made during this extraordinarily intense and productive period, the *coal bunker* series were closely related to specific perform-ances. But the connections were thematic rather than projective: the space in them is conceived as an arena for imaginary actions, a site for behaviour. The field

83. OPPOSITE: *Two Ties.* 1980.
Acrylic on photopaper,
108″×54″ (274×137cm). Private collection

of action in the new and freer pictures is, of course, *la scène de la vie moderne*: with these works McLean became essentially the painter of modern life. 'I have remarked,' said Baudelaire, 'that every age has its own gait, glance and gesture.' In these spectacular drawings, at once forceful and *insouciant*, and even more so perhaps in the sensational large-scale paintings that he later made in Berlin, it was indeed the gait, glance and gesture of our time in our places that he delineated in an ironically *bravura* performance.

Michel de Certeau has written, in a profoundly Baudelairean passage, of the semiotics of behaviour in the modern city and of our experience of its places and spaces: 'Like words, places are articulated by a thousand usages. They are thus transformed into "variations" – not verbal or musical, but spatial – of a question that is the mute *motif* of the interweavings of places and gestures: *where to live?* These dances of bodies haunted by the desire to live somewhere tell interminable stories of the Utopia we construct in the sites through which we pass. They form a rhetoric of space. They are "steps" (dance figures), glances (composing mobile geographies), intervals (practices of distinction), criss-crossings of solitary itineraries, insular embraces. These gesturations are our everyday legends.' McLean, with the wit and indifference to banality of the dandy, fascinated as such by the minutiae of fashion and the nuances of pose, saw in the most ordinary encounters of striped-tie-wearing eaters of after-dinner cheese something of

85. Preparing for *Possibly a Nude by a Coal Bunker* at Riverside Studios, London, September 1979

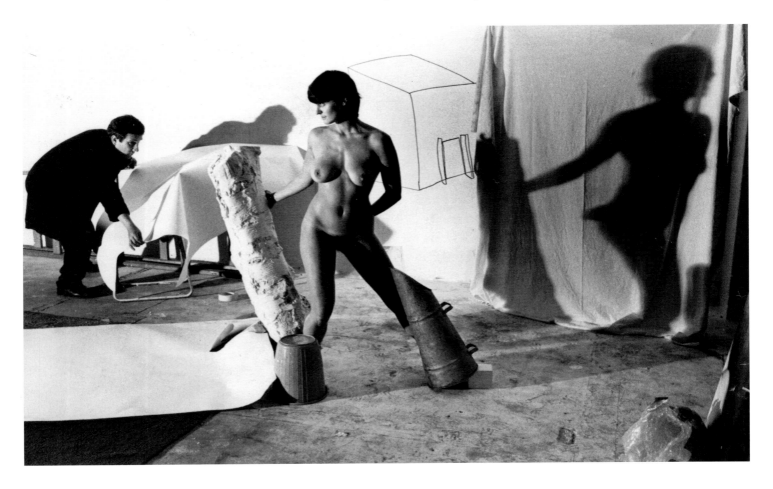

Baudelaire's 'modern beauty and heroism': 'The life of our city is rich in poetic and marvellous subjects. We are enveloped and steeped as though in an atmosphere of the marvellous; but we do not notice it.' McLean, like Baudelaire's hero Contantin Guys, 'began by being an observer of life, and has only later set himself the task of acquiring the means to expressing it.' In recording, even to some extent codifying, de Certeau's 'everyday legends' he is both faithful to the impressions of the 'fantastic reality' received and pays a 'flattering compliment to truth'. Baudelaire's classic essay on Guys is, even to details of technique and style, remarkably apposite to his case.

Word play, directly as an element of the picture or indirectly in titles (as in *Two Ties*), has continued to be a characteristic device of McLean's. The texts of his that form part of this book give evidence enough of his vigorously idiosyncratic approach to the language. The generously careless dislocations of syntax, the absurdities, nonsenses and repetitions serve a purpose for himself and for his reader: to discover meanings and truths that might remain hidden in formality and correctness. Language is a form of behaviour, and deliberately shifting out of its normal modes by the use of distortions, repetitions, rhythmic incantation, nonsensical intercalations and so on is universally recognized as a means to revelation and surprise. The strong presence of the word and text in so much of McLean's work, incorporated in it or at a tangent to it, signifies his fundamental

86. *Possibly a Nude by a Coal Bunker* at Riverside Studios, London, September 1979

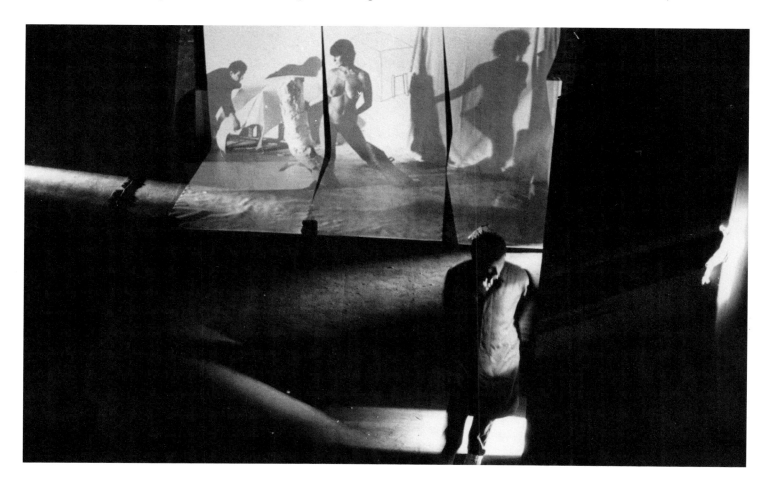

87. *Studies towards Possibly a Nude by a Coal Bunker.* 1980.
Acrylic on photopaper, each panel 112" × 54" (284 × 137 cm).
The artist

approach to art as a human activity that is essentially collaborative and social. This is not to say that his work in any medium is not governed by a powerfully directive visual and spatial aesthetic. At one point his ambition was to be a dancer, and he once said 'I've been interested in the idea of making beautiful things – although the subject matter, the spark that motivates a work may not be beautiful.' But it is to be emphasized that McLean is acutely interested in the environment within which the work is made, is concerned with the work as an interaction with it, a dynamic intervention of a kind that only art, with its ambiguities and indirections, its contradictory capacity for both critical irony and celebration, can make.

It is an emphasis that wants making, for McLean came to international prominence at the moment of the critical arrival of the so-called 'new painting'. Especially there was a dramatic revival of expressive figuration, with the middle-generation and younger German, Italian and British artists looking with renewed admiration and respect at the achievements of the great Northern Expressionist and Romantic painters and with a sense of liberation at the 'wild' later painting of Picasso, the deliberately 'crude' imagery of late Guston. McLean was one of a small handful of British painters selected for the highly influential 'A New Spirit in Painting' exhibition at the Royal Academy in January 1981, which had deliberately set out to present 'painting of intensive poetic force and piercing imagination' and to create a new critical context that acknowledged the vitality of painterly figuration and expressively personal abstraction. The purpose of Ammann's visits to his studio in the cold days of that January (inspired by a visit to the 1980 InK show) was to select work for McLean's exhibition at the Kunsthalle, Basel, in the early summer of that year. This was to be a major show, intended to travel to Rudi Fuch's Van Abbemuseum, Eindhoven, and to the Whitechapel, in London, at that time directed by Nicholas Serota. The conjunction of these events is indication enough of the exceptional interest McLean, *as a painter*, was exciting in international critical-curatorial circles at this time. In August he appeared in company with Beuys, Chia, Schnabel, Fetting and others in a mixed exhibition at Anthony d'Offay's new large gallery, which was rapidly establishing itself as a major international showplace; in November he opened his first one-man show there.

So McLean was quickly established as a painter in spite of himself: 'I don't think I'm a painter at all. I consider the things I'm doing as drawings. . . . I never set out to make a painting.' he said in 1981. He added later in the same interview: 'To do the paintings – we'll refer to them as paintings because it's easier – gives me a sense of freedom to be able to think about other things. I am always working on more than one thing at the same time.' It was a position he has steadfastly maintained. Referring to the Berlin paintings in 1985 he was to say, 'they weren't actually *painting*, they weren't dealing with problems that painters had been dealing with since the year dot.' So McLean was not committed to painting for itself. He approached the activity without preconceptions about the necessity for reinstating painting within 'a reassessment of traditional values'. It was for him, rather, part of a wider project, one way of looking at and thinking about things. As such it was an inevitable progression from what he had been doing before, and continuous with it: 'If you look at the work there is a very obvious development; the only way I could have possibly gone was into this area'.

Characteristically enough, before the end of 1981 McLean was experimenting with stone carving for the first time since his earliest years at art school. He was unhappy about repeating the Basel exhibition at the venues arranged. He was feeling unsettled, as if he had completed a cycle that had begun with his departure from Glasgow. He felt ambitious, as if he was at a new beginning, though the beginning of just what he couldn't predict: 'Now I've got to go off on another cycle. I want to make big works, whether its with architects or governments, there is something I have to do which hasn't been done yet.' He was clear about certain things: that he had a great deal to do and had the confidence and the ability to do it; that painting was indeed one of the many means by which new contexts for art could be created, contexts that would give his own work a different significance; that there were other ways also, having to do with collaboration, with finding or making spaces in which artists could work, and with the architecture of public space. At this moment of deeply felt potentiality McLean was invited to take up a DAAD fellowship in Berlin. A brilliant new cycle had indeed begun.

CHAPTER 7

In Berlin:

Good Work on Frankfurterstrasse

THE year 1982 was to be an *annus mirabilis* for McLean but it began unpromisingly. He made an inconsequential and jokey 'farewell' performance, *Sur le Plancher*, at Riverside, during which a large wedge of Brie was drawn by pulleys across the performance space, a scratch rock band of Croydon students played an interminable minimal riff, and McLean intoned with much gusto a comic litany whose significance was obscure to an indulgent art world audience – 'poncho poncho mucho macho mondo foodo limpo wristo . . .' In early February he left with his family for Berlin. The first floor flat at No. 1 Mariannenplatz was grand, with big beautiful rooms, and the studio provided, in the Kunstlerhaus next door, was like a gymnasium – at last a proper space for working. But the family felt at first alienated and unhappy; there were difficulties arranging schools and there was a language problem. Immediately behind the flat, within a few metres, was the lowering presence of the Wall. What had seemed like a good idea at a moment of high energy and expectant potential in London in December seemed less so in the smoky grey cold of a Berlin February. Beyond certain inconclusive ideas for performance McLean had no clear idea as to how he was going to use the time and space the Fellowship had made available. For the first time in his professional life he had no teaching commitments, a large studio, unlimited time. Momentarily daunted, he took a little time to take stock before making a conscious decision. He was in Berlin, everybody was painting. Why not take the 'obvious development' one step further? On his own terms he would make paintings.

McLean had not painted on canvas since his student days. The ready supply of free photopaper over several years had encouraged a free-wheeling attitude towards material that encouraged an immediacy and an energetic redundancy that a more expensive support material would have prohibited. In any case, as we have seen, McLean had not been interested in painting for itself but rather as a way of catching the fugitive absurdities and contrarieties of modern life; like performance it was a way of *enacting* a vision, of being at once the passionate subject and the ironic spectator. His attitudes and intentions were not about to change. With native resource, and with generous guidance from Berndt Koberling, the painter, McLean found to hand a ready supply of expendable canvas. Mariannenplatz is in Kreuzberg, a sprawling central district of Berlin, mostly working class, with a large Turkish population. To his delight he discovered he could buy canvas cheaply, in 150 metre rolls, from Turkish street traders. An abundance of unmixed acrylic medium and good cheap pigments were likewise available in local hardware shops, as were brushes in a variety unknown at home. McLean had formulated his

89. *Wunder Bar.* 1982. Acrylic on canvas, 72"×58" (185×149 cm). The artist

88. OPPOSITE: *Big Bratwurst* (detail). 1982. Acrylic and chalk on cotton. Two parts, each 79"×59" (200×150 cm). The artist

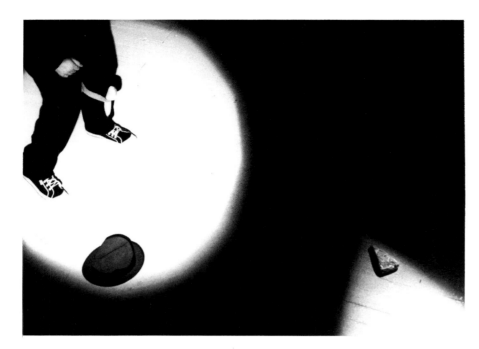

90. Studies from *Ballet Fromage: Une danse contemporaine*, Kunstlerhaus, Berlin, 1982. Photographer: P. J. Sohn

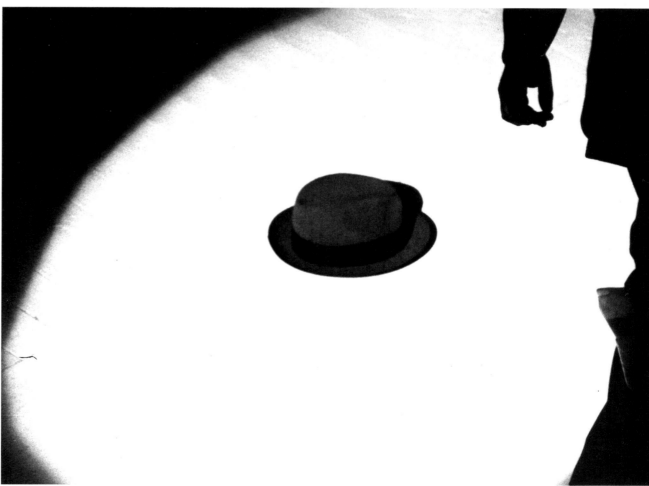

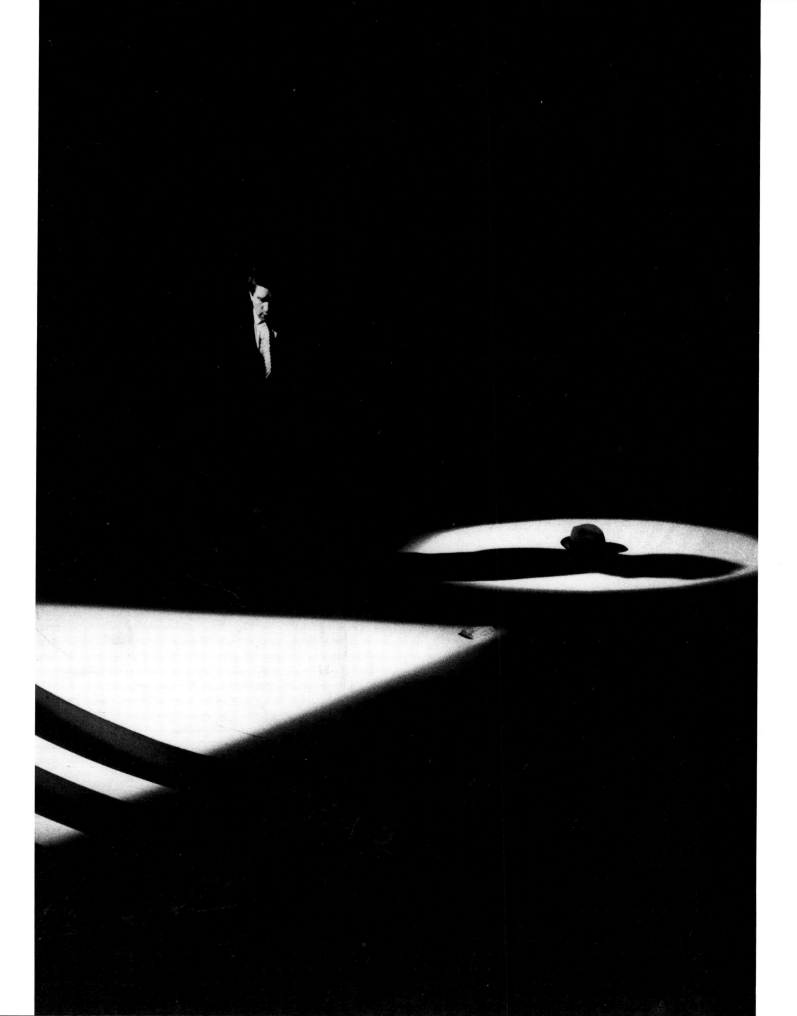

91. *Going for God.* 1982. Acrylic, crayon and charcoal on canvas, dimensions unknown. Private collection

intention, he had found his materials, and in West Berlin, in the artists' bars, the restaurants, the streets and the shops, he was about to discover a city 'rich in poetic and marvellous subjects'. He was beginning what was to be a spectacular creative adventure.

'I took my obsessions with me,' McLean says of his arrival in Berlin. The obsessions, with behaviour in public and domestic places, with the numerous devices by which people situate themselves in relation to others and with the problematic relations of art to life, were to be carried into new areas of experience as McLean found new subjects through which they would be explored. But first, as ever, it was necessary to encounter the convulsive subject. His work proper in Berlin began in the anger he felt in the canteen used by war veterans and others of the elderly poor who visited the Welfare departments that occupied part of the complex of old hospital buildings adjoining the Kunstlerhaus. Taking tea there himself, he observed them regimented daily into grotesquely jolly dances and party routines by a sadistic organizer of social events who insisted on the wearing of party hats. *Wunder Bar* is one of a handful of paintings that depict this pathetic spectacle, the grey misery of the scene intensified by the clownish hats, the flying forks and sausage and the toppling walking sticks. Prominently in view is the ruler, the symbolic device that measures the distance between those with power and those deprived of dignity.

'The obsessions I have carry my work through,' he said before he actually got to Berlin, 'That is why New Image painting has got little to do with my work at all.' Even so, when he began after the weeks of indecision to make paintings the violently expressive colour and vigorous figuration of the Berlin painters initially had some stylistic influence upon his work. The change of support had an immediate effect upon his practice: canvas takes acrylic into itself, and he was able to make a pictorial design from juxtaposed areas of brilliant colour, decorative and symbolic, and present the interaction of figures and objects, movements and positionings, in a variety of graphic modes. In these early Berlin works figures are often directly brushed on or reversed out in a line scraped through to a lower colour layer or simply drawn; faces are broadly painted with features drawn on in charcoal and crayon; objects like ladders, columns, stairs and schematic devices – spirals, lines of movement and of glance – are picked out as linear features. There is a certain crude vitality about these pictures, a painterly wildness and colouristic vehemence that was in the current mode but is expressive of a robustly objective anger rather than of darkly subjective *angst*. Satire is indignation salted by wit and modified by a humane sense of the absurd. In these paintings McLean is primarily a satirist.

It wasn't long before he found in the Berlin art world an object worthy of his satiric attentions. The early 'Eighties saw the final apotheosis of Joseph Beuys, artist, from Fluxus guru, radical educator and art theoretician, brilliant inventor of objects and actions, to world showman/shaman and conscience of the international art world. Of Beuys's genius and humanity McLean was never in doubt. What aroused his indignation was the near-religious veneration of the man and the wide-spread assumption that he had ascended above the realms of criticism, evidenced by the exalted prose that was written everywhere about him and by the

treatment of his drawings and assemblages as sacred relics of the artist himself rather than of the human spirit, to which as *fictional* traces they played touching and artful homage. Beuys was a man of wit and of purely human artistic ambition: 'Bruce, I have not started yet' he said at one of their meetings in Berlin. He was also utterly convinced of the transformative and redemptive power of art in human affairs and of its universal potentiality as a defining characteristic of the individual human spirit. This was a philosophy, expressed through art and profoundly democratic in its implications, with which McLean could wholly identify, however different might be his mode of operation from that of the older artist. And Beuys, like many of those of McLean's generation, insisted on the word *sculptor* to describe the multifarious activities that his personality and vision unified as a single continuous 'work'.

Of the cult of Beuys, and the disciples and adulators that McLean encountered in Berlin and elsewhere, he was less than patient. He discerned in their activities an unpleasant, even sinister, nationalism, a reverence for the artist that was ulterior and ideologically unhealthy. He found in their attitude and behaviour a compelling subject. Many of his paintings from now on featured the famous Beuysian homburg hat, the sign of his shamanistic powers and immediately identifiable badge of his *magic* status. Precisely because it fulfilled that symbolic function it could be effectively isolated as a target, and the more solemnly the hat was accorded its mystical significance the more seriously funny McLean's references to it became. *Going for God* was the title McLean gave to a number of paintings involving the figure of Beuys, not by chance resembling Bacon's famous Van Gogh (sacrificial hero of art), striding along or towards a cross, shepherd's crook in hand, emblematic German sausage flying nearby, watched intently by rapt demonic faces. A group of these were shown at Documenta 7 in Kassel, where Beuys inaugurated his magnificent action *7000 Eichen*, by which he intended to plant that number of oak trees, each accompanied by a basalt stele from a huge wedge-shaped gathering of these stones outside the Fridericianum, the site of the exhibition: '7000 oaks are a sculpture which has human life at its focus and the human everyday work as its scope of relevance. . . .' (After Beuys's death McLean contributed a major Berlin painting, *Ambre Solaire*, to the continuation of the 7000 Oaks work.)

Showing the *Going for God* pictures at Documenta 7 was the opening shot in a major theatre of a humorously ironic guerrilla campaign waged by McLean from the sidelines of what he was to term 'the art war', an international state of affairs in which he discerned the use of art for illegitimate purposes of personal and national promotion, a power play taking place in a context of art-directed political cynicism and commercial greed that was a vulgar denial of everything Beuys – his politics indistinguishable from his art – actually stood for. Observing the unholy alliance of flashily (and badly) dressed international dealers, collectors, curators, and self-promoting artists of no great talent converging on Kassel provoked McLean's *Yet another bad turn up*, a performance piece made in the following spring, 'a sombre work . . . (prompted) by the sighting of a pair of badly cut trousers in the Documenta 7 area.' Art proposes and exemplifies the unity of the human spirit across boundaries of class, nationality and culture: McLean's early repudiation of

92. *Exit the Egg.* 1982. Acrylic and chalk on canvas.
Four parts, each 102″×66″ (259×168 cm).
Private collection, West Germany

his 'Scottishness', his ability to communicate across language barriers in perform-
ances in Germany, Italy, France and Japan, his collaboration with craftsmen and
workers here and abroad, are all aspects of his total commitment to that concept of
art. His constant return to the art world as a subject for satire has entirely to do with
this identification, central to his work as a whole, of ethics with aesthetics. For it is
in that busy and complex place, where hustlers and hucksters brush shoulders
with priests and interpreters, where the vulnerable and the powerful come into
alarming conjunctions, where the distinction between price and value is forever
blurred, that art as object, action and commodity enters transactional life.

Using acrylic on canvas led very rapidly to a more radical clarification of image.
To achieve this McLean began to lay down overall fields of radiant colour, or of a
rich matt black, which created a density of objective effect quite new to his work.
Unlike the surface agitation by which the brushwork is registered on the
photopaper surface the cotton canvas soaks up the paint to become a soft and
luminous ground. On this he was able to draw, in pastel crayon, chalk or charcoal,
with a sharply defined linearity and a neon luminosity. It is also possible, by
altering the density of the medium, to apply the paint locally with a gestural
urgency, brushing directly on to the canvas or on to an already prepared ground.
This makes possible patches of affective intensity and allows a sort of rudimentary
modelling or emotive marking of the figures. All three components – richness of
ground, linear drawing, expressive gesture – could be deployed with the spon-
taneity and speed of execution that characterizes McLean's approach. Combining
them with a stunning virtuosity he created an unmistakeable personal style of
expressive versatility and elegant clarity.

At this time McLean also began to draw directly from the model. Many of the
Berlin paintings there figure the stylized features of Rosy McLean, depicted as
serenely unconcerned, classically calm and unaffected, posing or dancing, often –
as, in Exit the Model, and Exit the Egg – delineated in bright red. In those paintings and
several others she is attended by the somewhat less elegantly self-sufficient figure
of McLean himself, anxiously engaged in displays of acrobatic posing, nervously
whispering behind his hand, mopping his troubled brow or signalling in a pose
semaphore with his own version of the Beuysian hat. Several of these gestures
recur from painting to painting as McLean set about devising a repertoire of
attitudinal signals that might be configured in increasingly complex scenarios. In
Swimming Pool (Blue) his troubled positioning is in pointed contrast to the model's
sensuous posing. In Untitled (Red) the female form is drawn in yellow against a
ground of intense cadmium in a direct homage to Matisse, the Mediterranean
sensuality of whose later linear manner is invoked in many of these pictures. In the
grey drear of Berlin such homage takes on ironic overtones, emphasized by the
comic presence of the artist as insecure uxorious worrier going for a macho
masculinity. In Exit the Egg the female's own variety of moods and gestures, from
power display to boredom, is recorded in a series of portraits done in an agitated
and assertive orange and green.

The layerings and ambiguities of reference, with sometimes three or more
distinct categories of action occurring; the contradictory conjunctions of (in these
cases) erotic celebration and (partly self-directed) irony; the centrally depicted

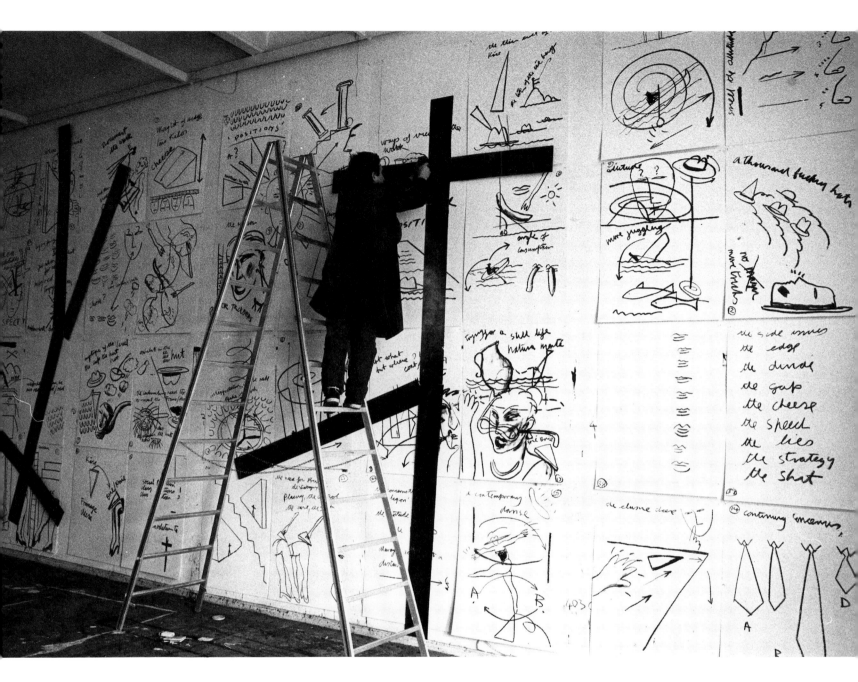

93. The artist working in the studio,
Kunstlerhaus, West Berlin, 1982
Photographer: Dirk Buwalda

94. *Bingo, Bingo, Bango, Bongo.* 1982.
Acrylic and chalk on cotton.
Arts Council of Great Britain

95. OPPOSITE: *Exit the Model.* 1982.
Acrylic and chalk on cotton, 98" × 145" (250 × 370 cm).
Leeds City Art Gallery

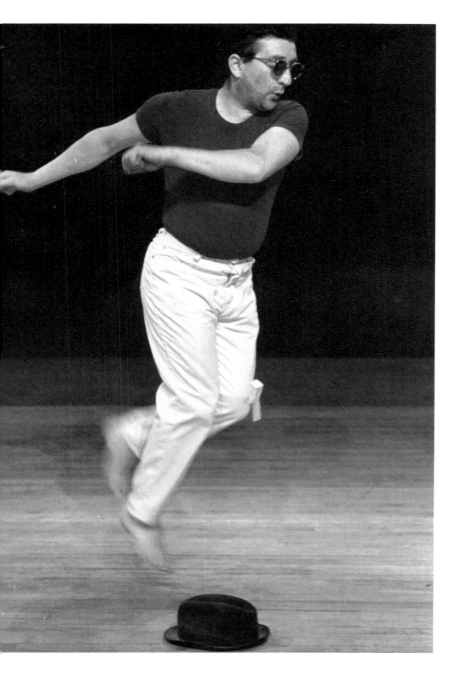
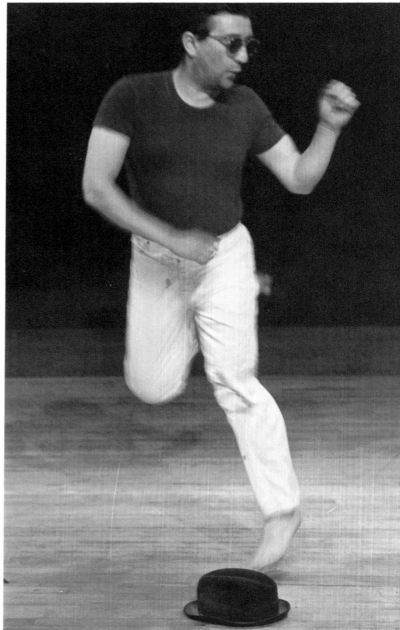

96. McLean rehearsing *Une Danse Contemporaine,*
London, 1982

comic histrionics of the artist himself – these are the elements of classic McLean performances. Turning with critical verve outwards from the studio to the life of West Berlin, motivated by a passionate curiosity, McLean created in this new manner a series of sensational tableaux of city life. Living in Kreuzberg, shopping now at the local Turkish grocers, now at Ka-De-We, 'the smartest shop in Europe', drinking at the Exil Bar, eating *bratwurst* from street stalls, meeting with international art stars at the Paris Bar, making and renewing friendships and acquaintances with Berlin artists, the McLeans quickly overcame their initial misgivings: they came to love the city with its complex fusion of ultra-sophistication and vulgarity, its monstrous conviviality. In a series of spectacularly large paintings McLean captured the crowded and hectic vitality of the modern crowd in a city whose crude energies, casual violence and matter-of-fact sensualities simultaneously fascinated, enthralled and appalled him. Like Guys, he entered 'into the crowd as though it were an immense reservoir of electrical energy'.

The earliest pictures in this mode register McLean's sense of the city's raw vitality, its direct and uncompromising physicality: at whatever social level, and whatever the partitions that might exist between one level and the next, there is always *life* at night on Frankfurterstrasse – *Sausage Street* – and the grosser appetites are satisfied there with gusto. In this aspect of the city's life McLean was especially impressed by the social and sexual power of the women; in many of the Berlin pictures they are shown flexing muscles and otherwise signalling physical and sexual confidence. The nighttown phantasmagoria depicted in the *Sausage Street* paintings, and in *Bingo, Bingo, Bango, Bongo*, for example, are orgiastic carnivals of eating, drinking, and sex, caught in the fervid light of nightclub and street.

Berlin was exhilarating but it could be dismaying and depressing. The Wall, the ever-present symbol of political partition and social separation; the coexistence in the show city – 'shop-window' of the West – of ostentatious wealth, unabashed commercial greed, poverty and deprivation; the claustrophobic intensity of social and political life – these contradictions exact their toll, and in a series of large complex paintings McLean pictured Berlin not as carnival but as a dark theatre of tension and unease, like an inner circle of Hell. Often in these paintings words are integral to the picture, a visible murmur of uncertainty and anxious positioning. This place, as one of the titles puts it, is *Contained (Historically, Politically, Physically)*, the site of *The General Manoeuvre*, of carpets of *Blue Spew* and of an *angst* compounded of social, artistic and political doubt and despair at the exit of the Hat, the man with the crook and the messianic Word. A group of these works was shown by McLean at the epochal Zeitgeist exhibition in Berlin in the autumn, where their elegant electrical linearities and satiric stance was in sharp contrast with the prevailing painterly expressionist *furore*. McLean could be seen as clearly pursuing quite other concerns than those of the new painting, but there could be no doubt that he was tuned in hypersensitively to 'the spirit of the age'.

The McLeans occasionally left Berlin, notably for a holiday in Italy in July. There McLean was able to observe the beach acrobatics and the flash exhibitionism of the deep-tanned divers performing blatant mating displays for the (apparently) sublimely indifferent female bathers. The absurdities of beach and poolside behaviour have always fascinated McLean and the Italian experience led to the

97. *Ambre Solaire*. 1982. Acrylic and chalk on cotton, 98″×145″ (250×370cm). Private collection

series of glamorous *Ambre Solaire* paintings, though these were not executed until after his return from Japan in October. What is most immediately striking about these works is the black ground, the intensity of which conveys by a visual paradox the brilliant Mediterranean light. The figures are picked out in a neon orange, their bodies brushed bronze. McLean has said that he was thinking about Hockney when he painted these pictures: 'What interested me was the problem of the splash. I was thinking of *The Bigger Splash*.' Of the generation of painters immediately preceding his own McLean admires Hockney particularly, especially the big still pool paintings animated only by ripple and splash. The sun-soaked hedonism of Californian life that Hockney celebrates in those paintings had attracted McLean's satiric eye in the earlier swimming pool and Yucca works. The *Ambre Solaire* paintings, with their densities of field, their facility of figurative line, their extreme economy of means, demonstrate vividly how far McLean had travelled from the frenetic manner of those earlier works.

The journey to Japan that McLean undertook at the beginning of October was his first to that country. It was to take part in *Thoughts and Action*, an impressive international *manifestation* involving five artists from five Western countries: Joseph Beuys, Daniel Buren, Dan Graham, and Giulio Paolini were the others. As always

98. *Swimming Pool (Blue)*. 1982. Acrylic and chalk on canvas.
Two parts, each 78″×58″ (199×149 cm).
Private collection, USA

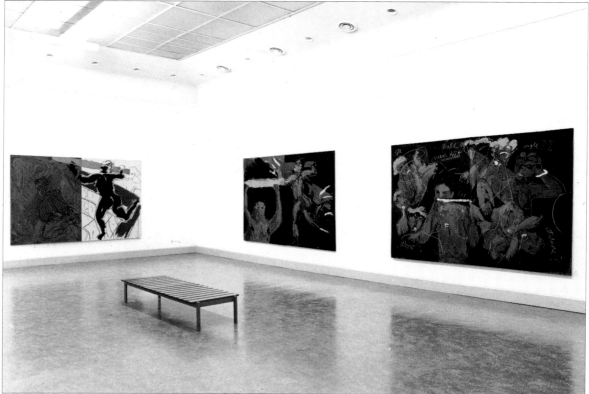

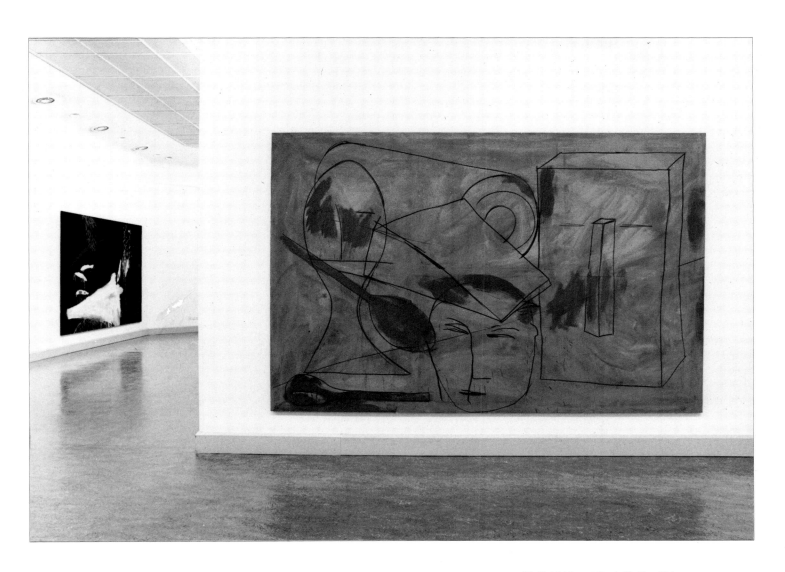

99. Exhibition at Stedelijk Van Abbemuseum, Eindhoven, November, 1982

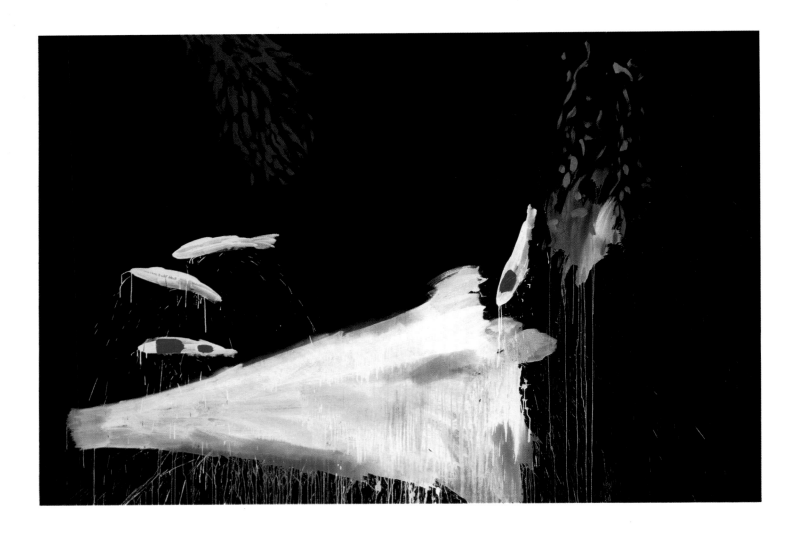

100. *Oriental Garden, Kyoto.* 1982. Acrylic on cotton, 98"×145" (250×370cm). Walker Art Gallery, Liverpool

he was fascinated by the elaborations of social behaviour, by the languages of gesture and of deployed objects, by the ceremonies of food and drink, and by the frantic movement of Tokyo. But it was in Kyoto that he saw and was moved by the small domestic ornamental gardens, no longer than sides of the house adjoined, whose exquisite design incorporated miniature trees, waterfalls, ponds, and magnificently large Koi carp.

On his return to Berlin McLean began work on a series of paintings quite unlike anything he had done before. With the large landscape-format *Oriental Garden, Kyoto* paintings the intention was to make the work as large as the gardens themselves, and, by a conceit as beautiful as that behind Monet's *Waterlilies*, to turn to the vertical plane the serene horizontality of the pools. The scale of the *Oriental Waterfall* paintings likewise matches that of their subject, as does their sheer and exhilarating verticality. There is a pictorial paradox here; wit at the heart of delight: in landscape we are accustomed to the conventions by which large things are reduced to the small span of the canvas, and we look at them as through a window or the aperture of a camera; here are miniature things represented on a large scale and we apprehend them direct, as they are.

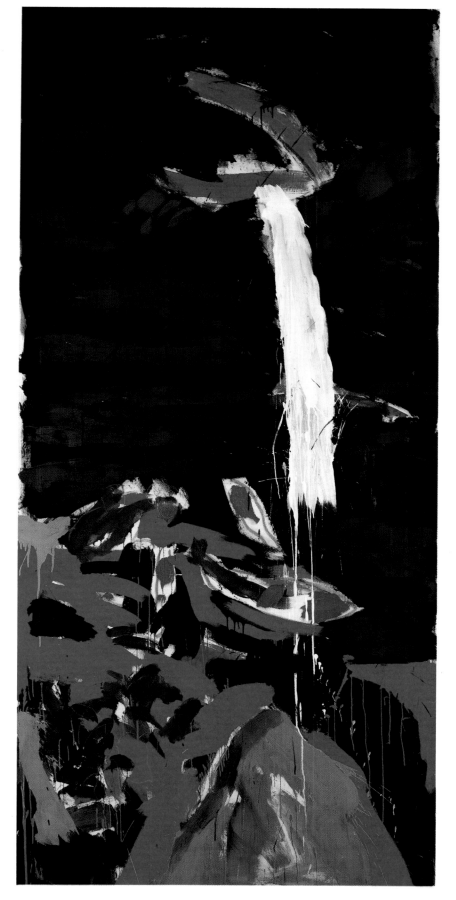

101. *Oriental Waterfall, Kyoto.* 1982.
Acrylic on cotton,
121″×59″ (308×150 cm).
The artist

Yet another bad turn up
a work based on a trouser
cut in the documenta 7 area
which table hi there, mmmm
oh ho well leave the beer
beige I think with some flare
coming in on the right zeit
moving up street feet
that sort of bad turn up
again for the book, no what
I mean.

102. *Yet Another Bad Turn Up.* Text for tape. 1983

yet another bad turn up
taken the advice to base
on actually scene trouser
cut/dash in the documenta
area, which table on no bad move
coming in on the right zeit,
that sort of bad turn up
again for the book, know what I mean
beige I believe with a moderate to
sixties flare oh no
bad one billo/brillo!
who makes the decisions
based on the style dilemma in the
selecter, matching beige
chas and dave
kevin and trace
common as muck
flash as fuck

bad lapel
bad move
bad decision
bad one brillo
beige courtelle stretch flares
tight round the bum
hugging the knee and
flared at the ankle
the foremost exponent of
media control looses in the
trouser stakes
the whole operation revealed in a badly cut
pair of rather nasty trousers.
the work dares to ask questions about decisions
the great courtelle trouser crisis.

McLean has no interest in Japanese art or its theory. But by an extraordinary intuitive leap these thrilling paintings catch, in both mode and subject, the essence of Zen, whose 'very technique' as Alan Watts tells us, 'involves the art of artlessness, or what Sabro Hasegawa has called the "controlled accident", so that paintings are formed as naturally as the rocks and grasses which they depict. . . . From the standpoint of Zen it is no contradiction to say that artistic technique is discipline in spontaneity and spontaneity in discipline.' It is a Zen proverb that 'one showing is worth a hundred sayings'. Much more could be written to show how close the paintings are to the spirit of Japanese art and poetry, not least in the extreme aesthetic economy of their simultaneous naturalness and artificiality, a quality they share by a lovely congruity with the gardens themselves. Their subject is also classically Japanese: the transience of time expressed in the image of petals falling on to water (one remembers the *Floataway Sculptures*). In a note to the catalogue of the 1985 John Moores Liverpool Exhibition, where *Oriental Garden Kyoto I* was awarded First Prize, McLean is diffidently witty about what he has achieved in these astonishing paintings, offering a low key to their meaning: 'A celebration of big fish in small ponds.'

In November 1982 the long-postponed Van Abbemuseum exhibition opened, now become a celebration of the prodigious achievement of the ten months in Berlin. More than sixty paintings were exhibited in ten large rooms, a revelation of an astoundingly prolific and varied output of work that established McLean for those who saw it as a painter of world class and authority. It was a grand parade, a demonstration of exuberant creativity and wonderful energy. For McLean it was a climax and a confirmation: 'I knew now that I could do it; I had made "the museum show", and I knew I could move on to something else.'

In December the McLeans returned home to Barnes. It was the post-Falklands winter, and from Berlin the wave of jingoistic patriotism accompanying the war had looked distinctly unhealthy. Whatever the rights and wrongs of the conflict itself, the flag-wagging jubilations and the hypocrisies of the politicians had seemed sickeningly like the symptoms of some deep social and political disease. To repeat the celebration of Eindhoven at the Whitechapel, where the final show of the three projected in 1981 was due to be put on in April, seemed the wrong idea. Besides, McLean wanted to return to the stone carving he had begun eighteen months before, and the Whitechapel would be an ideal place to show some heavy sculpture. He decided, for better or worse, not to show the Berlin works but to make a group of 'political' paintings to accompany the sculptures and to present a show more in keeping with the times and with his own sombre London-wintry mood. So it is the case that the great achievement of McLean's Berlin year has remained largely unseen in England, and unsung.

Apropos the Jug
Propositions and Collaborations

Sometimes it becomes necessary to make a statement.
Without irony?
Irony may be necessary to the statement. . . .

All my work is political: all art is political.
Matisse as well as Picasso?
Matisse even more than Picasso

(from '*A Brush with Politics*' May 1 1986: part of a dialogue between Bruce McLean
and Mel Gooding)

MCLEAN made the three large paintings for the Whitechapel April exhibition in the two or three days before the show opened. The greater part of his effort through an exceptionally cold three months at the beginning of 1983 went into the energetic carving of five monumental sculptures in Derbyshire grit stone; massive horizontal monoliths that occupied the space with a powerful material presence. The blocks were rough hewn, violently scarred and riven by power tools, which left rough unfinished surfaces, the natural structure and native obduracy of the material admitted and celebrated by contrast with the familiar linear motives – faces, female figures, wedges – incised into the stone and highlighted by marks painted crudely on to the surface. Together they represented an act of homage to the tradition of carved stone sculpture and a response to its challenge to the modern artist.

One of McLean's intentions in making the stone pieces had been to produce a body of works that would be critically and commercially 'difficult' and that would lack the virtuosity and brilliance of the recent painting. The very intractability of the sculptures, their sheer weight and lack of manoeuvrability were components of their meaning. McLean was well aware that the recollections of classical and sacramental grandeur, of the elemental dignity of the indestructible ancient monoliths that these pieces invoked, acted by ironic implication as a powerful reproach to the self-regarding worldliness of those engaged in 'the art war'. The international set that vies for prestige, influence and power in the temporal world, validating its manoeuvres through the visibility of its association with art and artists, is at the same time deeply complicit with the very political, commercial and military institutions whose purposes absolutely deny the spiritual and humane values embodied in art.

The paintings on the wall at the Whitechapel were spontaneous and minimal,

104. *The Cheese Players*. 1983.
Acrylic and charcoal on canvas,
118″×156″ (300×400 cm).
The artist

103. OPPOSITE: *Untitled* (detail). 1986.
Acrylic, enamel and collage on canvas,
102″×144″ (259×366 cm). The artist

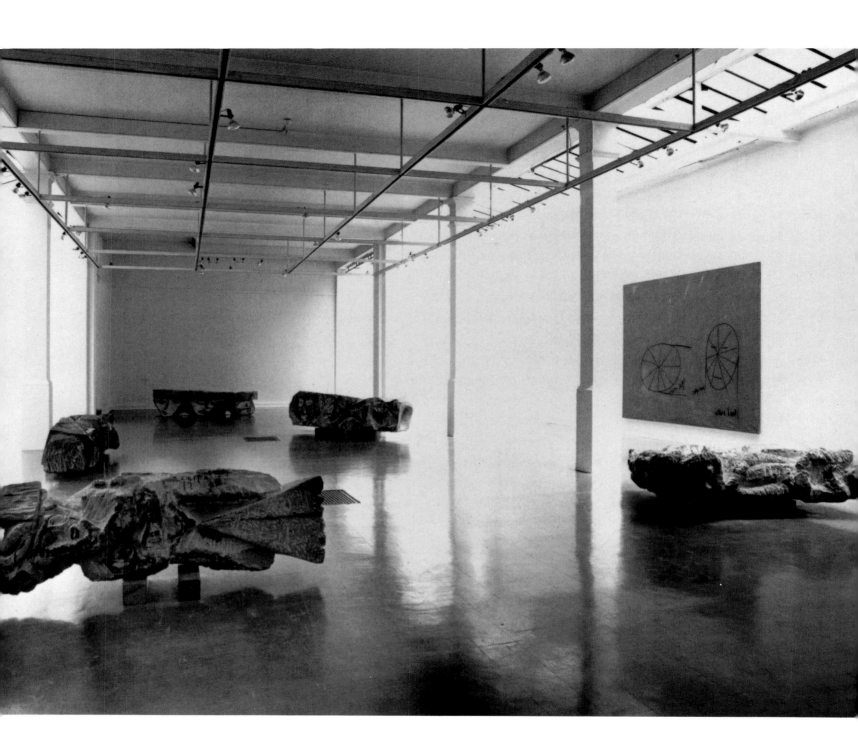

consisting of simple motives charcoaled quickly on to an emblematic grey ground (grey is always associated by McLean with the besetting sins of accountancy and political conformity). They were marked with gnomic phrases giving clues to their references and further indicating the way in which McLean had developed a visual/verbal language of witty economy. The images were linear representations of heads, two being those of 'cheese-players' (chess is the game which quintessentially imitates politics) and others watchers of the great game; of segmented circles, the big cheese being divided like a pie-chart; of the wedge/slice of Brie, the thin end of which – social *politesse*, political *finesse* – is the beginning of any manoeuvre, the thick end a visual pun on the flash trouser flare; of the bridge-head, the point of contact and penetration in a power struggle; of the Hat and its shadow. The words were comparably direct: *Who is the big cheese? Who owns the cheese?* and *Own up.*

The Whitechapel show signalled McLean's continuing commitment to a complex art of intervention and presentation in which one work reflects off another and themes are elaborated through a series of recurring images, words and ideas, gestures and arrangements of objects, turning upon the interplay of key metaphors, emblems and colours. At a time when he was riding the international wave of painting with unmatched aplomb and could have used the Whitechapel as the occasion for a spectacular homecoming its uncompromising starkness and

106. The artist in garage studio, Barnes, early 1984. Photographer: Bruce Miles

105. LEFT: Exhibition at the Whitechapel Gallery. April 1983

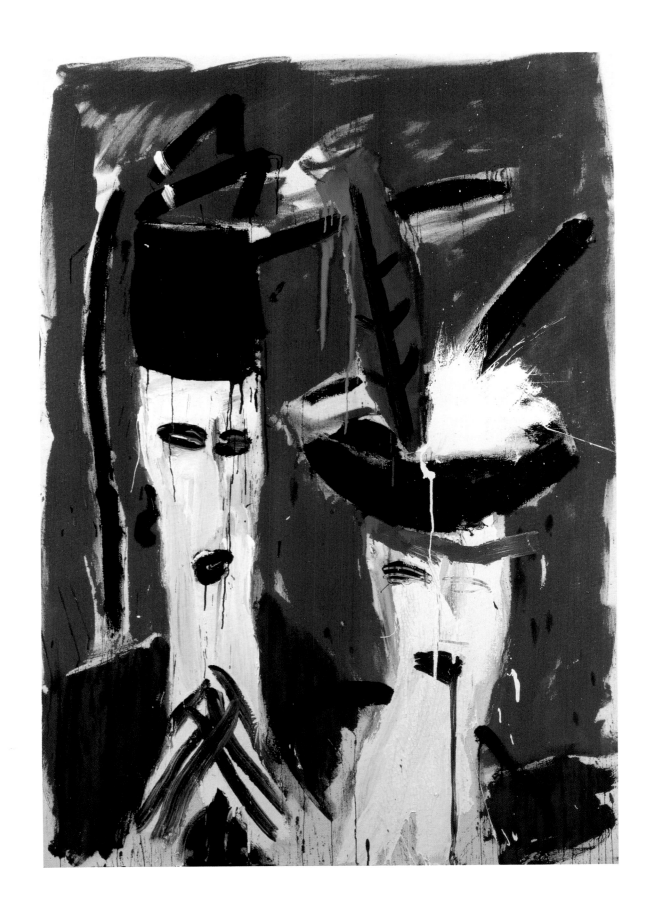

107. LEFT: *Fish and Pan Head.* 1983. Acrylic on canvas,
65"×59" (165×150 cm). The artist

108. *Untitled.* 1984. Acrylic on canvas, 84"×66"
(212×168 cm). The artist

109. *Untitled.* 1984. Acrylic on canvas, 75"×58"
(191×148 cm). The artist

110. *Yet Another Bad Turn Up* at Riverside Studios, London, May 1983

111. RIGHT: *Some Unpleasant Bending*. 1985. Acrylic on canvas, 84″×66″ (214×168cm). The artist

rhetorical economy matched the Tate's *King for a Day* as an act of renunciation and assertion of independence. The challenge it made to art world values and to the political culture within which they operate was underlined by the performance of *Yet Another Bad Turn Up* at the Riverside Studios during the run of the exhibition. These events took place in the period of the run-up to the post-Falklands election in June. It had been a time when it was 'necessary to make a statement'.

The return to London marked the beginning of a period of diverse activity and multiple collaborations, of intense development for McLean towards the realization of his ambitions to make a new kind of situation for art outside the limitations of existing set-ups, whether commercial or publicly subsidized: 'another kind of context for ourselves, which might be another lifestyle, another world in a sense' is how he had spoken of it in 1981. And he wanted to work on 'very big works, whether it's with architects or governments', projects that would bring into the ambit of art, as collaborators in its making and beneficiaries of the environments it creates, those people who inhabit the everyday world and are presently excluded by the 'art world' and its organizers. The politics in McLean's work stems directly from a belief in the centrality of art to the development of human consciousness and to social and domestic well-being.

McLean had no intention of giving up painting at this time; what was crucial was to define its purposes. He was still uninterested in what he called 'painterly problems'. Not long after the Whitechapel show he left the empty factory he had used as a studio for the stone works and moved into a friend's lean-to garage in Barnes, where he embarked upon a period of furious creative effort, making an enormous number of paintings in a tall narrow space that was cluttered with garden tools, children's bikes, stepladders, and a rabbit hutch. McLean found the space itself and the domestic situation around it immediately congenial, and it was close enough to home for him to be able to work in the way that suits his temperament, at odd times of day or night, unpredictably and spontaneously: '. . . the physical problems I had with space made me work in a particular way. I couldn't actually get back far enough to see what I was doing till I opened the front doors of the garage and took the paintings outside. I had to work very close to the canvas. I like to go for something quickly – hit it immediately: I can't fiddle and diddle. The fact remains that all these kinds of things are real, the kids coming in and out, being able to go upstairs for a cup of tea or a bottle of wine, it kept me in touch with some sort of other reality, which I do need for the work.'

The physical conditions were not unlike those of the cubicle rooms at Riverside Studios where he had worked on the *Yucca* and *Pillar to Post* drawings in 1980 and where he'd had to lay the pictures on the floor and climb a stepladder to get a view of them. And in the garage he worked in a similar manner, fast and in series, making large paintings with the freedom and lack of inhibition that might more commonly be associated with sketchbook work. The difference was that McLean now had the Berlin experience behind him and worked on canvas with the confidence and facility that he had previously brought to his drawing on paper. He worked in the garage studio through the winter and spring of 1983 to 1984 on a body of paintings that have a marked stylistic unity. They were shown in Berlin, New York and Florence, but never as a coherent group in this country.

These paintings have a startling immediacy and vitality. The gesturally brushed violence and the arbitrary dribble and splash of the figurative elements is in direct contrast with the surrounding fields of undifferentiated colour saturated into the canvas, sometimes pure and radiant, vivid blue, red, orange or green, and sometimes darkly tonal, grey, bottle green and black. This is an expressive use of colour for its own sake: in dynamically ironic counterpoint to the dramatic action depicted it asserts its own glorious or tenebrous actuality, freed of any descriptive burden. This use of colour enables McLean to come to the simplest and boldest solution to the problem of pictorial space, even as it plays an affective role, like a powerful music, suggesting joy or disquiet, celebration or fear.

The mysterious conjunctions of figures and objects and the inexplicable events in these arenas of colour are encounters abstracted from the human drama of the everyday. These absurd actors in what might be the terminal farce are adorned with the ridiculous accoutrements of contemporary style – Gucci bags, Gucci shoes, tartan socks – or provided with pipes (signifying their status as proper subjects for modern art) that emit clouds of obfuscating smoke, or wearing saucepans upon their heads (the modern still-life subject, the essential domestic object, turned into a helmet or gun-turret). Separated each from each, they stare at

112. *Going for Gucci.* 1984. Acrylic on canvas, 98" × 145" (250 × 370 cm). Private collection

each other in passive indifference or envious cupidity, their alienation signalled by the recurrent McLean symbol of division and apartness, the wedge, which undergoes countless witty transformations. We have seen it as a piece of Brie, the dinner table conversation piece, the talking point ('I was struck by the Brie') that distracts the guests from the realities around them; as the club tie, the old school tie, the badge of distinction and exclusivity; as the trouser leg and the lapel of a certain cut; as the privileging plinth: here it is the stepladder with its connotations of social ascent and descent; the rocket and the bomb; the heads of the protagonists themselves.

The garage paintings are notable for their extreme economy of means, directness of address, stark simplicity of style, gestural vehemence and passionate indignation. The climax of this phase of work came in paintings McLean made over the Easter weekend of 1984. These featured figures at the foot of the Cross and included two large scale paraphrases of *Christ as Man of Sorrows Beneath the Cross* by the unknown Master of the Presentation in the Temple, a picture McLean had come across as a tiny black and white catalogue reproduction from the Picture Gallery of Berlin's Staatliche Museum. These angry and reverential paintings are among McLean's finest works. Imbued with a terrible irony, they dangerously

balance satiric anger at the veneration of fashionable commodities against the pathos invoked by Christ's slumped and sorrowful figure.

McLean continued to paint in bursts of energy, at the same time embarking upon a formidable programme of work in various media in collaboration with an extraordinary range and number of people. In the summer of 1984 he moved once more, this time into a large studio at Riverside Studios, where he was able to work for nearly two years and where he produced several paintings on a larger scale than had been possible in the garage. These maintained a stylistic and thematic continuity with the works of the previous year but developed the iconographic vocabulary, returning to an imagery of acrobats and circus folk, of swimmers and divers, but adding images of boxing (competitive violence), juggling (trickery, sleight-of-hand), and home decorating (ladders, rolls of lino etc., signifying domestic respectability as a cover for domestic violence: the large rolls of red lino suggest a sexual as well as a physical threat).

From this period dates the introduction into McLean's stock of the now-familiar image of the female figure as amphora or jug; sometimes simply sensuous, a beautiful visual pun, an allusive identification of Aphrodite with the ancient amphorae brought up in Aegean fishermen's nets; sometimes an over-filled vessel whose explosively emetic splashings and spillings has figured obsessively in paintings, posters and prints, notably in the important series of violent 'splash' paintings that McLean made in 1986. By a characteristic McLeanian conceit the image conflates ideas of plenitude and pleasure with those of overspending and waste: the vessel containing the oil, wine and water, necessary to life, pleasure and sacrament alike, is also the pot of gold, or the oil barrel that spews out the slick to pollute the very beaches where Aphrodite, the naked Goddess, came ashore.

This figure first occurred in *Dream Work*, the book which McLean made with the present writer between 1984 and 1985. It was inspired by the superb *livres d'artistes* of Braque, Picasso, Matisse and Miró and by those French art magazines of the 1940s that had often contained original lithographs by major artists. It began as an inventory of images, developing into a sequence of brilliantly coloured screen-printed images that opposed the cold north (Scotland, Berlin) to the warm Mediterranean south. The collaboration on this book extended to the master screenprinter, Michael Schonke, whom McLean had met towards the end of his Berlin period working at the *Druckwerkstaat*, the print workshop for artists in the building next to the Kunstlerhaus. This was the first of several books that McLean and Gooding, working together as *Knife Edge Press*, made in the following years, taking obsessional McLeanian themes and images – the ladder, manoeuvres on the domestic front, the jug, his grandfather's *potato against a black background* and *scone off a plate* – and elaborating them in the performance of sequence and with the accompaniment of text.

Dream Work also contained another image, the black battleship, that became the subject for a series of remarkable paintings by McLean in 1985. The idea of the battleship relates directly back to the 'art war' concerns of *Yet Another Bad Turn Up*, whose set was battleship grey and designed to look like the side of a ship, with a central bridge on which McLean, pipe-smoking and contemplative, took 'breaks' and surveyed the scene. (The pipesmoker as observer, *hors de combat*, non-

113. OPPOSITE: *The Blue Lino, the Red Flag.* 1985.
Acrylic on canvas,
84″×66″ (213×169 cm).
Photograph: Courtesy Galerie Gmyrek, Dusseldorf.
Private collection

committal, occurs in countless McLean works over these years.) Behind the haunting images of these black paintings, too, are recollections of the naval engagements of the Falklands war, also unconscious memories of Dufy's black ship in *Le cargo noir*, sgrafitto-scratched, like McLean's, into its own black and oily smoke. (Dufy's great painting had been seen at the Hayward, though not by McLean, in 1983; he had seen the painting only in reproduction.) The extreme simplicity of these pictures – and of those that substitute for the ship the amphora/nude – in which the emblematic subject is figured in a surrounding sea ('wine dark') of engulfing blackness, is a function of their eloquence. They register a darker side to McLean's vision, a consciousness of the encroaching possibilities of disaster – spiritual, political, ecological – that threaten the world, and which give greater urgency and poignancy to his celebrations of life, sex and art.

McLean's awareness of the potentialities of violence and disjunction in social and political behaviour is directly related to his interest in architectural and social space – the nature of the rooms, buildings and places in which people make their lives. The central perception that how people behave is a function of the spaces they inhabit and the objects they use underlies much of his work in the 1980s. Its importance to him goes back to his beginnings in a hard city and his formation in a school of art that was at once a practical working place and a visionary statement on that very theme. (Among his father's unrealized architectural ambitions was the renovation and reconstitution of the Gorbals tenement blocks into workable living apartment buildings, each with its courtyard – 'defensible space' – and each flat with its own bathroom and lavatory.) Relationships are defined, at every level of human activity, domestic to geopolitical, in terms of the dispositions of spaces, the use of objects within those spaces and the ways in which movement is determined by the space available.

114. LEFT: *Red Wine Sea*. 1985. Acrylic on cotton, 101"×77" (259×198 cm). The artist

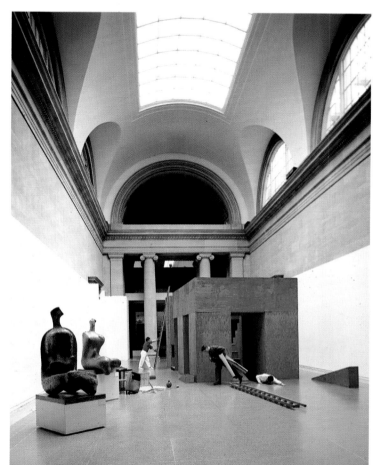

115. *Good Manners or Physical Violence* at the Tate Gallery, London, Summer, 1985. Photographer: Miki Slingsby

117. OPPOSITE: *A Song for the North*, a performance sculpture
made with David Ward, Gavin Bryars and P. M. Hughes,
at Albert Dock, Liverpool, September, 1986,
to celebrate the projected opening of the Tate Gallery,
Liverpool in 1988. Photographer: David Ward

116. *Good Manners or Physical Violence* at Riverside Studios,
London, October, 1985. Photographer: David Ward

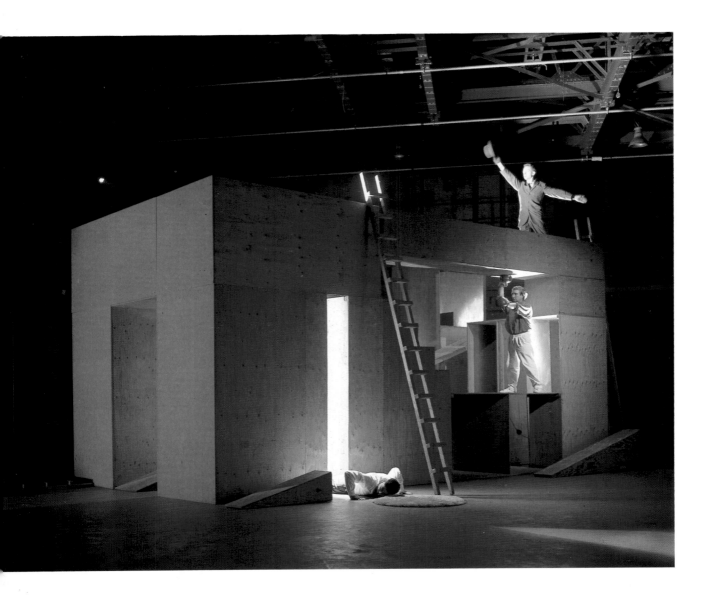

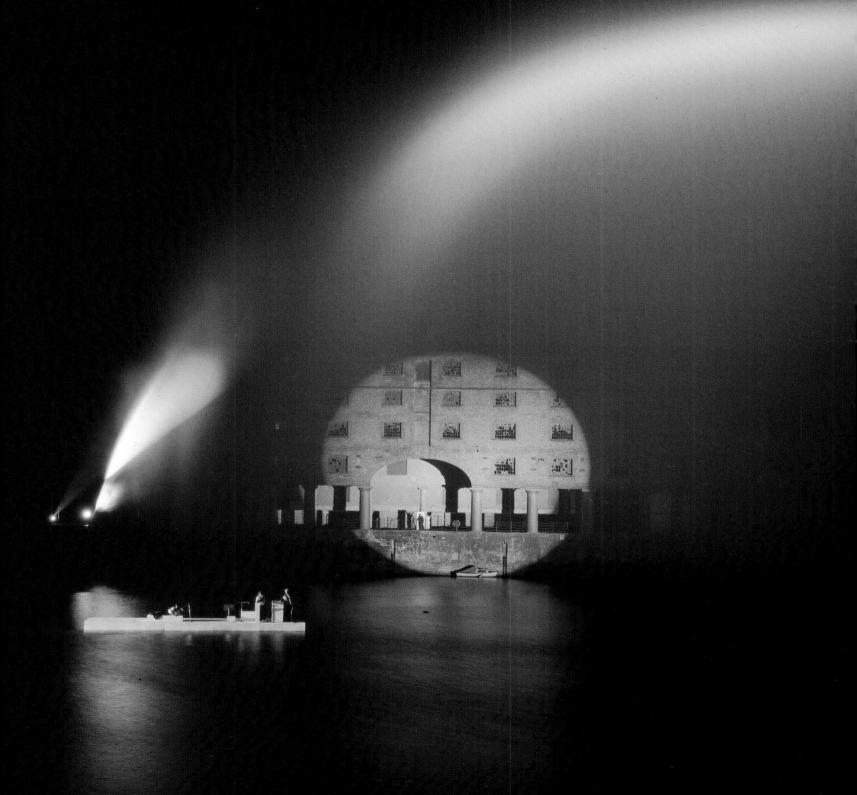

The Ballet will attempt to deal with problems of 'division', (conceptual/ideological/political and physical) in society. The cheese/fromage ref is the wedge, the social etc divide. The physical structure of the performance space will determine, to a greater than lesser degree the physical behaviour of the spectator, audience.

The performance space will also operate independantly of the performers. The structure will be designed with the help of the architect Will Alsop and will be fabricated in shuttering plywood, it will also be transportable. The space will be overtly lush/minimal/simple/complex.

A constructed sound will be used in the work. The 'dance' will be choreographed and an attempt will be made to construct and formulate a universal body language. Conventions of contemporary dance and gesture will be analysed, researched and developed in an attempt to create the first work which by its authority and complexity/clarity will be totally mis-interpreted. The piece will be interpreted in many languages, verbal as the work proceeds. The work will be about positioning and re-positioning in the art world and about the use of art/culture as a weapon (instead of nuclear power) in order for some powers to attempt to gain world supremacy.

A visual spectacle of the work will be on the one hand minimal to reflect current trends/style world wide etc, and on the other, lush extravagant, colourful, rich in complex visuals with carnal cardinals, nodding donkeys, wagging tongues, fast moves, popes, and models some historical.

118. From programme for *Une Danse Contemporaine*. 1982

Good Manners or Physical Violence, a performance sculpture presented at the Tate Gallery and the Riverside Studios in 1985, could not have put the point more directly. Within, around and on top of a huge architectural structure – 'the blue box' – which McLean, with some help from his son Willy, carpentered himself, three characters performed a complicatedly ritualized set of behavioural manoeuvres. Excessive politesse ('a slight one at the neck, a considerable bend at the hip'), dim and uncomprehending conformity ('I looked right, I looked left; I took one step forward, I took two steps back'), and grimly robust physicality ('Hello! What do you think you're looking at?') were represented respectively by the characters played by David Ward, Angus McCubbins and McLean himself, who interacted in a comic ballet of neurotically repeated moves and encounters. The box/cabin/compartmentalized block, with its blind corners, its passageways, its various levels, its enclosures, and its *ensemble* of accompanying props – the symbolic ladders, the kitsch ornaments and furniture, lampstands, occasional tables and lino rolls – was a vivid image of the standard settings for the banality of modern life. It was a place in which the convivialities and codified magnanimities of good manners and what they represent in terms of human kindness and affection were replaced by meaningless etiquette, repetitive acts and mindlessly assertive aggression. It was a place of alienation and discourtesy, waiting for violence to happen: McLean's metaphor for Britain in the 1980s.

Recent years have seen McLean irrepressibly prolific and various: he has made drawings, paintings, prints, sculpture, furniture, books, ceramics, and performances, much of the time in close and committed collaborations with other artists, craftsmen, and technicians. Collaboration is more than a convenient means to an end, a way of getting things made or done. It is in itself part of the project, the performance of centrally important principles: it is an aspect of the effective practice of an art of propositions, a means to impersonality of statement. It amounts to a practical enactment of the Beuysian principle that 'every man is an artist' in its profoundest meaning: not that every individual has 'something to express', but that art is ultimately a collective definition of what it is to be human. Each 'work' is but part of the larger *work* (the word itself being a clue to the meaning of the activity): the process by which human consciousness is realized.

This concept is linked to McLean's sense of his own work as a continuing process in which the objects and actions he makes are seen as so many parts of a whole, the components of a complex serial revelation with an implicit proposition. ('The politics in my work is not a reaction to events; it is an anticipation of events.') This goes some way to explain his lack of interest in documentation and academic record, and his apparent indifference to whether or not important bodies of work are seen or not seen in this country. He is addressing a wider audience, from within a line of creative-critical energy that connects Duchamp and Picabia with Beuys and Warhol, each of whom, significantly, achieved impersonality through technical experiment that eliminated 'style', through collaboration and through a performance and *persona* that carried over from art into life.

Much of McLean's work during this most recent period has been in the form of demonstration rather than of depiction and commentary; it has consisted of

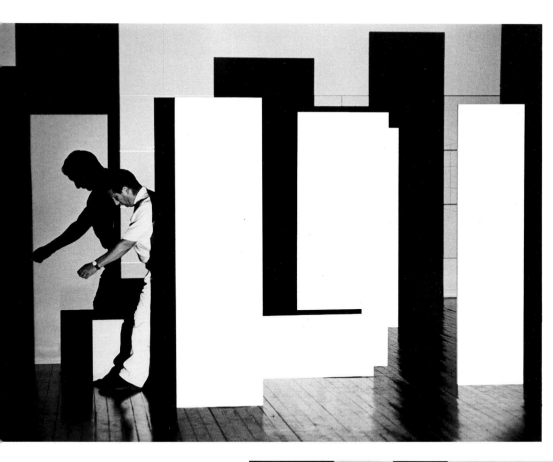

119. *Partition*, a performance sculpture made with David Ward, at the Fruitmarket Gallery, Edinburgh, August, 1986. Photographer: Antonia Reeve

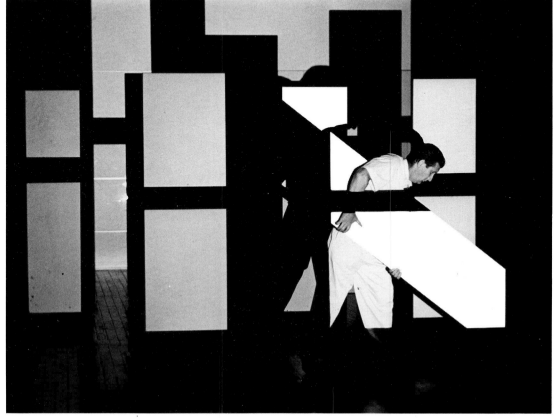

121. The Bar at the Arnolfini Gallery, Bristol, 1987

120. *Design for the Arnolfini Bar.* 1987.
Watercolour and crayon on paper. 30"×20" (76×51 cm)

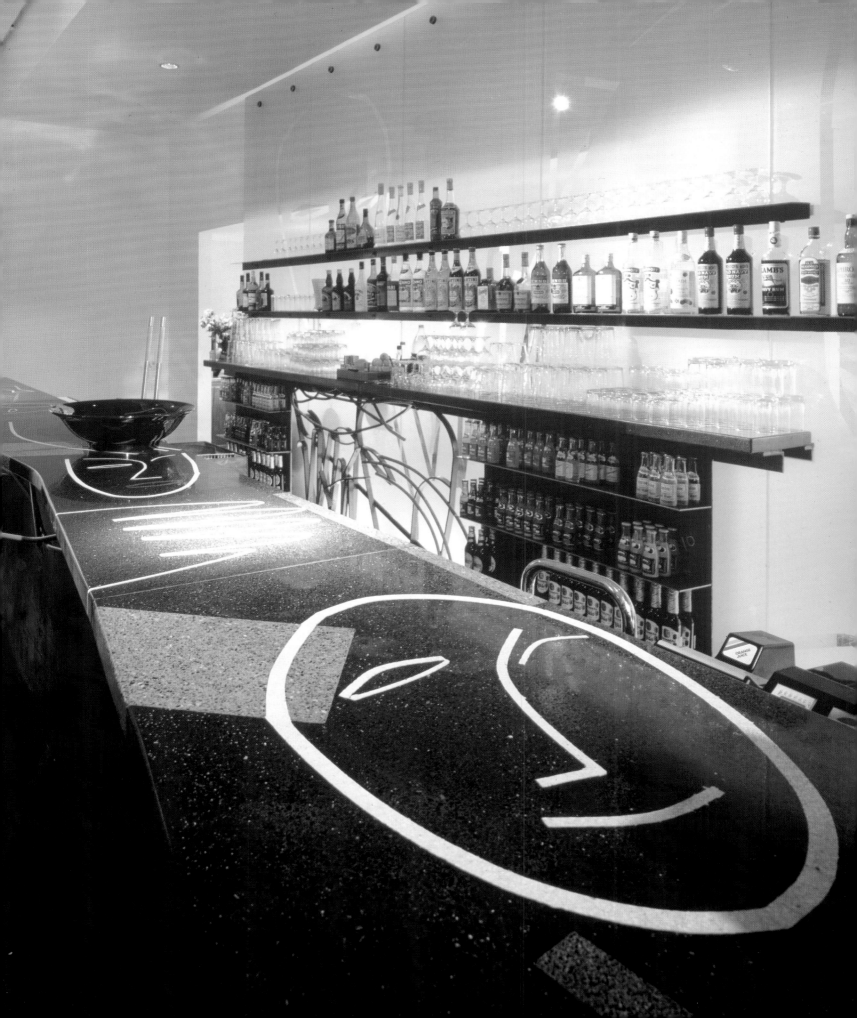

making and placing actions and objects in real space: sculpture, furniture, pots; or in modes of presentation that move in sequence through real time: performances, books, film; or, perhaps most significantly, in actual or proposed architectural projects. This last development was an inevitable progression for McLean, his first major commission being to design, with the architect David Chipperfield, a new restaurant-bar at the Arnolfini Gallery in Bristol. It was a particularly appropriate work with which to begin: to create a space for seriously playful posing in a context of art; a place for eating, drinking, conversation and conviviality. But before that McLean had devoted much time in the period 1984 to 1986 collaborating with a number of friends on an abortive grand plan for a palace of art, to be created out of a disused grain silo in Mortlake, with designs prepared by an architectural accomplice from *Masterwork* days, Will Alsop. The concept of the 'palace' was derived in part from memories of InK, and its building and its programme were to be part of the realization of the 'new context' for art and artists that McLean had spoken of in 1981.

The proposal for the restaurant bar at the Arnolfini came from the Director, Barry Barker, after seeing McLean's extraordinary exhibition at the Anthony d'Offay Gallery in March 1987, *The Floor, the Fence, The Fireplace*. In that he had shown drawings for imagined interiors, ceramics, and, most importantly, furniture sculptures in the form of tables, fireplaces and mantelpieces. These last incorporated terrazzo, a material previously unconsidered by artists, manufactured with imaginative enthusiasm to McLean's specifications by John Ryder in his

122. *Fireplace*. 1988. Reconstituted stone, terrazzo and steel, 54″×60″×24″ (137×152×61 cm). The artist

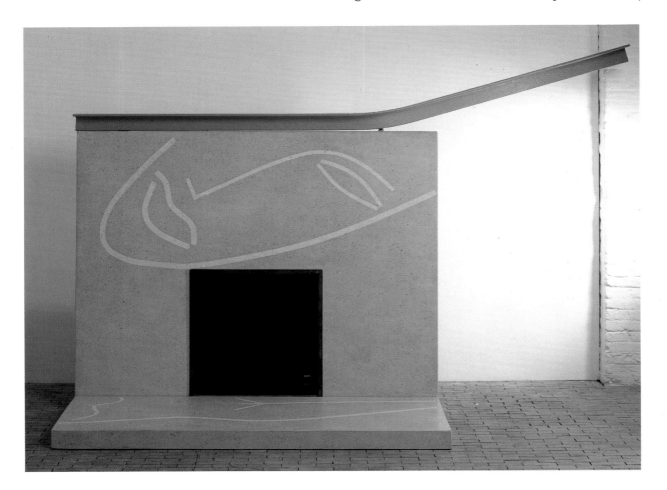

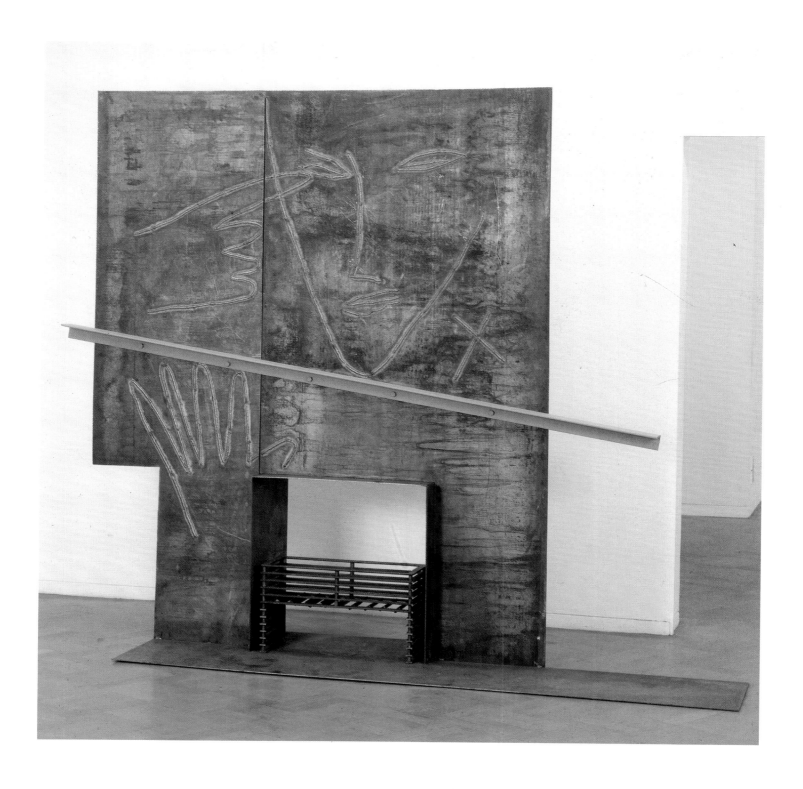

123. *A Place for a Lean.* 1987. Steel and acrylic,
94″ × 115″ × 32″ (240 × 294 × 82 cm).
Private collection, London

124. *Three Bowls.* 1986. Terracotta with coloured glaze.
Diameter each 18″ (46 cm)

125. RIGHT: *Jug.* 1987. Earthenware with coloured glaze,
45″×20″×5½″ (114×51×14 cm)

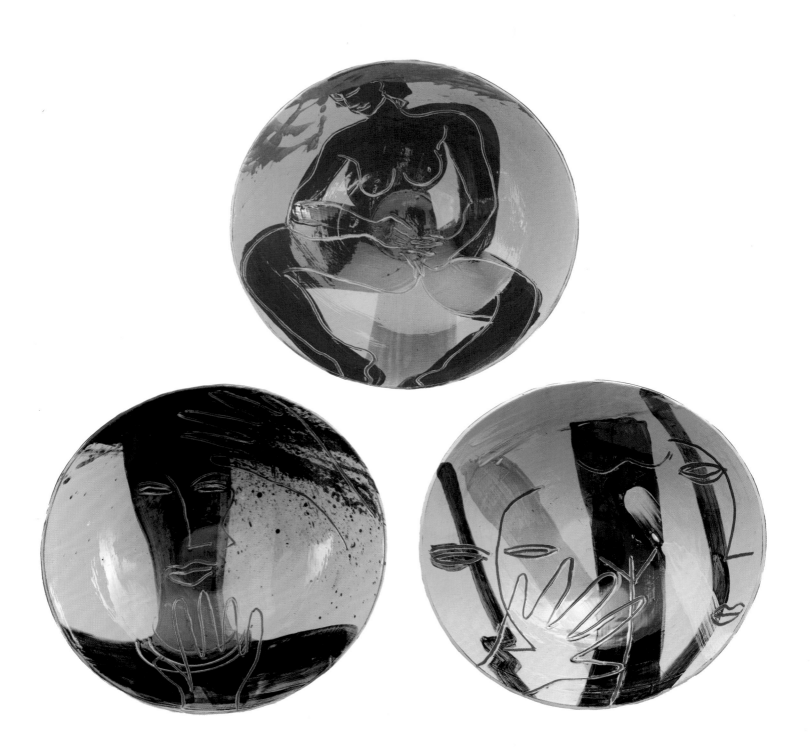

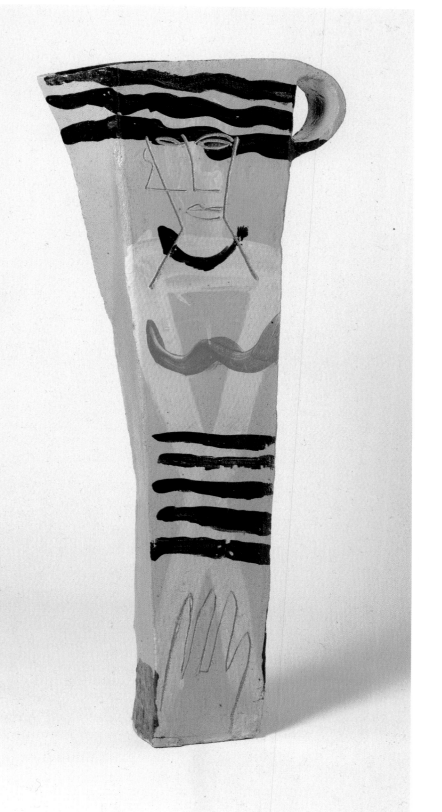

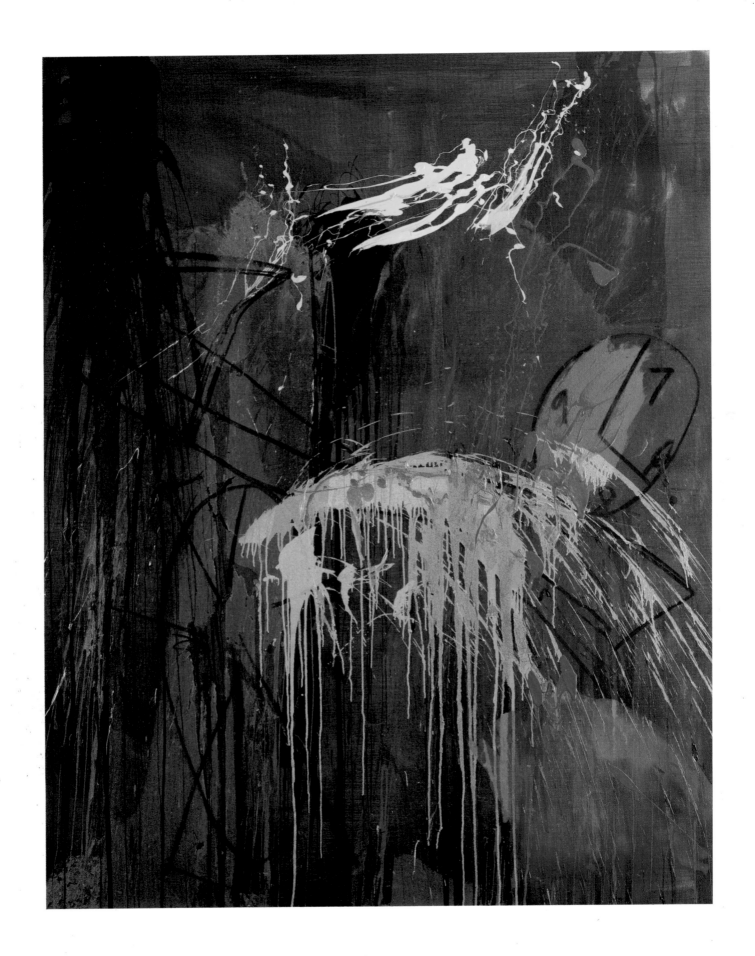

North London factory, and plate and wrought strip steel, worked by Simon Veglio in McLean's studio into configurations that recalled the fanciful organic linearities of Mackintosh decoration.

The mantelpiece and shelves for leaning were clearly conceived as furniture for pose, physical modifiers of behaviour. In addition to the elegancies of line – the sculptural 'drawing in air' of David Smith's phrase – they incorporate the solid material presence of heavy-duty girders, painted in bright colours in ironic reference back to the painted steel sculptures of Caro. Whereas the 'object sculpture' of the new generation was distinguished by its lack of function, its absolute abstract self-sufficiency, McLean's sculpture is *useful*, a furniture for a room, and in defiance of the Modernist prescriptions of functional purity of form, it employs decorative and referential motifs – faces, hands, the nude figure – in playful arabesques. Standing by them, leaning on them, sitting on them, walking round them, the user of these pieces enters into a speculative dialogue with them about the actions they facilitate or provoke. The drama of everyday life, which revolves round the objects and props of everyday use, was invoked in the text

126. OPPOSITE: *The Decorative Potential of Blazing Factories*. 1988. Acrylic on canvas, 102″×78 (259×198 cm). The artist

127. *Untitled (Silver Splash)*. 1986. Acrylic, enamel and collage on canvas, 102″×144″ (259×366 cm). The artist

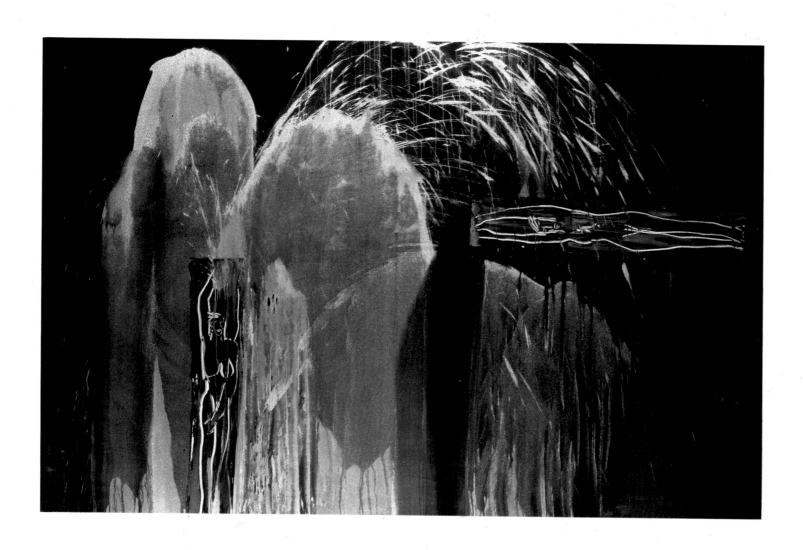

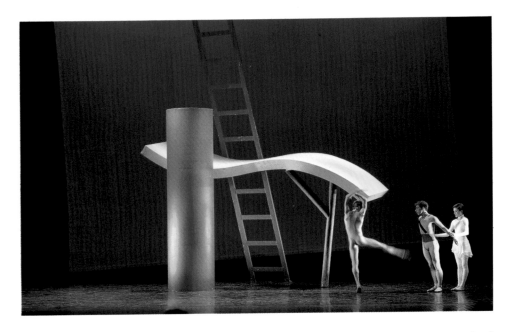

128. Set for *Soldat*, for Ballet Rambert at Sadler's Wells, London, Spring 1988. Choreography by Ashley Page, music by Stravinsky

129. OPPOSITE: *Untitled (Gold Splash)*. 1988. Acrylic, metallic paint and collage on canvas, 102"×78" (260"×198cm). The artist

written by the present writer for the Knife Edge book, *Home Manoeuvres*, which accompanied the exhibition:

> *Enter. Go through the door. Take the floor.*
> *Assume the room. Negotiate the table. Address the chair.*
> *Consider its proposition; consider the position:*
> *to take a seat or take a stand?*

McLean had come a long way from St Martin's; more than twenty years after leaving the School he was here making a complex and comic statement that set against the solemnly rarified and exclusive attitudes to art embodied in the famous 'forums' a set of implicit values and ideas that placed art in the space of real life, on the floor of the house, in the rooms where we live.

The ceramic jugs, plates and bowls, image-objects of brilliant glazed colour that McLean had made in an exuberantly prolific outburst through 1986, provided these living spaces with the utensils of civility and celebration, the plate for bread, the jug for wine, the bowl for fruit. Furniture and pots alike – being what they are as objects of use and decoration and at the same time metaphors for the immanence of art in life – are typical McLean devices, philosophical ploys embodied in actual form, inviting discourse and action. The bar at the Arnolfini brought all these materials and objects together in an environment intended for social use, its spatial dispositions being based upon an understanding, deeply researched by McLean over many years, of how people actually behave in bars.

The idea of a work as a behaviour-modifier, an object in space embodying an implicit proposition, and demanding a responsive manoeuvre, was wittily developed in McLean's setting for *Soldat*, the ballet to music by Stravinsky choreographed by Ashley Page for the Ballet Rambert in the autumn of 1988. For this the centre stage was occupied by an abstract structure whose architectonics were derived from multi-component sculptures made by McLean in the 1960s

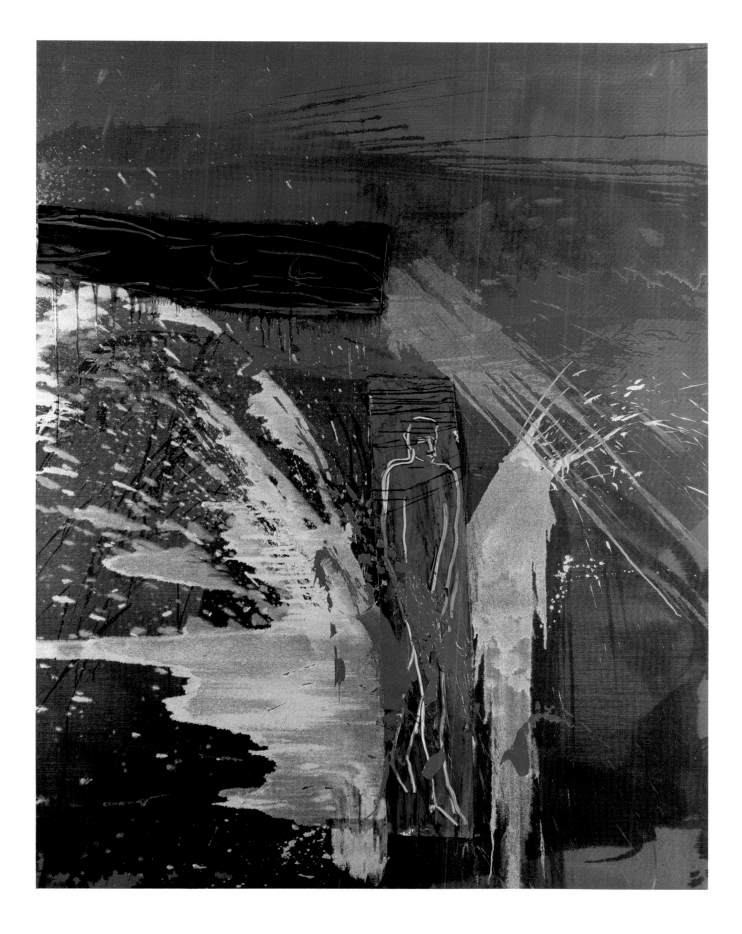

under the influence of St Martin's. The ballet was directly shaped by this dominant *ensemble*, whose forms and colours related symbolically to its themes, which concerned the temptation by the devil of the young soldier of the title. Heaven, Earth and Hell were all given their appropriate levels in the structure, a McLeanian ladder making movement between them possible. The costumes were also designed by McLean and included an infernal trio, each with a sinister saucepan/ gun-turret helmet and an emblazoned 6 across his chest, to make up as they danced in line abreast the triple 6, number of the Beast, proposing to the innocent that '*Do what thou wilt shall be all the law.*' These designs were a new departure for McLean, dynamically combining his obsessions with social behaviour in a given space, with architecture and with dance, performance and spectacle. They signalled yet another direction for his talents.

At the moment of writing McLean is embarked upon new moves, new actions: he is turning his formidable energy and creativity to a long-planned film; to a major new artist's book, a *manifesto* for the end of the century in which his philosophy will declare its alliances and allegiances; to further designs for dance and for opera; to new performances; to new paintings and prints; and now, especially, to major architectural undertakings. Whatever he does will inevitably involve friendship and collaboration, for they are the absolute necessities to his operation, the ground of his vision. It is a vision of what is possible, informed by a clear-sighted knowledge of what is the case.

130. OPPOSITE: *Untitled (Red, Black and Gold)*. 1988. Acrylic and charcoal on canvas, 102″×78″ (259×198cm). The artist

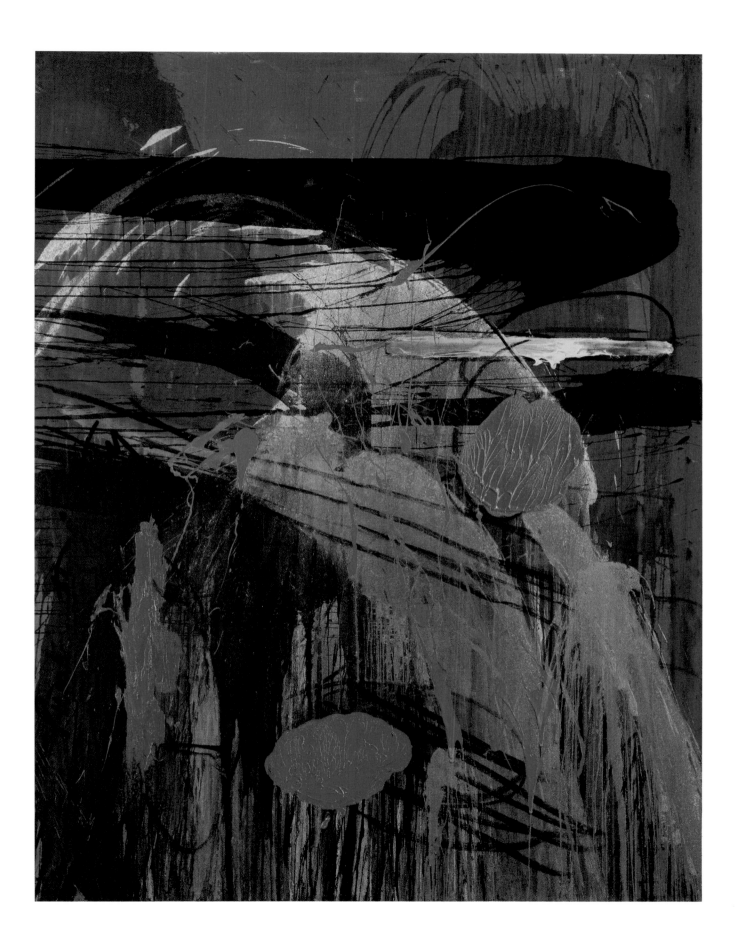

Notes and References

CHAPTER 1

'Nothing is lost' is an American proverb.

Robert Melville designated 'the new linear school etc.' in a review of F. E. McWilliam's sculpture in the **Architectural Review**, Dec. 1952. Herbert Read's famous phrase first appeared in his Introduction to the Venice Biennale catalogue in 1952. The complete text of Oldenburg's statement can be found in Barbara Rose *Claes Oldenburg* (MOMA, New York, 1970).

CHAPTER 2

Francis Bacon speaks of 'deepening the game' in *Interview 1* (October 1962) in *Interviews with Francis Bacon* by David Sylvester (Thames and Hudson, London, 1975).

The quotations from William Tucker are from *William Tucker Sculptures* (Arts Council, 1977) and from his essay *The Object*, first published in **Studio International** in 1972, and reprinted in *The Language of Sculpture* (Thames and Hudson, London, 1974).

CHAPTER 3

Roland Barthes's observations on photography are contained in *Camera Lucida* trans. Richard Howard (Jonathan Cape, London, 1982); Susan Sontag's in *On Photography* (Allen Lane, Harmondsworth, 1978). For photographs of Dan Graham's 'minimal forms' see Gregory Battcock ed. *Minimal Art A Critical Anthology* (Studio Vista, London, 1969). For Carl Andre's photographs of found materials see *The new avantgarde Issues for the Art of the Seventies*, text by Gregoire Muller (Pall Mall Press, London, 1972).

CHAPTER 4

Hans Richter describes Kurt Schwitters's performances in Chapter 4 of *Dada Art and Anti-Art* (Thames and Hudson, London, 1965). Erving Goffman's *The Presentation of Self in Everyday Life* was published in the USA in 1959, and in the U.K. in 1969 (Allen Lane, Harmondsworth). Michael Baxandall's *Painting and Experience in Fifteenth Century Italy* was published in 1972 (Oxford University Press). Quotations from McLean are from the *Hayward Annual 1979* (Arts Council).

CHAPTER 5

Sukracarya and Coomaraswamy are quoted in *Tantra Art* by Ajit Mookerjee (Ravi Kumar, New Delhi, 1966). Baudelaire's remark is from *The Painter of Modern Life V: Mnemonic Art* in *The Painter of Modern Life and Other Essays*, trans. and ed. Jonathan Mayne

131. OPPOSITE: *Moody Mer.* monotype from 'S. B. Factors 2–15'. 1989.
Photo courtesy of The Scottish Gallery

(Phaidon, London, 1964). Philip Rawson's essay *Drawing: Adjustments* was published in the catalogue of the 5th International Drawing Biennale, Cleveland, (U.K.) (1981)

CHAPTER 6

The epigraph is from Baudelaire's essay on Constantine Guys *The Painter of Modern Life* (already cited)

Jean-Christophe Amman's description of McLean's 'studio' is from *For Bruce McLean*, an introduction to the catalogue of *Bruce McLean: Firenze*, at the Galleria Fina Bitterlin, Florence, 1984.
McLean's remarks on his work come from the following: ***InK* Documentation** 7(InK MGB, Zurich 1981); The Tate Gallery Illustrated Catalogue of Acquisitions 1982–84; and from *Bruce McLean interviewed by John Roberts* in **Artscribe** No. 32 (December 1981). Michel de Certeau's essay *Practices of Space* is found in Marshall Blonksy (Ed.) *On Signs* (Basil Blackwell, Oxford, 1985). Baudelaire is quoted from *The Painter of Modern Life*, and from *The Salon of 1846 (XVIII: On the Heroism of Modern Life)*, in Charles Baudelaire *Art in Paris 1845–1862*, trans. and ed. Jonathan Mayne (Phaidon, London, 1965). McLean is quoted on working conditions in the garage studio from an interview with Mel Gooding in **Artscribe** No. 51 (March–April 1985).

CHAPTER 7

Alan Watts writes on 'Zen in the Arts' in his book *The Way of Zen* (Thames and Hudson, London, 1957). McLean is quoted from conversations with the author.

CHAPTER 8

A Brush with Politics was published in **Artics** 4 (Barcelona, June, July and August, 1986). McLean is quoted from the 1985 **Artscribe** interview already cited.

132. Images adapted from *Apropos the Jug. Knife Edge Press. 1988*

One Man Exhibitions

1969	Dusseldorf	Konrad Fischer
1970	Halifax	**King for a Day** Nova Scotia College of Art Gallery
1971	London	**Objects no Concepts** Situation
	Paris	Galerie Yvon Lambert
1972	London	**King for a Day** Tate Gallery
	Milan	Galeria Francoise Lambert
1975	Oxford	**Early Works 1967–1975** Museum of Modern Art
	Newcastle	Robert Self Gallery
	London	**Nice Style: The End of an Era 1971–1975** PMJ Self
1977	London &	**New Political Drawings** Robert Self Gallery
	Newcastle	
1978	New York	**The Object of the Exercise** The Kitchen (performance sculpture and drawing installation with Rosy McLean)
1979	Southampton	University Gallery
	London	Barry Barker
	Zurich	InK
1980	Glasgow	**New Works and Performance/Actions Positions** Third Eye Centre (travelled to Fruit Market Gallery, Edinburgh and Arnolfini, Bristol)

1981	Paris	Chantal Crousel
	St. Etienne	Musee d'Art et d'Industrie
	Amsterdam	Art and Project
	Basel	Kunsthalle
	London	Anthony d'Offay Gallery
1982	Vienna	Greta Insam
	Tokyo	Kanransha Gallery
	New York	Mary Boone Gallery
	Vienna	Modern Art Galerie
	Paris	Chantal Crousel
1982/83	Eindhoven	Van Abbemuseum
1983	Tokyo	Kanransha Gallery
	Dusseldorf	Kiki Maier-Hahn
	Berlin	DAAD Gallery
	Munich	Dany Keller
	London	Whitechapel Art Gallery
	London	Institute of Contemporary Arts
1984	Berlin	Galerie Fahnemann
	Karlsruhe	Badischer Kunstverein
	Munich	Dany Keller
	New York	Art Palace
	Tokyo	Kanransha Gallery
	New York	Bernard Jacobson Gallery
1985	London	Anthony d'Offay Gallery
	London	Bernard Jacobson Gallery
	Dusseldorf	Galerie Gmyrek
	London	Tate Gallery
1986	London	Bernard Jacobson Gallery (Ceramics)
	London	Anthony d'Offay Gallery (Ceramics)
	Edinburgh	The Scottish Gallery
1987	London	Anthony d'Offay Gallery
	Berlin	Galerie Fahnemann
	Atlanta	Hillman Holland
1988	Netherlands	Museum van Hedendaagse Kunst
	Dusseldorf	Galerie Gmyrek
	Tokyo	Kanransha Gallery
1989	London	The Scottish Gallery (Monotypes)

Selected Group Exhibitions

1965	London	**Five Young Artists** Institute of Contemporary Arts
1966	London	**Painting and Sculpture Today** Grabowski Gallery
1969	Bern	**When Attitudes Become Form** Kunsthalle; travelled to Museum Haus Lange, Krefeld and Institute of Contemporary Arts, London.
	Seattle	**557.087** Seattle Art Museum; travelled as **995.000** to Vancouver Art Gallery
	Dusseldorf	**Prospect-Projection** Kunsthalle
	São Paolo	**Road Show** Bienal de São Paolo (British Council travelling exhibition)
1977	London	**In Terms of, an Institutional Farce Sculpture** Serpentine Gallery
	Kassel	**Documenta 6**
	Paris	**Observations Observed** Biennale des Jeunes
1979	Paris	**Un Certain Art Anglais** ARC
	London	**Un Morceau de Gateaux** in **Inside Outside** Royal College of Art (with Sylvia Ziranek)

	Zurich	**A Certain Smile** InK
	London	Hayward Gallery Annual Exhibition
1980	Zurich	**Dokumentation 7** InK
	Venice	**Art in the Seventies** Biennale
1981	London	**A New Spirit in Painting** Royal Academy of Arts
	London	**New Work** Anthony d'Offay Gallery
	Sydney	**The 4th Sydney Biennale** Art Gallery of New South Wales
	London	**British Sculpture in the Twentieth Century** Whitechapel Art Gallery
	Kassel	**Documenta 7** Museum Fredericianum
	Berlin	**Zeitgeist** Martin-Gropius-Bau
	London	Anthony d'Offay Gallery
1983	Tokyo	**Thought and Action** Laforet Museum
	London	**Art in Aid of Amnesty** Work of Art Gallery
	London	**New Art** Tate Gallery
	London	**December Exhibition** Anthony d'Offay Gallery
1984	Cambridge	**When Attitude Becomes Form** Kettle's Yard Gallery
	New Haven Connecticut	**The Critical Eye** Yale Centre for British Art
	New York	**An International Survey of Recent Painting and Sculpture** Museum of Modern Art
1985	Liverpool	**John Moores Exhibition 14** Walker Art Gallery
	Tubingen	**7000 Oaks** Kunsthalle
1985/86	Athens	**11 European Painters** National Gallery
	Sydney	**The Sydney Biennale** Art Gallery of New South Wales
1987	London	**British Art in the 20th Century** Royal Academy of Arts
1988	Le Havre	**Thirty Years of British Sculpture** Musée des Beaux-Arts
1989	Berlin	**Balkon mit Facher** DAAD

Work and Performance with Nice Style

1972	Oslo	**Grab it While You Can** in **British Thing** Sonja Henie Niels Onstad Foundation
1973	London	**Arthur Tooth and Sons**
		Critics Choice
	London	**Deep Freeze** plus press conference Hanover Grand
	London	**Modern Posture and Stance Moulds** Royal College of Art (in collaboration with Roselee Goldberg)
1974	London	**A Problem of Positioning** Architectural Association (lecture/demonstration with Paul Richards)
	London	**High Up On a Baroque Palazzo**, Garage
	London	**Final Pose Piece** Morton's Restaurant
1975	London	**Nice Style: End of an Era 1971–1975** Robert Self Gallery

Performance Sculptures

1965	London	**Mary Waving Goodbye to the Trains** performance for street and roof, St Martin's School of Art
1969	London	**Interview Sculpture** with Gilbert & George, St Martin's School of Art, Royal College of Art, and Hanover Grand
1971	London	**There's a Sculpture on My Shoulder** Situation
1973	London	**Semi Domestic Poses** Royal College of Art

1975	London	**Concept/Comic** Robert Self Gallery
	Oxford	**Objects no Concepts** Museum of Modern Art
1976	London	**Academic Board** Battersea Arts Centre (in collaboration with William Furlong)
1977	London	**In terms of, an Institutional Farce Sculpture** Serpentine Gallery
	Kassell	**In terms of, an Institutional Farce Sculpture** Documenta 6
	London	**Sorry! A Minimal Musical in Parts.** Battersea Arts Centre (with Sylvia Ziranek)
1978	New York	**The Object of the Exercise** The Kitchen (with Rosy McLean)
1979	Southampton	**Action at a Distance** Performance Festival (with Peter Lacoux, Rosy McLean and Sylvia Ziranek)
	London	**Sorry! A Minimal Musical in Parts** Hayward Gallery (with Rosy McLean)
	London	**The Masterwork, Award Winning Fishknife** Riverside Studios (with Paul Richards)
1980	Edinburgh	**Action at a Distance, Questions of Mis-interpretation** Fruit Market Gallery
	Glasgow	**A Thinner Brim** Third Eye Centre
	London	**Possibly a Nude by a Coal Bunker** Riverside Studios
	Zurich	**Possibly a Nude by a Coal Bunker: A Statement InK**
	Amsterdam	**High up on a Baroque Palazzo** The Mickery Theatre (with Paul Richards)
1981	Basel	**A Contemporary Dance** Kunsthalle
1982	London	**Farewell Performance** Riverside Studios
	Essen	**Une Danse Contemporaine** Folkwang Museum
	London	**Painting on the Angst** Anthony d'Offay Gallery
1983	London	**Yet Another Bad Turn-up** Riverside Studios
1985	London	**Good Manners and Physical Violence** Riverside Studios (with David Ward)
	London	**Good Manners and Physical Violence** Tate Gallery (with David Ward)
	Dusseldorf	**Simple Manners and Physical Violence** Kunstakademie, Dusseldorf; Kunstmuseum, Dusseldorf and Hochschule, Cologne
1986	Newcastle	**Physical Manners and Good Violence** Laing Art Gallery
	Edinburgh	**Partition** Fruitmarket Gallery (with David Ward)
	Liverpool	**A Song for the North** Albert Dock, Liverpool/Tate Gallery
1988	Liverpool	**The Invention of Tradition** Albert Dock, Liverpool/Tate gallery (with David Ward, Gavin Bryars and P M Hughes)
	London	**A Ball is not a Dancing School** Whitechapel Art Gallery (with Dennis Greenwood, Catherine Tucker and David Ward)

Published Works

Not Even Crimble Crumble Studio International, October 1970
Their Grassy Places and **An Evergreen Memory** Studio International, May 1971
King for a Day catalogue for Tate Gallery, London
Nice Style at the Hanover Grand Audio Arts, London 1973 (Tapes)
Nice Style 1971–1975: The World's First Pose Band Flash Art, June/July 1975
Sorry: A Minimal Musical in Parts Audio Arts (supplement) 1977 (Tape)
A National Anthem Audio Arts, London 1977 (Tape)
I Want to be a Seagull Salon Arts Magazine, Dusseldorf 1978
Titles, Teacups Salon Arts Magazine, Dusseldorf 1979
Ways of Viewing Mackerel and Mandolins Aspects no. 4, Newcastle 1978
The Masterwork Award Winning Fishknife Audio Arts (supplement) London, 1979
Tape/Slide Piece Audio Arts (supplement) London, 1979
Drawing Aspects No. 16, Newcastle, Autumn 1981

With Knife Edge Press

Dream Work 1985
Ladder 1987
Home Manoeuvres 1987
A Potato Against a Black Background 1988
Apropos the Jug 1988

Select Bibliography

1969 **Some Recent Sculpture in Britain** Charles Harrison, Studio International, vol. 177, no. 907.

1971 Introduction to **Road Show** catalogue, John Hulton, São Paolo Biennale

1979 **Interview with Bruce McLean** William Furlong, catalogue for Hayward Annual, Arts Council of Great Britain, London

 Pose Performance of Bruce McLean Nena Dimitrijevic, Art Monthly, no. 24

 Bruce McLean Nena Dimitrijevic, in Un Certain Art Anglais, Musée d'Art Moderne de la Ville de Paris

1980 **The Biography Drawer** Sarah Kent, in Bruce McLean, Third Eye Centre Glasgow

 Bruce McLean – Oh Really – The Appearance of Non-Prodigal Son or Can You Hear Me at the Front? David Brown, in Bruce McLean, Third Eye Centre, Glasgow

 Bruce McLean Nena Dimitrijevic, Kunsthalle Basel, Whitechapel Art Gallery, London and Stedelijk van Abbemuseum, Eindhoven

1981 **Bruce McLean** catalogue for Musée d'Art et d'Industrie, St. Etienne

 Bruce McLean interviewed John Roberts, Artscribe no. 32 December

1983 **Bruce McLean: Berlin/London** catalogue, Whitechapel Art Gallery, London and DAAD Galerie, Berlin, Text: John James

 Talking with Bruce McLean Michael Archer, Art Monthly no. 66 May

1984 **Bruce McLean** Mario Amaya, Art Palace, New York and Studio International no. 1006

 Bruce McLean Jean Christophe-Ammann, Galleria fina Bitterlin, Florence

 Bruce McLean Andreas Vominckel, Badischer Kunstverein, Karlsruhe

 An International Survey of Recent Painting and Sculpture The Museum of Modern Art, New York

 1965 to 1972, When Attitudes Became Form Kettle's Yard Gallery, Cambridge, Ed. Hilary Gresty

 New Work Good Work Mel Gooding, Galerie Fahnemann, Berlin

1985 **Simple Manners or Physical Violence** Norman Rosenthal, Galerie Gmyrek, Dusseldorf

 Bruce McLean Tate Gallery, London

 Bruce McLean Tate Gallery, London (pamphlet)

 Bruce McLean Interviewed Mel Gooding, Artscribe no. 51 March-April

 Bruce McLean and the Cultural War Chrissie Iles, Performance no. 37 Oct–Nov

1986 **Bruce McLean** Mary Rose Beaumont, Edinburgh Festival, The Scottish Gallery, Edinburgh

1988 **Where Do You Stand?** Mel Gooding, Museum voor Hedendaagse Kunst 's-Hertogenbosch, Netherlands

Index

Figures in *italic* refer to illustration numbers